GENTHE'S PHOTOGRAPHS OF SAN FRANCISCO'S OLD CHINATOWN

PHOTOGRAPHS BY
Arnold Genthe

SELECTION & TEXT BY
John Kuo Wei Tchen

DOVER PUBLICATIONS, INC.
New York

To the memory of
Victoria Chen Haider
and to Syed Haider
and Sean Chen Haider.

Published in Canada by General Publishing Company, Ltd., 30 Lesmill Road, Don Mills, Toronto, Ontario.
Published in the United Kingdom by Constable and Company, Ltd.

Genthe's Photographs of San Francisco's Old Chinatown is a new work, first published by Dover Publications, Inc., in 1984.

Book design by Carol Belanger Grafton

Manufactured in the United States of America
Dover Publications, Inc., 31 East 2nd Street, Mineola, N.Y. 11501

Library of Congress Cataloging in Publication Data

Genthe, Arnold, 1869–1942.
 Genthe's Photographs of San Francisco's old Chinatown.

 1. Chinatown (San Francisco, Calif.)—Description—Views. 2. San Francisco (Calif.)—Description—Views. 3. Photography, Artistic. I. Tchen, John Kuo Wei. II. Title. III. Title: Photographs of San Francisco's old Chinatown.
F869.S36C473 1984 779'.9979461 83-5319
ISBN 0-486-24592-6 (pbk.)

PREFACE AND ACKNOWLEDGMENTS

In American popular culture, the Chinese have been caricatured as exotic, sometimes sinister, oddities, always alien to American life. The Chinese, it has been argued, are foreigners. Even those who are United States citizens are in reality still Chinese: after all, they certainly don't *look* American.

Nevertheless, Chinese have been working and surviving in the United States for over 200 years. Therein lies a great deal of yet undocumented, untold history. This book is a work of reclamation. It is an effort to counter deeply rooted myths and stereotypes and, using the great and enduring photographs of Arnold Genthe, to convey the subtle texture and flavor of the everyday life of the Chinese in San Francisco's Chinatown from 1895 through the earthquake and fire of 1906.

As a social historian, I am always painfully reminded of the fragility of the threads connecting our present with the past. When I first began my fieldwork in San Francisco, Mark Lai advised me to speak immediately with Soon K. Lai, a gentleman in his eighties who had been a prominent figure in San Francisco's Chinese community and who had a sharp, clear memory. "He can probably identify everyone in those photographs," I was told. After emerging from a few days of archival research, I discovered that in the interval Mr. Lai had stumbled on some steps, hit his head, and died.

I did not realize how significant Mr. Lai's untimely death would be until I came to find very few Chinese who survived from 1906. Exclusion acts had prohibited the immigration of Chinese women, and antimiscegenation laws had prohibited the marriage of Chinese and whites. This meant that those workers who were here could have no families and therefore had no descendants to pass on their life stories. Like most working people, the Chinese of that time left few written records of their lives. The 1906 earthquake and fire destroyed whatever documents did exist. Soon K. Lai was one of the few remaining threads linking us with the past. Without the benefit of his knowledge, many of the individuals appearing in these photographs must remain anonymous. (If any readers are able to identify any people or places in these photographs, please contact the author, John Kuo Wei Tchen, 448 50th Street, Brooklyn, N.Y. 11220.)

I was fortunate, however, to have spoken with Ching Wah Lee, Grace Lee, and Yuk Ow before each of them passed away. These elders, along with their contemporaries, were the true experts on the San Francisco Chinatown I have tried to reconstruct. I would like to express my belated, but most heartfelt, appreciation for their generosity and knowledge.

I owe my greatest intellectual debts to two scholars. Harvey Goldberg opened my mind to the importance of historical inquiry. Him Mark Lai has been rightfully called the dean of Chinese-American studies. He is a full-time engineer by day and a dedicated historian at all times. He has helped me during all phases of this book's preparation.

While I was in San Francisco, a number of individuals shared knowledge and rice. Thank you Enid Lim, Laverne Mau Dicker, Major Check Yee, Judy Yung, Alice Fun, Philip Choy, Clinton Young, and Margie Chen. Thanks also to James Dao for looking at a rough draft of the manuscript. David Wright provided me with hard-to-find articles from *The Wave* and *Camera Craft*. Mrs. Ricarda Genthe, wife of Arnold Genthe's nephew, kindly allowed me to interview her in New York City. Bernard Riley and Gerald Maddox of the Library of Congress led me to Genthe's original glass negatives and lantern slides. Toby Quitslund, undoubtedly the single most knowledgeable Genthe scholar, helped me throughout my research and writing. My appreciation to Hayward Cirker, Stanley Appelbaum, and Alan Weissman of Dover Publications for their faith in the significance of Genthe's Chinatown photographs.

My greatest personal debts are to Lin-Sie Zhao Tchen and Judy Susman. Ms. Tchen raised me with an appreciation of Chinese history and culture. Judy Susman provided inestimable intellectual and moral support throughout my work on this book.

In May 1979, my sister and friend, Victoria Chen Haider, was killed by the crash of American Airlines DC-10 Flight 191. She had been reaching new heights in her career as a fiction editor and just beginning her life as mother and writer. It is to her memory, and to Syed Haider and Sean Chen Haider, that this book is dedicated.

All errors in this volume are my responsibility alone.

New York, New York JOHN KUO WEI TCHEN

A NOTE ON TRANSLITERATION

Chinese words and names have generally been transliterated into English according to the pinyin system (in Mandarin, or "national language"). In addition, the Cantonese (using the Yale system) frequently appears in parentheses on the first appearance of a name, word, or phrase, e.g. Siyi (Sei Yap). Asterisks (*) indicate where a proper name has been kept in a nonpinyin spelling used in the United States by that person; in many of those cases the pinyin spelling is then given in parentheses, e.g. Ng Poon Chew* (Wu Panzhao). This procedure is sometimes also followed for ordinary nouns.

CONTENTS

LIST OF PLATES
THE TITLES IN QUOTATION MARKS ARE GENTHE'S.

GENTHE'S PHOTOGRAPHS OF SAN FRANCISCO'S OLD CHINATOWN

INTRODUCTION
TANGRENBU—THE STREET LIFE OF
SAN FRANCISCO'S CHINATOWN, 1895–1906

In the sultry late spring of 1895, a young German doctor of philosophy by the name of Arnold Genthe sailed into New York harbor on the liner S.S. *Normannia*. Although he was arriving in the middle of a great migration of impoverished eastern and southern Europeans, Genthe was not coming to the United States as an immigrant. While the steerage below was packed with the desperate poor of many nationalities, Genthe was comfortably traveling first-class with the Baron von Schroeder and family. The Baron had met Genthe in Hamburg and needed a tutor for his son Heini. Having completed his doctoral work at the University of Jena, Genthe wanted to avoid being drafted into Kaiser Wilhelm's Prussian army and had agreed to work with the young von Schroeder for two years in the Baroness's home city, San Francisco.[1]

Genthe was beguiled by San Francisco. His poetic description of the city, recorded in his 1936 autobiography *As I Remember*, illustrated how deeply entranced he was:

> As soon as I had unpacked I went for a long walk, up hill and down and up again, until the whole glamorous panorama was spread out before me. The approach through vestibule of cliff and mountainside; the golden stretch of the dunes; the Bay, misted by the silver fog, or captured by the softly incandescent blue of a clear sky; the full-rigged barkentines and the many little ships, always coming and going, their sails bellying in the stiff breeze; the long curve of the waterfront with its rows of liners and sailing vessels from all ports of the world, tied up at their berths or lying at anchorage in the stream; the spicy tang of the sea and of cargoes piled high on the quays; Fisherman's Wharf and its rainbow fleet; the deep-throated songs of the Italian fishermen as they mended their nets; Telegraph Hill, where the fishermen's shacks clung like swallows' nests to the sides of the cliff—against the background of the variant sky they created a mural of such beauty that during the fifteen years I was there my eyes never tired of it.[2]

The German guidebook to the United States that Genthe brought had a sentence about San Francisco that intrigued him: "It is not advisable to visit the Chinese quarter unless one is accompanied by a guide."[3] This Chinese quarter, or Tangrenbu (Tong Yen Fau; "Port of the People of Tang [i.e. Chinese]"), was the home base of tens of thousands of Bay-area Chinese. However, to non-Chinese it was known as the mysterious, exotic, and sometimes dangerous Chinatown.[4] Predictably, Genthe headed for this section of the city the first chance he could. In Tangrenbu, Genthe found a living culture totally foreign to his experience. The colors, the smells, the language made him feel compelled to write to his family. Searching for illustrations to accompany his letters, he

could only find "crudely colored postal cards," none of which satisfied him. He attempted to sketch residents and soon found that "as I got out my sketchbook the men, women and children scampered in a panic into doorways or down into cellars."[5] He then chose to try his hand at the relatively novel medium of amateur photography.

Building upon these rather innocent beginnings, Genthe returned time and again to Chinatown, taking over 200 photographs on glass negatives. These marvelous photographs of San Francisco's Tangrenbu launched him on a long, productive career as a highly acclaimed photographic artist; and at the same time they preserved rare, priceless glimpses of the rich street life of old Chinatown as it was before being leveled by the disastrous earthquake and fire of 1906.

San Francisco's Tangrenbu

The 1895 Tangrenbu that Arnold Genthe ventured into was hardly the simple "Canton of the West" he perceived it as. It was the spiritual, if not actual, home of tens of thousands of Chinese who, because of a tidal wave of racist hostility, were forced to live in a segregated section of the city. Chinatown had been shaped by the swirling crosscurrents of an epic three-way struggle between industrial capitalists who sought to remake the West as they saw fit, Chinese merchants and workers who sought work and survival, and an often racist, yet class-conscious, white working class driven by anger and fear for their livelihood. To truly understand the story that Genthe's photographs tell, it is necessary to comprehend these forces that molded early California history.

Chinese had been reported living in Yerba Buena, a sleepy Mexican trading village, as early as 1838, a full ten years before gold was spotted at Sutter's Mill nearby.[6] Within a year, the "manifest destiny" fervor of United States ruling interests had wrested vast tracts out of Mexico's northern territories. In 1849, Yerba Buena became San Francisco, and a year later California became the thirty-first state admitted into the Union. James O'Meara, an early San Francisco settler, noted that the pioneer Chinese tended to be merchants and traders. "Most of the Chinese who came here were men of means enough to pay their own way and here they mainly embarked in mercantiles or trading pursuits. In 1849 . . . no Chinaman was seen as a common laborer. . . ."[7] These early Chinese had come primarily from the three wealthy commercial and agricultural districts of Nanhai (Namhoi), Panyu (Punyu), and Shunde (Shuntak), known

as the Three Districts, or Sanyi (Saam Yap), which surrounded the major southern port city of Canton. Merchants from Sanyi often dealt with Chinese agents for Western colonial companies, and therefore had access to travel on American clipper ships. Merchants and traders from Guangdong and Fujian, the two provinces flanking Canton harbor, could be found in ports throughout the Pacific rim. In San Francisco, the earliest Chinese stores were located on Sacramento Street between Kearney (now Kearny) Street and Dupont Street (now Grant Avenue). Sacramento Street was called Tangrenjie (Tong Yen Gaai) or the "Street of the Chinese People." As the San Francisco economy boomed with hopeful gold seekers, the city experienced continual labor shortages throughout the 1850s and 1860s. It was cheaper for male miners who refused to wash their own clothes, for example, either to send their dirty laundry on a clipper ship to Hong Kong or Honolulu to be washed or to simply throw it away, than to pay the rates to have their clothes done locally. The pioneer entrepreneurs and industrialists of the region needed workers to lay roadways, reclaim swampland, work company-owned mines, make boots and shoes, and perform hundreds of other wage-paid tasks. The white men who flooded the Pacific coast were generally obsessed with making a fortune and returning to their homes back east. Native Americans, derogatorily called "Diggers" by whites, would not cooperate. Nor would the "greaser" Mexicans or other Hispanic Americans who invested their ambitions in gold mining. American clipper ships, which at that time were the world's quickest mode of transportation, offered the most realistic solution to the labor shortage. To the west, across the Pacific, lay China, and Chinese "coolie" laborers had already been profitably used on British colonial plantations in South America and the West Indies. Chinese workers were seen as the solution, and the San Francisco Chinese merchants became the key to bringing them over.

In the mid-1800s, China was in chaos, and its social fabric was unraveling. The repressive Qing Dynasty rule of Manchu foreigners was seriously weakened by the disastrous opium trade forced upon the nation by the British Empire. Western imperial powers forced an "open door" trading policy with the beleaguered country and accelerated the draining of the government's silver coffers. The Taiping Rebellion erupted from 1850 to 1864, and left a wide swath of destruction and death in southern China. Banditry was rampant; the more ruthless landlords exacted large tithes from tenant farmers and evicted them when they couldn't pay. Many of these landless peasants migrated to the growing, Western-dominated urban centers of Canton, Amoy, Macao, and Hong Kong to look for work and escape. These desperate poor formed the ranks of laborers whom Westerners called "coolies," which in Chinese ("kuli" in the Mandarin dialect) signifies "bitter strength" (and derives from the Anglicization of the Tamil term for "hireling").

The British not only wanted Chinese markets in which to sell their surplus cotton goods and profitable opium, they needed laborers to take the place of black plantation slaves nominally freed by the Emancipation Act of 1833 in the West Indies, Australia, New Zealand, South Africa, and Canada. Chinese laborers were also recruited for plantations in Peru, Cuba, and the Sandwich Islands (Hawaii). In a span of 30 years, hundreds of thousands of Chinese laborers were tricked and lured onto British,

American, and other Western ships for the long journey across the Pacific Ocean. Conditions on these frigates were often comparable to, and sometimes worse than, those of the African slave trade with North America. The mortality rate was as high as 40 percent on one ship to Peru. These conditions led to frequent riots, murders, and in several cases the seizing of the ship.[8]

Gentler techniques of persuasion were used to attract Chinese to the United States. Many Guangdong residents had already heard the news of the gold rush. San Francisco, in fact, was called in Cantonese Gam Saan, or "Golden Mountains." American clipper-ship companies were eager to carry human cargo because it was more profitable than goods. They contracted Chinese brokers to lure Chinese as passengers to the United States with enticing handbills conjuring up glittering images that would satisfy a poor person's fantasies. One particularly sensational, but nonetheless typical, handbill circulated in April 1870 stated:

All Chinamen make much money in New Orleans, if they work. Chinamen have become richer than mandarins there. Pay, first year, $300, but afterwards make more than double. One can do as he likes in that country. Nobody better nor get more pay than does he. Nice rice, vegetables, and wheat, all very cheap. Three years there will make poor workmen very rich, and he can come home at any time. On the ships that go there passengers will find nice rooms and very fine food. They can play all sorts of games and have no work. Everything nice to make man happy. It is nice country. Better than this. No sickness there and no danger of death. Come! go at once. You cannot afford to wait. Don't heed wife's counsel or the threats of enemies. Be Chinamen, but go.[9]

In the late 1840s and 50s a number of Chinese workers were contracted for a specified number of years, in exchange for passage to Gam Saan; however, these contracts were difficult to enforce. One Edward Lucatt stated: "The fifteen coolies I brought from China, and who were under bond for two years with the party who engaged them, were no sooner ashore than they resisted their contract, and each turned his separate way. Nor would the authorities interfere. . . ."[10] Most Chinese workers came on a credit-ticket basis in which a Chinese merchant in Hong Kong or Canton lent them passage fare, around $40–50. Upon arriving in the United States the connecting merchants would help find workers jobs and collect the interest and principal from monies earned. The San Francisco Chinese merchant then stood to make double profits by either filling the contract-labor needs of American companies or employing the workers themselves. When contracted by American firms, part of the arrangement was that the labor crews would buy their supplies exclusively from that merchant. The merchant would also hire Chinese foremen to supervise the workers, thus solving the communication problems between the white bosses and the Chinese workers. In 1852 alone, over 20,000 Chinese were reported to have passed through the San Francisco custom-house shed.[11] In contrast to the Sanyi merchants, most of these immigrants came from the neighboring, but much poorer, Four Districts, or Siyi (Sei Yap), of Xinhui (Sanwui), Taishan (Toishan), Kaiping (Hoiping), and Enping (Yanping). And as was true with white fortune hunters, few women were among these workers.

Soon stores spread down Dupont Street, spilling onto both sides of Jackson between Kearney and Stockton. In

1856, *The Oriental,* the first San Francisco Chinese-language paper, published a directory listing 33 general merchandise stores, 15 Chinese herb stores, five doctors, five restaurants, five butchers, three tailors, three boarding houses, three wood yards, three bakers, two silversmiths, one wood engraver, one curio carver, one broker for American merchants, and a Chinese interpreter.[12] The concentration of stores in this convenient downtown wharfside area made it ideal for Chinese workers arriving in the city. However, most Chinese did not live in this area, nor were Chinese businesses restricted to these streets. Fully 80 percent of the Chinese in California in the 1850s and 60s were distributed throughout the mining areas. The *Oriental* directory also listed a candle factory on Brennan Street and Third, Ning Yang* Co. on Broadway, Young Wo* Co. on the slopes of Telegraph Hill, Yan Wo* Co. in Happy Valley, and a Chinese fishing village on Rincon Point.[13]

Chinese miners soon discovered that the mines were not the key to the prosperity they dreamed of. As early as 1849, 60 Chinese working for a British mining company at China Camp, Tuolumne county, were driven off their claim by a party of white miners.[14] A pattern soon developed in which many white Protestant miners declared that these deposits were their exclusive domain and chased away all other people. Chinese were thus forced to mine claims that whites had already abandoned. Although not all white miners were so racist and xenophobic, they all gained from reduced competition with other miners. The independent miners were greatly threatened by companies hiring groups of workers to mine the claims for them.

The conflict between Chinese miners working for companies and independent white miners became especially acute when surface deposits were largely exhausted by the 1870s. Expensive equipment and intensive labor were now required to extract the more elusive gold deposits, putting individual prospectors at a great disadvantage. Although the majority of Chinese miners were independents, they soon became identified with these hated companies, and were driven out of many mining areas. Notices were often posted warning Chinese to leave the area. One such flyer in Mariposa proclaimed: "Notice is heareby given to all Chinese on the Agua Fria and its tributaries to leave within 10 days from this date, and any failure to comply shall be subjected to 38 lashes and moved by force of arms."[15] Attacks against Chinese became frequent, and Chinese were stripped of legal recourse. In 1854, Chief Justice Murray of the California Supreme Court delivered the opinion that the 1850 state law which said, "No Indian or Negro shall be allowed to testify as a witness in any action in which a white person is a party," should be extended to "Chinese and all other people not white."[16]

One of the common excuses for restricting the rights of Chinese in America was the contention that they made their money in the United States but sent it back to China, therefore draining the region of reinvestment funds. Ironically, aside from the question of how much money was sent back to workers' families in Southern China, the discriminatory Foreign Miners' Tax, of which Chinese were the primary contributors, accounted for at least half of California's entire state revenues from 1850 to 1870.[17]

With the general decline of gold mining in the 1860s, the building of railroads quickly occupied the foreground of industrial capitalist interests. A transcontinental link from the West to the East and points in-between meant the possible development of the region's agricultural and manufacturing industries. Gabriel Kolko, the noted American historian, states: "From the end of the Civil War until the beginning of the First World War, the railroad was a central, if not the major, element in the political, economic, and social development of the United States. . . . Until the rise of big business in steel, agricultural machinery, and oil, the epic villains in American history in the period from 1870 to 1900 were, John D. Rockefeller excepted, railroad men."[18]

The federal government and Eastern banks underwrote the massive capital necessary for the construction costs of the Central Pacific Railroad. This highly lucrative franchise was organized by the soon to be notorious "Big Four" railroad barons of the West: Mark Hopkins, Collis P. Huntington, Charles Crocker, and Leland Stanford. Initially, poor Irish immigrants were hired to start railroad construction beginning from Sacramento; however, as the tracks ascended the foothills of the Sierra Nevada Mountains, many workers refused to spend days carving a few feet of granite from a mountainside. In 1865, 50 Chinese workers were hired by Charles Crocker on an experimental basis. Pleased with the results, and desperate for laborers regardless of color, Crocker recruited several thousand Chinese workers within six months. Three years later a total of 8,000 to 10,000, many of whom were former miners, were hired to blast through and over the treacherous mountain range. In the severe winter of 1866, Chinese crews worked and lived underneath the snow. Flash avalanches of snow frequently buried workers. One American reporter witnessed a huge snowslide descending upon two workers. "Seeing it approach, they stepped behind a tall rock, but it buried them 50 feet deep. In spring their bodies were found standing upright, with shovels in their hands."[19] An 1870 newspaper account noted the shipment of 20,000 pounds of bones, representing some 1200 individual railroad workers, being sent back to China for proper burial.[20]

On June 24, 1867, thousands of Chinese railroad laborers laid down their tools and went on strike demanding better pay and an eight-hour day, stating, "Eight hours a day good for white men, all the same good for Chinamen." Although the strike was lost, the Central Pacific management took the work stoppage quite seriously and wired to New York asking about the feasibility of bringing west some 10,000 black workers.[21] After the completion of the transcontinental link at Promontory Point, Utah, Chinese railroad workers were employed throughout the North American West, from Texas to Canada, building regional and local lines.

While many Chinese miners found employment on the railroads, others chose to establish fishing operations, familiar to them from what was a common occupation in Guangdong Province, China. Shrimp camps dotted San Francisco Bay from Point San Pedro to Point San Mateo. The shrimp were netted, boiled, and dried primarily for export to Japan, the Sandwich Islands (Hawaii), and China. In 1880, approximately 1,000,000 pounds of dried shrimp were shipped across the Pacific. Chinese fishermen were barred from the San Francisco market, which was dominated by hostile Italian immigrants; however, they did supply San Diego and several other coastal areas with fresh fish. The fish that did not sell were salted and dried. Abalone was also harvested; although Americans

did not eat the mollusk, they fancied the shells and bought them from Chinese vendors for jewelry and decorations. Chinese also fished for sharks, caught crabs, and gathered seaweed for food and to make agar-agar. Through the 1880s, the Chinese were excluded from salmon fishing, even though they composed a sizeable proportion of the seasonal labor force in salmon canning, an important national industry emerging in the Pacific Northwest and Alaska.[22]

During this time, other Chinese supplied the labor-intensive work force critical to the building up of local industry and commerce, such as constructing wagon roads and stone bridges and fences; building levees for swampland reclamation; digging irrigation canals and ditches; filling San Francisco Bay with landfill; and even excavating the caverns of the Napa and Sonoma valleys for wineries. Improved local roads, reclaimed land, irrigation canals, and interstate rail links combined to make the development of a profitable agricultural economy possible.

In the 1850s, still other Chinese miners followed the occupational shift of Hispanics, who were also evicted from the mines. Both groups, one after the other, took up small-scale potato farming and truck gardening. Chinese truck gardens started out as small one-person operations and soon grew in popularity and size. These independent farmers came to supply San Francisco, among other cities and towns, with approximately one-fifth of its fresh vegetables through the 1880s. A network of vegetable peddlers brought these perishables from house to house in neighborhoods throughout the city. Some Chinese cultivated small fields of strawberries and other fruits. Most Chinese farmers occupied land for short terms as sharecroppers. In exchange for raising the crops, tending orchards, and taking care of the properties, the sharecroppers kept two-fifths to one-half of the harvest.

Chinese were but a small minority of California farmers. However, the impact of Chinese agricultural workers was felt not on the small independent plots but on the large agribusinesses of the San Joaquin and Sacramento Valleys, which dominated California agricultural production. Chinese, along with Irish, Germans, and American Indians, formed the ranks of California's farm workers. Unlike the other groups of workers, Chinese were generally not hired full-time, but were brought in only when needed, hence earning the dubious distinction of becoming the region's first migrant farmworkers. They picked grapes, made wine, cultivated and harvested orchard fruits, picked cotton and hops, tended livestock, planted and harvested wheat, and performed countless other farm-related tasks. Carey McWilliams, prominent California labor historian, has even asserted that "in many particulars the Chinese actually taught their overlords how to plant, cultivate, and harvest garden crops."[23]

Chinese labor contractors performed the indispensable service of providing labor as needed, at a fixed price, to the state's agricultural businessmen. This ready supply of labor reduced the need for these large farms to maintain a regular force of full-time workers. As these large farms prospered, small independent family farmers came to resent the increasing power that the large cash crops and railroad freight rates had over the market prices. And, as with the mining industry, Chinese laborers came to be identified with the large agribusinesses as the source of

woe for the small white farmer. One such farmer put it the following way:

> If those men had not monopolized the growth of currants in large quantities by the aid of Chinese labor, even with the Chinese here and they holding their lands, those currants would be grown by men who would use their own children, their girls and boys, in picking of these currants. . . .[24]

By the mid-1870s a rural anti-Chinese movement gained strength, and farm producers reluctantly began to replace Chinese with often inexperienced white urban workers. Despite the sometimes fierce agitation, Chinese managed to hang on to their positions as lowly migrant workers, jobs that few Anglo-American workers have been willing to take to this day.

In San Francisco, Sacramento, and other growing urban areas, light manufacturing began to develop. Woolen mills required large capital investments, therefore limiting the industry to large firms and an available force of cooperative laborers willing to subject themselves to factory discipline. During the early to mid-1860s two large San Francisco factories were able to gain Civil War supply contracts for blankets and clothing. However, with the ending of the war in 1865 the two plants ran at only 50 percent of capacity. This recession brought about layoffs. Racist white workers blamed the unemployment and wage reductions upon the 400 to 500 Chinese workers. As with other California industries, hierarchies of pay within the woolen mills developed, reflecting the sexual and racial attitudes of the times. Although Chinese composed three-quarters of the entire woolen labor force, they were paid at the lowest rates. Chinese were forced to work the labor-intensive, less skilled jobs and were paid from $.95 to $1.50 per day; white women, who were often hired to replace Chinese, received $1.25 to $1.50 per day; whereas white males, who generally had supervisory positions, were paid a uniform salary of $2.50.[25] Factory bosses soon discovered that the industry could not be exclusively Chinese, that it was important to mix Chinese with white workers so as to maintain supervisory control. Robert Peckham, the president of the San Jose Woolen Mills, commended Chinese workers for learning their jobs quickly and being very "industrious," but complained that these employees could be a little "crotchety." "They have the power of combining. If you do not happen to get along with them, and have a difficulty with one, the whole lot will stand up for each other, and as a general thing go together."[26]

Parallel patterns existed in other growing California manufacturing industries. Chinese workers were pitted against white women and sometimes children in the lower-paying jobs, while white men held skilled or supervisory positions commanding a higher wage, which was often higher than the national average. The prevailing anti-Chinese feeling among whites prevented effective job-action protests. Since upward advancement was limited, the Chinese quite sensibly gravitated toward establishing their own manufacturing businesses in areas that required low initial capital investment. The areas that proved to be the most popular and economically viable were the needle trades, shoe and boot making, and cigar making. In these areas, Chinese could set up their own small-scale factories and escape discriminatory treatment at the workplace.

In all three light industries Chinese workers organized labor guilds that resembled American craft unions. This gave these workers a greater bargaining leverage with Chinese bosses as opposed to white overseers. Yet despite the autonomy gained by Chinese workers and bosses in these industries, they would soon lose their competitive edge to the increasingly technological and powerful businesses that were mass-producing the same goods in the East. Chinese could easily move into these areas of industry precisely because the predominant national trend was away from small sweatshop operations toward concentrated mass-production factories that greatly lowered the costs of items produced relative to labor time invested.[27]

The completion of the nationwide rail system sparked an explosion of industrial development across the entire nation. Western industries now competed with the East for markets, and the tremendous tide of poor European immigrants entering though Castle Garden in New York City now had means to travel westward in search of a livelihood. The labor shortages that had characterized the 1850s and 1860s, when Chinese workers had entered developing mainstream industries, now gave way to surpluses of white immigrant workers willing to take on jobs that U.S.-born whites had previously shunned. The 1870 California census indicated that the Chinese formed only one-twelfth of the state's population; however, it has been estimated that Chinese workers made up as much as one out of every four California workers.[28] In the ensuing decades of white migration to California this relatively high ratio of Chinese workers was quickly reduced. The increasingly integrated national capitalist economy reeled from periodic depressions in the 1870s and again in the 1890s. Western railroads, coupled with increased economic concentration in the form of land monopolization and factory industrialization, so totally transformed the social landscape that many residents and recent migrants were left confused and angered. For the great majority of people, expectations of plentiful job opportunities, through which hard-working Horatio Algers could pull themselves up by their bootstraps and become successful, proved illusory at best. Frustrated expectation bred great social unrest. Masses of unemployed, militant trade unions, and antimonopoly political rallies punctuated these periods of economic downturn. Although the much-hated "monopolists" were a main target of organizational agitation, the Chinese were increasingly often made the scapegoats for social problems.

In July 1877, crowds of mainly unemployed whites gathered in sandlot rallies throughout California. The militant Irish-led state Workingmen's Party initiated many of the sandlotters' demands. Combined with the regional branches of the Grangers, an organization that represented small family farms across the nation, the Party argued for an eight-hour day, the nationalization of the railroads controlled by the "Big Four," the closing off of property-tax loopholes for the wealthy, the cutting of city bureaucrats' salaries down to the same level as those of skilled labor, and additional class-conscious demands. Their first slogan was "Down with the Bloated Monopolists!" On one of the July evenings an angry crowd with torches in hand climbed up to Charles Crocker's Nob Hill mansion and threatened to burn it down. At the same time, many of the same sandlot leaders railed against the

Chinese. White Protestant "manifest destiny" arrogance here translated into a nativist attack on Chinese. "Anti-Coolie" clubs proliferated in working-class San Francisco neighborhoods. Their demand was, "The Chinese Must Go!" Denis Kearney, the fiery orator of the Workingmen's Party, was quoted by local newspapers as saying: "Judge Lynch is the only judge we want." "Bring guns to the sandlots and form military companies; blow up the Pacific Mail docks [the place where Chinese immigrants landed, owned by the 'Big Four']." "The monopolists who make their money by employing cheap labor better watch out! they have built themselves fine residences on Nob Hill and erected flagstaffs upon their roofs—let them take care that they have not erected their own gallows." "When the Chinese question is settled, we can discuss whether it would be better to hang, shoot, or cut the capitalists to pieces."[29]

Violence mounted against the Chinese. On July 23, bands of young men swept through 20 to 30 Chinese wash houses. On the following evening, they committed random murders of Chinese, set fires, fought with police. And on the third night, they set fire to a lumberyard bordering on the Pacific Mail Steamship docks, and fought with firemen trying to put out the blaze. Although anti-Chinese agitation was not new, the sentiment and scapegoating was now incorporated into the web of local, regional, and state politics. Both the local and state Republican and Democratic parties adopted virulently anti-Chinese platforms throughout the 1870s and 1880s. Opportunistic politicians soon found that vehement anti-Chinese and antimonopoly rhetoric won votes. Many regional politicians were so elected. Countless discriminatory laws were passed. Chinese children, for example, were denied access to public schools, and since Chinese could not legally become naturalized citizens they were not allowed the rights of American citizens. In 1870 a penalty of not less than $1,000 was to be levied against any "Asiatic" brought into the state without proof of "good character." Six years later the law was declared unconstitutional. In 1874, the San Francisco Board of Supervisors passed ordinances requiring that those laundries not employing vehicles, which meant Chinese businesses, had to pay a quarterly license fee of $15, whereas the more prosperous, generally white-owned businesses, which owned one or more vehicles, had to pay only $2 per vehicle per quarter. Later that same year the ordinance was declared void by the County Court. Whether these laws were eventually overruled or not, these harassing regulations had the cumulative effect of provoking the Chinese to withdraw whatever trust they had had in the American legal and legislative systems.

Pro-Chinese forces, which supported the rights of Chinese to work and live in the West, tended to represent either regional big businesses, which depended on Chinese laborers; traders, who depended on Asia's millions of potential consumers; or Christian missionaries, who sought good relations with China and its possible millions of converts. Before the 1876 State Senate Committee, commissioned to investigate the "Chinese Question," and before the 1877 U.S. Congressional Joint Special Committee, a corps of local and regional businessmen testified to the critical contributions Chinese labor had made to the state. Many argued that their toil actually raised the social position of white labor. Charles

Crocker, one of the "Big Four" rail barons, flatly stated, "I think that their presence here affords to white men a more elevated class of labor. As I said before, if you should drive these 75,000 Chinamen off you would take 75,000 white men from an elevated class of work and put them down to doing a low class of labor that the Chinamen are now doing, and instead of elevating you would degrade white labor to that extent."[30] Christian missionaries, who expressed far deeper understanding of and sympathy for the Chinese than most Americans, supported the immigration of Chinese to the United States with the primary goal of converting them to Christianity. Their support, although often truly beneficial to the Chinese, betrayed a condescending paternalism that seemed to apologize for Western imperial domination of China. The Reverend Otis Gibson, a staunch and outspoken supporter of the Chinese, conveyed a fundamental contempt for Chinese culture in his Congressional testimony: "Their civilization is lower than the Christian civilization of America. The religion of the educated may be formulated as a blind fatality; the religion of the masses a heartless, superstitious idolatry."[31]

The anti-Chinese political movement was not restricted to local socio-economic issues; it encompassed a moral world view of right and wrong, good and evil. The issue was intricately entwined with the perceived divine right of America, as a "white" nation, to enlighten and dominate North America and beyond. The United States was commonly personified by Columbia, a lily-white woman robed in white, a symbol of purity and civilization better known today in the form of the Statue of Liberty. China, however, was most often presented as a hoary, ancient, moribund, and pagan country overflowing with look-alike people. Countless political cartoons printed in the American popular press depicted Chinese as devilish, winged, bat-like creatures; hordes of grasshoppers ravaging wheat fields and attacking Uncle Sam; or subhuman-looking workers with octopus-like arms monopolizing jobs while idle white boys loitered around.

There were countless other graphics decrying the "yellow peril." Penny-press pamphlets and books flooded the popular market warning of the impending doom. One typical pamphlet, printed in San Francisco by H. J. West in 1871, was titled "The Chinese Invasion: They are Coming, 900,000 More. The Twenty-Three Years' Invasion of The Chinese In California And The Establishment of a Heathen Despotism in San Francisco. Nations of the Earth Take Warning!" Another, published in Boston by Walter J. Raymond in 1886, was titled "Horrors of the Mongolian Settlement, San Francisco, California. Enslaved And Degraded Race of Paupers, Opium-Eaters And Lepers." A San Francisco doctor published, in the city's Biennial State Board of Health Report of 1871, an article entitled "The Chinese and the Social Evil Question." He stated with full authority that the Chinese were "inferior in organic structure, in vital force, and in constitutional conditions of full development."[32] Other local physicians testified that Chinese were, as a race, physiologically different from whites in that their nerve endings were further away from the surface of the skin and they were therefore less sensitive to pain. This meant that Chinese workers could labor for longer hours in terrible conditions and not complain. Much of this anti-Chinese xenophobia dovetailed with crude social Darwinism and human eugenics movements that asserted the evolutionary and inbred superiority of white races over all nonwhite peoples. It was generally accepted by white Christians that interracial sexual relations would dilute the purity of races. Anti-miscegenation laws that already applied to blacks and Native American Indians were extended to include Chinese in over 30 states; California did not repeal its anti-miscegenation law until 1948. These movements were historic forerunners of the fascist and Ku Klux Klan movements of recent American history.

The anti-Chinese movement successfully equated Chinese with the devil and monopoly trusts on a nationwide level. In 1887, a white miner in Lake County, Colorado, when asked what rank and file labor "wanted," responded: "Laws should be passed compelling equal pay to each sex for equal work; making all manual labor no more than eight hours a day so workers can share in the gains and honors of advancing civilization; prohibiting any more Chinese coming to this country on account of physiological, labor, sanitary, and other considerations, as the country would be happier without Chinamen and trusts." What is so significant about this statement is not what the miner said, which was fairly typical of many anti-Chinese workers, but the fact that there were no Chinese in Lake County five years before or after he made the statement. Even by those without direct contact with Chinese, the belief that they were no good for the United States was widely accepted.[33] During times of great socio-economic dislocation the Chinese were characterized in such a way that average, mainstream white Americans perceived them as legitimate targets for the deep-seated frustrations of farmers and workers across the country. In 1882, the United States Congress passed the Chinese Exclusion Act, prohibiting Chinese workers (though not merchants, students, or diplomats) from entering the United States. Chinese workers thus earned the dubious distinction of being the first national group prohibited from immigrating to the United States. The act was amended in 1884; in 1888 it was renewed as the more restrictive Scott Act, which extended the proscription to all Chinese women, with the exception of merchant's wives. The Scott Act was extended another ten years in 1892, and in 1902 it was extended indefinitely. The passage of the law betrayed a national consensus that the United States was to be a white nation. Even at the height of Chinese immigration in the 1870s, the Chinese represented no more than 4.4 percent of all immigrants, in contrast to the whopping 94 percent who were European. At the height of "yellow peril" xenophobia in the 1880s through the 1890s, the Chinese made up only 0.4–1.2 percent of the immigrant population, whereas Europeans composed 95–97 percent.[34]

The Chinese were subject to random and organized violence of increasing intensity during the 1870s and 1880s. The most fervent anti-Chinese agitators not only wanted the Chinese restricted—they wanted them expelled from the country. In 1885 and 1886, the white residents of Seattle and Tacoma, Washington, evicted all the cities' Chinese residents, putting them on a barge to San Francisco with warnings not to return. Chinese farmworkers were violently driven out of the fertile Sacramento and San Joaquin valleys. In 1880, Denver riots left one Chinese dead and $20,000 worth of property damage. A riot in Los Angeles' Chinese quarter in 1871 left 15 Chinese hung from balconies and two Chinese shot dead. The single most brutal anti-Chinese riot occurred in Rock

Springs, Wyoming, in 1885, where angry white coal miners, working for the Union Pacific, rampaged through Chinese miners' shacks, killing 28 and wounding 15. Federal troops were called in to quell the rioting. No indictments were made. The U.S. Congress later paid an indemnity of $147,000 to the Chinese for property losses sustained. Even in Juneau, Alaska, Chinese working for the Alaska Mill and Mining Company were forced to leave in two schooners. Trade unions organized regional boycotts of Chinese-made goods and of companies that employed Chinese. This effectively curbed the participation of Chinese workers in mainstream industries. The cigar industry set a prime example. In 1874, white cigar makers adopted white labels to be put on individual cigars to indicate they, as white union men, had produced the cigars. The label showed a dragon on one side and the union mark on the other, with the words "White Labor, White Labor." Stores that sold only their cigars were awarded a certificate that read:

> Protect Home Industry. To All Whom It May Concern: This is to certify that the holder of this certificate has pledged himself to the Trades Union Mutual Alliance, neither to buy nor sell CHINESE MADE CIGARS, either wholesale or retail, and that he further pledges himself to assist in the fostering of Home Industry by the patronage of PACIFIC COAST LABEL CIGARS of which the above is a facsimile.[35]

The practice was later adopted by the Cigar Maker's International Union in the 1875 Convention. In one racist moment, both the cigar label and the union label had been originated.

The regional and occupational routing of Chinese workers forced many to return to China. Others migrated eastward, hoping for better conditions, and many retreated to urban Chinatowns. Whereas San Francisco's Tangrenbu was originally a refueling station for Chinese scattered throughout the region, it became more and more a segregated ghetto that kept the Chinese in one area, and whites out. These events form the backdrop of the Tangrenbu of the 1890s, the segregated world into which a starry-eyed Arnold Genthe stepped in 1895. It is this history that had been etched into the faces and memories of the subjects of Genthe's camera.

Arnold Genthe

Arnold Genthe was born to a highly educated, well-to-do Berlin family in 1869. Hermann Genthe, his father, was a professor of Latin and Greek at several "gymnasiums" which prepared upper-class German youth for college studies. Amid times of growing Prussian bureaucracy and militarism the family soon moved to the free and modern city of Hamburg, where Hermann Genthe founded and was president of the Wilhelm Gymnasium. Genthe was proud to note that his family had produced a long line of noted and accomplished scholars, architects, and teachers. The family library contained more than 200 books authored by its various members. His paternal grandfather alone was responsible for 30 volumes on linguistics and literature. One especially revered relative of young Genthe, Adolf Menzel, was a pillar of the German painting establishment. Genthe harbored a deep passion to be a painter. Menzel, however, politely suggested: "You have some talent, but considering the finances of your family, I feel it would be advisable for you to follow in the footsteps

of your father and grandfathers. You will paint, of course, but not for fame or profit."[36] With that sobering advice, at 19 Arnold entered the University of Jena, where he majored in classical philology. As a student he compiled a collection of German slang, edited previously unpublished correspondence between Goethe and Hegel, fought a duel, and wrote a doctoral thesis in Latin. Genthe was also literate in Greek, French, Anglo-Saxon, Hebrew, and English.

Genthe's lettered, polished background made him at home with San Francisco's emerging social elite. The Baroness von Schroeder was the daughter of railroad magnate and banker Mervyn Donohue. Genthe lived with the family, moving with them when they left their rented apartment on Van Ness Avenue and Sutter to stay in the posh Hotel San Raphael, a resort hotel that the Baron owned, and moving with them again to one of the several von Schroeder ranchos in San Luis Obispo County, not far from San Francisco. One of the ranchos, the Nacimiento, bred cattle and stretched for 50,000 acres from hills to valleys to mountains. It was in this setting that Genthe tutored young Heini von Schroeder. Their shared love for horses took them on long rides through this magnificent countryside. When Genthe had free time he would travel to San Francisco and wander through its streets and clubs.

By the late nineteenth century, San Francisco had smoothed out its rough frontier-boomtown edges and emerged as the premier West Coast seaport metropolis. The entire Western region of the United States was entering an era of great industrialization and large-scale agricultural development. Between 1870 and 1900, the population of San Francisco leaped from 137,000 to over 400,000. The investments in building the Union Pacific railroad, the discovery of gold in the Comstock Lode, Nevada, and the clothing manufacturing boom spawned by the Civil War created a nouveau-riche society primarily based in San Francisco. Upon Nob Hill lived the "Big Four" railroad barons and the "Bonanza Kings" of the Comstock gold. Jim Flood was so flush with his newfound wealth that he built a $30,000 brass fence around his Nob Hill brownstone mansion. It was the sole task of one house servant to keep the fence polished.[37] From their mansions and castles the Huntingtons, the Crockers, the Floods, the Townes, and the Stanfords controlled the region. Their presence and money fostered an extravagant upper-class subculture in letters and the arts.

The Bohemian Club was at the center of this elite subculture, and Genthe was one of its privileged members. "A Club like the Bohemian could not have developed anywhere else," Genthe wrote in his autobiography. "It started from small beginnings in 1872 when San Francisco was still an outpost, removed by time and distance from the artistic advantages of the larger and older cities of the American East. A group of men of education and travel met to discuss the possibility of creating these benefits for themselves, and having a good time of it as well." "With its atmosphere of cordiality it became the rendezvous of wits, bon vivants and celebrities—writers, painters, sculptors, musicians, men of the theater, and those who occupied high places in government and finance."[38] Here Genthe came to know such local and national luminaries as Jack London, Will and Wallace Irwin, Mary Austin, Ambrose Bierce, Xavier Martinez, Sinclair Lewis, Frank Norris, and Charles Warren Stoddard

Genthe developed his skills as a photographer within this supportive cultural climate. Desiring to use more sophisticated darkroom equipment, he joined the California Camera Club. There he began to experiment with enlarging and cropping his Chinatown prints, some of which appeared at the club's annual exhibitions. As early as 1897, his photographs also began to appear in *The Wave*, a small but important illustrated weekly featuring the arts, literature, and society. *The Wave* was one of the early United States weeklies that published photographs. No doubt, the favorable comment that Genthe began to receive gave him the confidence to "venture into a more exacting phase, one that had been tempting me for some time," portrait photography.[39]

A bachelor all his life, Arnold Genthe had a lifelong fascination with beautiful women, and he was constantly in their company. This was a trait that Dorothea Lange, who worked as an assistant to Genthe in New York City, was to observe decades later: "Yes, he was a real roué, a real roué."[40] One morning in San Raphael, he was enraptured by "a goddess swinging a tennis racket." "Her hair was a cloud of flame. Her skin was like a rose petal. With head erect she moved her perfectly molded figure with a free and easy grace." "Everywhere one went one saw these fine-featured, valiant young women, with their extraordinary coloring and their radiant spirit." Yet, Genthe moaned, "Theirs surely was a beauty to be recorded. But when one saw photographs of them the radiance and the spirit were missing."[41] In most of the portraits taken at this time the sitters were immobilized in front of painted backdrops. "There must be some way," Genthe thought, "of taking their pictures so that they would be more than a mere surface record and would have more relation to life and to art than the stiffly posed photographs that gave the effect of masks behind which the soul of the subject was lost."[42]

By 1897, Genthe had completed his tutorial responsibilities, and Heini von Schroeder was prepared to take his examinations for entrance into a gymnasium in Germany. Rejecting teaching offers from several German universities, Genthe decided to become a full-time portrait photographer. He found a two-story studio on Sutter Street and here he developed a distinctive, unstilted portrait style for his upper-class customers. A portrait of Mrs. W. H. Crocker, the wife of the powerful banker, with her three children earned Genthe renown among San Francisco's elite. Word of Genthe's novel photographic techniques quickly spread through blue-book circles. "With so many women of means and position using their prestige in my behalf, it was not surprising that my photographs became the fashion. Before a year had passed, I had acquired a large clientele. Often people had to wait outside in carriages, or sit on the stairs, since I had no reception room."[43] Much of his popularity was due to his ability to adjust lighting and suggest poses that favorably portrayed even "plain" women. In a few years, he enjoyed a thriving, lucrative business.

The year 1901 marked Genthe's emergence as an aesthetic innovator within the photographic world. With the publication of two articles, one in *Overland Monthly* and one in *Camera Craft*, he explained the phototechnique and articulated the philosophical principles of the "Genthe style." In "Rebellion in Photography" he included 19 of his most prized portraits and asserted that a group of emerging young "rebel photographers," himself included, had created the way to obtain photographs of truly artistic merit which abided by the aesthetic laws laid down by painters and sculptors through the ages. The "cherished traditions of the old time photographer were ruthlessly discarded, with the result that there are now quite a number of serious workers, who make pictures for money (and they charge rather high prices) that not only please the artists, even those who for years blindly maintained that a photograph could never be a work of art, but also the intelligent public, that is sensitive to subtleties and originality of treatment."[44]

Although Genthe wrote as if he were a detached observer, he clearly was referring to his own work. He had finally achieved his childhood desire to become a painter. But instead of brush and paints, his medium was camera and film. He saw himself as a pioneer in a new form of artistic portraiture. He was on the threshold of a long and accomplished career, and by 1906 he had stopped taking photographs of Chinatown, concentrating his efforts on Genthe-style portraits, for which he would eventually win national acclaim.

Arnold Genthe and Tangrenbu

In the shadow of Nob Hill society lay Tangrenbu, ten crowded blocks inhabited by San Francisco's Chinese—a region that Arnold Genthe exotically referred to as the "Canton of the West."[45] Genthe bought a small, black, rectangular "detective" camera, equipped with a fast Zeiss lens, to take pictures there. "For my first experiment I could scarcely have chosen a more difficult subject. The alleys and courtyards were so narrow that the light found its way through them for only an hour or two at midday. In order to get any pictures at all I had to hide in doorways or peer out from an angle of a building at some street corner. But I went bravely ahead."[46]

In a small closet darkroom on the top floor of the von Schroeders' house, Genthe developed his first glass negatives. Encouraged by his initial results, he frequented the Chinese quarter, especially during Chinese New Year and special holidays. "Many days I stood for hours at a corner or sat in some wretched courtyard, immobile and apparently disinterested, as I waited, eager and alert, for the sun to filter through the shadows or for some picturesque group of characters to appear—a smoker to squat with his pipe, or a group of children in holiday attire."[47]

Standing at six foot two, with bushy eyebrows and a wild mane of hair, Genthe was an imposing presence everywhere he went. His lurking around doorways and alleys must have appeared especially peculiar and suspect to Tangrenbu residents. In his autobiography, Genthe explained that he had to develop this "candid camera" approach because "I had learned that the inhabitants of Chinatown had a deep-seated superstition about having their pictures taken. To them the camera was a 'black devil box' in which all the evils of the earth were bottled up, ready to pounce upon them. Not only did the grown people run from it, but the older boys and girls had been trained to gather up their little sisters and brothers at the sight of one and to run into cellars or up the stairways."[48]

This quaint "black devil box" statement has been widely accepted by subsequent American exhibitors and photohistorians.[49] John Thomson, a British photographer traveling in China from 1862 to 1872, had observed: "I . . . frequently enjoyed the reputation of being a dangerous

geomancer, and my camera was held to be a dark mysterious instrument, which, combined with my naturally, or supernaturally, intensified eyesight gave me power to see through rocks and mountains, to pierce the very souls of the natives, and to produce miraculous pictures by some black art. . . ."[50] Similar claims were made by Western photographers about Native American Indians, who were said to fear that their likenesses would be stolen by "shadow catchers." This type of belief can probably be found wherever Western industrial cultures have come into contact with less technologically developed cultures.

These comments make marvelous anecdotes. The historical evidence, however, tends to contradict them, at least in Genthe's case. By the 1890s, most, if not all, of the Chinese in the United States had already come into contact with cameras and photographs. Western-frontier photographers captured many Chinese looking directly into the lens. Many early Chinese workers in the United States had carte-de-visite and cabinet portraits taken to send back to their families and friends in China. Passport-type photographs were also used for the identification papers of Chinese reentering San Francisco after a trip to China. Photographs had become so much an integral part of everyday life in California that it is difficult to believe that the Chinese and Chinatown were totally cut off from and oblivious to them as Genthe would have us believe. Even in imperial China, Western photographers, such as John Thomson, had become commonplace in the major cities and in a number of cases had taught the trade to Chinese, who were practicing commercially in Hong Kong as early as the 1860s. The Chinese residents of Tangrenbu were hardly the pagan, unsophisticated people Genthe described them as. However, some residents indisputably hid from Genthe's camera, and the explanation lies not with a "backward," childlike thinking, but with their keen sense of survival. Having experienced American anti-Chinese hostility in virtually all areas of everyday life, the Chinese came to realize that the best way to survive was to avoid unnecessary contact with unknown whites. Children and adults ran from Genthe because they simply did not trust this intruder and were not sure what he was up to. Was he an immigration agent? Would they be deported? Would they get in trouble? Besides these basic considerations, Tangrenbu residents must have also resented outsiders coming in and treating them as curiosities. Genthe describes one of his photographic "adventures" into the quarter, illustrating some of the antipathy many residents must have felt:

> Only once in my many ramblings was I in danger. An English photographer whom I had met said he would like to take some night pictures of the "Devil's Kitchen" [an area where Chinese vagrants and poorer workers gathered]. Had I been alone I would have had no fear, but going there in this instance involved a responsibility, and I asked the Chief to detail a detective to accompany us. We managed to get in without attracting attention as it was pitch dark in the court. But when the flashlight [i.e., flash powder] went off like a pistol shot, on the balconies and rushing down the stairways came a shouting, threatening mob. Several shots were fired. "You'd better run for your lives," said the detective, taking us by the arm. Needless to say we beat a hasty retreat.[51]

It is also possible that initially Chinese did not mind outside photographers coming in. A. C. Vroman, frontier photographer of the American Southwest, noted that in the 1850s and 1860s local tribes were tremendously cooperative with photographers in general, despite any reservations they may have had about how the sun could be used to create these uncanny likenesses. However, as more photographers invaded their lands and relations with whites grew uneasy, native people became more suspect and hostile. In the 1870s and 1880s, tourists would come barging in, touching sacred objects, disrupting private ritual dances, and in general treating residents with disrespect. Considering the history of the relations of Chinese with white Californians, it is likely that a similar pattern developed.[52]

Once Genthe became a regular sight on the streets of the community, individual responses to his presence must have changed and relaxed. However, it is difficult to gauge the degree of comfort and trust his subjects felt from looking at the photographs. Most of Genthe's Chinatown photographs were "candid camera" shots, where the subjects were, at the moment the lens was opened, unaware of the photographer's presence. In his autobiography, Genthe reflected, "Even in the early days of slow lenses and slow plates, when it was much more difficult to catch a person unawares, on account of the necessarily longer exposures, I managed successfully."[53]

On the surface, photographs appear to the viewer as objective visual documents authentically reproducing any given scene. The presence of the photographer seems to be that of an invisible, and passive, bystander. Yet the ultimate content of the photograph is, in reality, intimately determined by the relationship the photographer has with his or her subjects. The two photographs shown in Plates 1 and 10 were taken in close sequence. The normal activity shown in the first scene of the man selling animal remnants (the one that was printed in *Old Chinatown*; see Plate 1) is rudely interrupted in the second photograph (see Plate 10). The people shown have come to realize that this outsider is taking unsolicited photographs of them and they are giving Genthe a few choice words of advice. Genthe was obviously not welcome here. The response that he received here indicates that he was definitely limited in the shots he could take. He either had to catch people totally off guard in public spaces or had to foster enough trust in his subjects for them to let him into their private spaces.

Just how well did Genthe know the community? Undoubtedly Genthe was familiar with Tangrenbu and had gotten to know some of its residents. The individuals in a number of his best portraits display an open willingness to pose or look his camera straight in the lens. (The portraits in Plates 20, 48, and 52 are good examples.) Contrary to the prevailing tendency to represent Chinese as gross and mysterious caricatures, these sensitive portraits demonstrate Genthe's ability to portray Chinese as individuals whom one could meet and get to know. In *As I Remember*, Genthe devotes several paragraphs to describing two of the people he got acquainted with. One man, possibly pictured in Plate 74, was an "old friend." He was "a miserable old skeleton who had been smoking opium for many years" and lived with a cat in some basement dive.[54] Another acquaintance was San Lung*, a fortune-teller who always sat outside on the corner of Stockton and Clay Streets waiting to catch tourists. "He, too, was parched and cadaverous, but he had a merry twinkle in his eye and an ever-present grin in his toothless mouth. His was a wise humor, and he brought it fre-

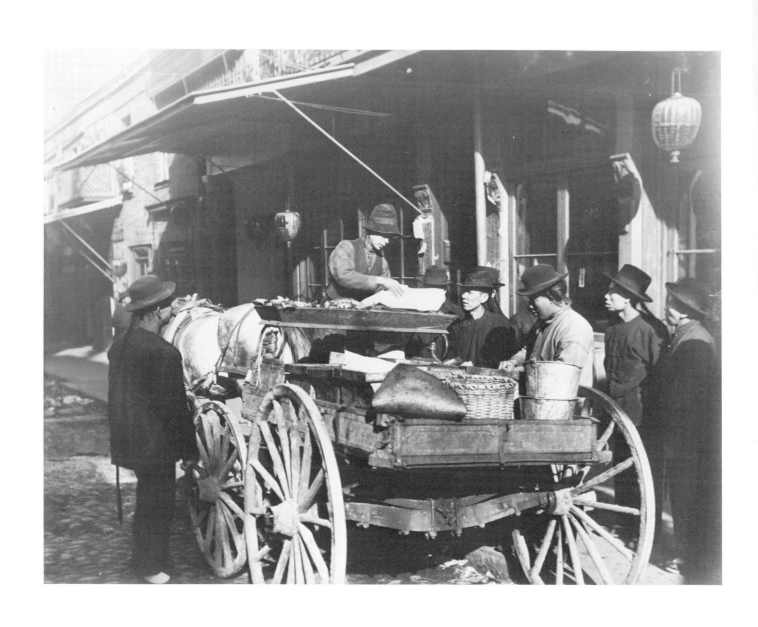

PLATE 1. "The Fish Peddler" (Genthe's title). See Introduction, p. 11. Compare Plate 10.

quently to bear upon his prophesies when he wanted to give them a personal touch."[55] In these same pages, Genthe tells of his Chinatown haunts, including the above-mentioned "Devil's Kitchen," the Chinese theater, pawnshops in which he would buy porcelains and jades, temples, and fancy restaurants. On occasion "big merchants" would invite him to lavish banquets.[56] Genthe was also friends with Donaldina Cameron, head of the Chinese Presbyterian Mission at 920 Sacramento Street.

Genthe's knowledge of Chinatown was certainly greater than that of most non-Chinese San Franciscans. He did not, however, exhibit a greater knowledge than certain regular outside visitors to the community. These "slummers" were generally young, middle-class whites who spent their idle hours hanging out in Chinatown. They would get a bite to eat, show their friends some of the "quaint" sights, shop in curio bazaars, and possibly smoke some opium. Chinatown to them was a place in which to be distracted and entertained. The old opium smoker with a feline sidekick was known to many tourists who paid for guided tours through the community. In his 1933 reminiscence of San Francisco, Charles Dobie, who spent some of his youth roaming the streets of Tangrenbu, described what appears to be the same man:

> We always entered the Palace Hotel in the hope that we could attach ourselves to a party of tourists threading their way to the lodgings of the old man who smoked opium. How old he was no one could have said, but he looked incredibly ancient. His face was like wrinkled parchment, his body a mere dried husk that gave no contours to his sagging clothes. He was toothless, as may be imagined and he possessed two things—a faithful cat, and a mysterious slab of onyx set in an ebony frame supposed to exert a charm on all who left money for the purpose. His mind was clear enough to promote the sale of these charms and once this matter was settled, he would stretch out in his bunk and treat his visitors to an exhibition of opium smoking.[57]

This man made his living from his contact with white tourists; it is, therefore, not surprising that Genthe came to know him. San Lung, the fortune-teller, was also a common fixture of the tourist circuit. Many old San Francisco postcards show either him or his colleagues sitting at a folding table outside on the sidewalk. The traditional Chinese use of divination was part of the ritual and practice of Chinese temples, which were called "joss houses" by Americans, and was performed by respected temple priests. Whether San Lung was an authentic priest serving community residents or not, his street-corner stand came to be an expected and scheduled "sight" in organized tourist visits. The other places that Genthe frequented were also common attractions for outsiders. Guidebooks recommending the "sights" of the city often spoke of the Chinese theaters, the "joss houses," and, for the more adventurous, a look at the "Devil's Kitchen."

Genthe was not likely to have been considered an insider with a deep understanding of the ways of the community, and his writings do not demonstrate a genuine friendship with residents. In point of fact, several of his photographs are incorrectly labeled. The photograph of the men selling animal remnants from a wagon was published and exhibited as "The Fish Monger" and "The Fish Peddler." It is possible that Genthe deliberately mislabeled this photograph for fear of offending his uppercrust patrons. However, the peddler selling chickens, shown in Plate 58, was called "The Vegetable Peddler."

And other titles, most notably "The Street of the Slave Girls" (Plate 80), "Reading the Tong Proclamation" (Plate 53), and "A Slave Girl in Holiday Attire" (Plate 13), had more to do with stereotypical misunderstanding of what was going on in Chinatown than with what was actually on the negatives. Will Irwin, the author of the text accompanying Genthe's photographs in *Pictures of Old Chinatown*, wrote of Chinatown from this very same limited and distorting point of view. In the text Chinatown is described as an exotic, foreign community, populated with colorful characters and adorable children amid curious sights. The 47 pages of descriptions offer little genuine insight into the situation or history of the residents of Tangrenbu.

A fuller, more fruitful understanding of Arnold Genthe and his relationship with Tangrenbu can be gained from the careful examination of the photographs themselves. Genthe rarely if ever printed his photographs full-frame. In order to achieve what he felt was a more pleasing "artistic" composition, in most of his Chinatown prints he used but small portions of his three-by-four and four-by-five glass negatives. The photographs published in *Pictures of Old Chinatown* (1908) and *Old Chinatown* (1913) were often printed several different ways as exhibition prints. The present volume contains 130 of the over 200 known photographs in existence (in either prints or negatives). Many of these photographs have never been published, or never shown full frame. Whenever possible the photographs reproduced here have been printed full-frame from the original glass negatives or lantern slides (often showing the white crop marks Genthe used to delimit the "desirable" areas). For those pictures for which negatives have not survived, copies have been made directly from existing prints.

A thorough inspection of these prints leads to a number of interesting and very revealing discoveries regarding the image of Chinatown Genthe wanted to convey. Even a quick and superficial inventory of his negatives and prints indicates some immediately noticeable biases running through his work. Of the 159 photographs I have examined, 100, or two-thirds, show children as either principal or essential figures in the compositions; and 74, almost one-half, show Chinese, primarily children, in holiday dress. To the casual observer, there may appear nothing unusual in these proportions. Tangrenbu, however, was primarily a male bachelor society that included only a small minority of merchants' families. Children, therefore, were few and far between. But it is obvious that children were a favorite subject with Genthe. It is quite possible that he found them to be far more cooperative and uninhibited before the camera than adults. It is also highly likely that his patrons especially favored these shots.

In addition to their overwhelming focus on children, nearly half of all Genthe's Chinatown photographs were of individuals in ornate holiday dress, which gives the impression that this dress was commonly worn on an everyday basis. In reality there were only a few holidays during the Chinese lunar calendar that warranted such festive clothing. Most of the dress was probably worn during Chinese New Year's week, occurring in late January, February, or early March. The preponderance of holiday shots indicates that Genthe tended to take his photographs on special occasions in the community. He seems to have preferred extraordinary to everyday scenes. Whatever the explanation for these skewed proportions, it must be kept

in mind that what is shown in the photographs is only a very selective view of the community. The "Street of the Gamblers" photograph conveys, far more accurately than most of these pictures, the actual feeling and typical appearance of everyday life in the community.

In discussing his photographic philosophy, Genthe argued strongly against the prevalent practice of freely retouching photographs. In his 1901 article "Rebellion in Photography," he stated:

> The aim of the retouch ought to be, besides removing flaws in the film, simply to modify what the lens and plate have exaggerated; wrinkles that appear too prominent, freckles, which our eye does not see as dark spots, etc. But the removing of characteristic lines, the "modeling" of the face with the retouching pencil, is something a photographer with any artistic conscience will not do.[58]

This attitude did not carry over, evidently, to a number of his Chinatown photographs. A photograph of Genthe with camera in hand is shown here (see Plates 2 and 3) first as it was retouched and then in its original, unretouched form. Suddenly, as if by magic, a bearded Caucasian man appears peering over Genthe's arm. The retouched version was printed darker so that the work of the touch-up crayon was not as evident. In *Old Chinatown*, the same picture appears with all figures cropped out, except that of the young Chinese boy. Not much can be surmised from this example alone except that for some reason Genthe wanted the bearded man out of the composition.

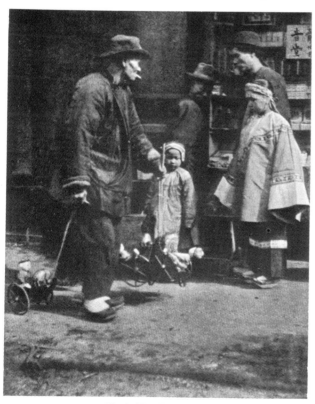

Fig. 1. "The Toy Peddler."

Genthe's intention becomes clearer, however, when we look at a number of other photographs that he also touched up or carefully cropped. At least two versions of "The Toy Peddler" exist. In *Old Chinatown* (see Figure 1) the peddler is shown passing in front of an outdoor concession stand with candies and assorted packages. The

sign on the stand is written in Chinese.[59] In the print made directly from the original glass negative (see Plate 64), the very same scene is shown with one significant alteration (the minor differences are due to lack of cropping). The Chinese sign, with writing in Chinese characters, is now blank. Upon closer inspection, one can discern words that have been scratched out; they are not Chinese, however. The sign, actually written in plain English, reads: "Chinese Candies 5 Cts. Per Bag" (see Fig. 2). The Chinese words that appear in the published version are fake and are but a fragment of a sentence that has nothing to do with the candy stand. Genthe went through a great deal of trouble to give his patrons the impression that this stand was more foreign and "Chinese" than in fact it was. The sign was intended not so much for the Chinese, who knew what all the assorted goodies were, as for non-Chinese tourists, who must have constantly asked the stand keeper, "What is that?" and "How much is it?"

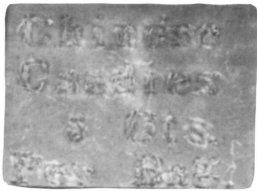

Fig. 2. Enlargement of sign in Plate 64.

Whereas this is by far the most blatant and dramatic instance of tampering, in many other photographs arms and legs have been etched out, telephone and electrical wires blocked out, and, in several cases, full figures of white people made to disappear. Genthe also tended to print and publish his most purely "Chinese" photographs, those which did not show Caucasians intermingling with Chinese in the streets. After looking at his Chinatown books and exhibition prints, the viewer gets the distinct impression that Tangrenbu was indeed an exotic, picturesque "Canton of the West," a totally Chinese city within San Francisco. The truth of the matter is that this ideal, "pure" Chinese quarter never existed, except in the imagination of its non-Chinese nonresidents. On the face of the matter, Genthe seems to have violated his own photographic principles. In all likelihood he truly held to his professed standards in most of his later career. However, his earlier, more experimental photographs, including many of his Chinatown shots, were probably created with another motivation even stronger than those implied in his openly stated philosophical convictions.

It is tempting to place Genthe's Chinatown photographs in the tradition of social documentary photographers like Jacob Riis or Lewis Hine. The Chinatown photographs appear to be comparable to Riis's photographs of tenement ghettos of the Lower East Side, or Hine's coal-miner and child-labor series; however, important distinctions and qualifications need to be made. Both Riis and Hine were committed to using their photographs as tools for alerting the public to grave social problems. Although they had different political orientations, both were die-

hard social activists constantly seeking to document poor and working people's lives and living conditions. And Hine, even more than Riis, made direct and honest portraits of his subjects in their social setting, revealing a deep empathy with and respect for them. His Ellis Island series, which included many portraits of arriving immigrants, was certainly often "beautiful" when judged only by aesthetic standards, but, more significantly, constituted a powerful "human document" about the plight of European immigrants coming to America. Hine established an American social-photographic standard later maintained by Works Progress Administration (WPA) and Farm Security Administration (FSA) photographers and by those associated with the New York-based Photo League. Genthe, on the other hand, was hardly a socially concerned photographer. Although his Chinatown photographs are the best visual documentary records of the subject in that period, his intention was not to use his photographs to educate the public about Tangrenbu. If it had been, they could have shown far more breadth and depth in subject matter and not be so skewed toward children and exoticism. His photographs were created to be hung in the homes of upper-middle- and upper-class friends and patrons.

In 1936 Genthe, reflecting on early years in San Francisco, wrote:

> My inmost desire to be an artist had never really left me. My friends among the artists had been generous in their praise of my drawings and watercolors, which I knew, however, to be mediocre, and had no hope that the slight talent they showed might lead to anything worth while. In the camera I saw a new and exciting art medium—one by which I could interpret life after my own manner in terms of light and shade.[60]

During his Chinatown period, Genthe sought to express and work out his long-standing artistic vision through his new-found pictorial medium. He did not so much view the Chinatown photographs as visual documents faithfully describing the life of the quarter as he used the subject matter as a vehicle for his personal artistry and as a means of earning a living. Unlike Riis and Hine, Genthe was not a social documentarian, even in his Chinatown photographs; he was simply an artistic photographer interested primarily in expressing his personal vision.

Genthe should more appropriately be compared to Edward Curtis, whose 20-volume *The North American Indian* (1900–30) is the most significant single body of visual information about the "Indian." In Christopher Lyman's revealing study *The Vanishing Race and Other Illusions: Photographs of Indians by Edward S. Curtis*, we learn that many of Curtis' concerns ran parallel to Genthe's. Both photographers have been seen as ethnographers documenting vanishing "racial" communities, and both photographers assumed highly aesthetic attitudes towards the portrayal of their subjects. Curtis actively manipulated his images. He not only carefully cropped and retouched, but even went further than Genthe by paying Native Americans to stage scenes and pose in anachronistic costumes he assembled. Despite the deliberate manipulation, both photographers conveyed the impression to their largely middle-class white public that they were privy to the true inside view. Genthe was very much aware of Curtis' images and lauded them in a 1901 article: "E. S. Curtis' Indian studies occupy quite

a place by themselves. They are of immense ethnological value as an excellent record of a dying race, and most of them are really picturesque, showing good composition and interesting light effects."[61] Not at all coincidentally, both photographers emerged during the rise of tourism in American popular culture.

White genocidal policies had already greatly reduced Native American populations and pushed them into isolated reservations. White tourists equipped with cameras were now the "invaders," and the Indians now depended on tourism for their livelihood. Curtis tried to capture a pretourist, prereservation image in his photographs, attempting to recreate his vision of authentic vanishing American Indian communities. Theodore Roosevelt was among Curtis' staunchest supporters. J. Pierpont Morgan loaned him the funds to undertake a 20-volume series which would sell for $3000 a set.

In an effort analogous to Curtis', Genthe tried to portray a mythical, purely Chinese "Canton of the West." When the Chinese had been pushed into ghettos, the tourist trade was one means by which they were able to make a living. After the 1906 earthquake and fire and the 1911 establishment of the Republic of China, the old Chinatown disappeared forever. And photographs of Genthe's version of old Chinatown became nostalgia, marketable to upper-crust San Franciscans. The wealthy could now own an original print of an "authentic," irretrievable past. In addition, Genthe's photographs—along with chop suey—made Chinatown more accessible to curious non-Chinese tourists.

Arnold Genthe sought and found a certain poetic beauty in the streets of Chinatown. He enjoyed taking magnificent individual portraits like "The Pekin Two Knife Man" (Plate 9), "The Shoe Maker" (Plate 48), and "The Fish Dealer's Daughter" (Plate 20). He made the people in these portraits seem so real that the photographic images seem prepared to answer our questions about the lives of their subjects. He also preferred dramatic compositions like "Doorways in Dim Shadows" (Plate 82), "The Street of the Gamblers" (Plates 47 and 72), and "The Opium Fiend" (Plate 74). In these he conveys a sense of isolation, rootlessness, and idleness. And he ultimately focused his attention on children and their raw, positive energy in photographs like "Boys Playing Shuttlecock" (Plate 113), "The Cellar Door" (Plate 67), and "The Pigtail Parade" (Plate 116). He obviously loved the children of Chinatown, and shared a deep faith with Tangrenbu's elder residents that the future was bright as long as these children were around.

Whatever motivations ultimately lay behind Genthe's photographing of this community, his negatives and prints are fabulously rich with the visual details of the everyday street life of old Chinatown. The honesty and directness of his best images take us beyond even Genthe's own limited knowledge of Tangrenbu to gain glimpses into the radiant soul of its residents.

Today, with 80 years of hindsight, we can use these dazzling aesthetic documents to illuminate a neglected area of American history. Genthe's photographs are invaluable because they tell us of a San Francisco Chinatown long gone *and* of a certain phase in American photography and its role in American culture. Ultimately, Genthe's original artistic vision embodied in these photographs is not as important as how we reinterpret these images

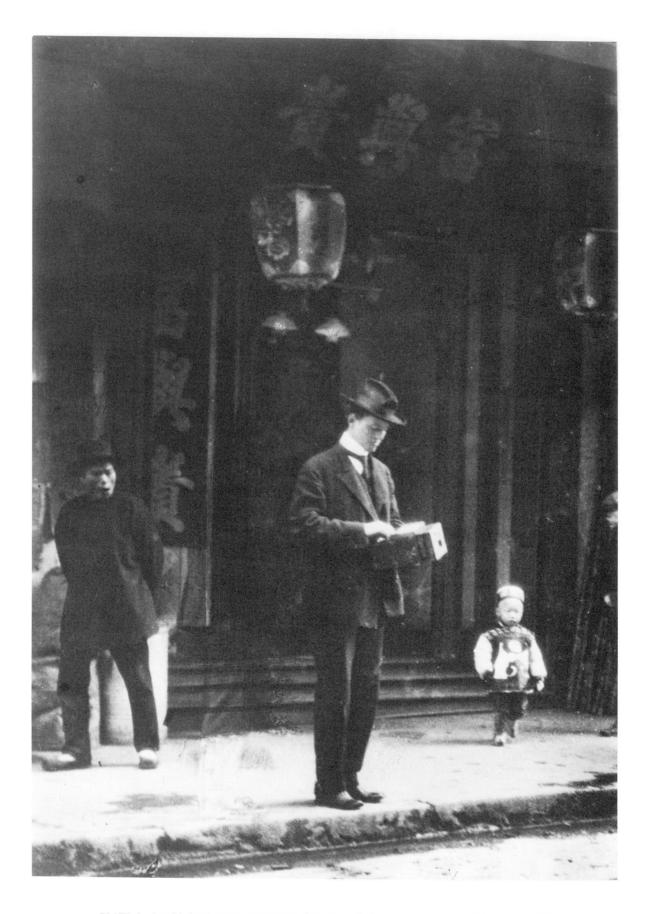

PLATE 2. Arnold Genthe with camera in Chinatown (retouched version, used in part in *Old Chinatown*, 1913). (Genthe's title: "An Unsuspecting Victim.") See Introduction, p. 14.

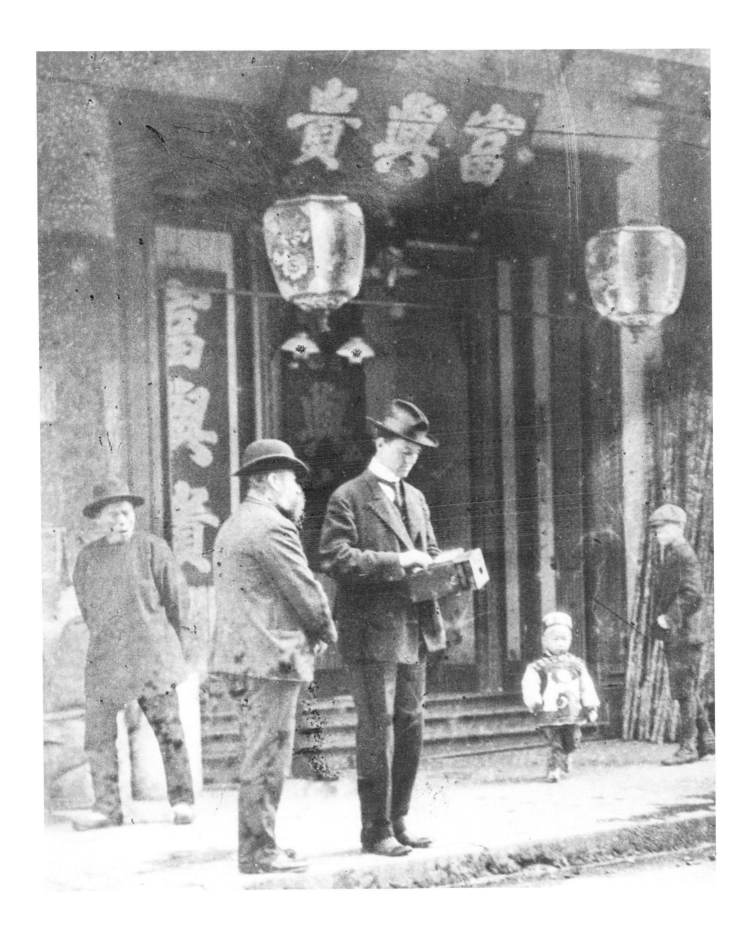

PLATE 3. Arnold Genthe with camera in Chinatown (original, unretouched version).

today. If we understand them as more than simply nostalgia, then perhaps we can better understand our lives in the historic present.

Notes

[1]Facts about the ocean liner Genthe traveled on are from a copy of the passenger manifest of the S.S. *Normannia* (14 June 1895), in the possession of Cynthia Jaffee McCabe, Hirshhorn Museum and Sculpture Garden, The Smithsonian Institution, Washington, D.C. The story of Genthe's dodging the draft was told to me, in a private interview, by Mrs. R. E. Genthe, the wife of Arnold Genthe's nephew.

[2]Arnold Genthe, *As I Remember*, 1936, pp. 31–32.

[3]*Ibid.*, p. 32.

[4]The syllables of Tangrenbu are: "Tang," referring to the Tang Dynasty, "ren," meaning people, and "bu," meaning port or city. Altogether the word means "Chinese city." The Chinese in California also referred to San Francisco, where the largest of the early California Chinese settlements was located, as "Dai Fau" (Cantonese), or "the large city." The people of northern China, and now of China in general (except for minorities), call themselves the Han after that dynasty (roughly 200 B.C. to A.D. 200); those of southern China, integrated into the nation as a whole at a later period, identified with the Tang Dynasty (roughly A.D. 600 to 900).

[5]Genthe, *As I Remember*, p. 33.

[6]Thomas Chinn, H. Mark Lai, and Philip P. Choy, eds., *A History of the Chinese in California: A Syllabus*, 1969, p. 10.

[7]James O'Meara, "The Chinese in Early Days," *Overland Monthly*, May 1884, p. 477.

[8]Persia C. Campbell, *Chinese Coolie Emigration to Countries Within the British Empire*, 1923, p. 97; Watt Stewart, *Chinese Bondage in Peru*, 1951, pp. 55–76.

[9]Russell Conwell, *Why and How*, 1870, pp. 155–56.

[10]Cited by Chinn, *op. cit.*, p. 15, from Edward Lucatt, *Rovings in the Pacific from 1837*, vol. 2 (1851), p. 363.

[11]Mary Roberts Coolidge, *Chinese Immigration*, 1909, p. 498.

[12]Chinn, *op. cit.*, p. 10.

[13]*Ibid.*, p. 10.

[14]Ping Chiu, *Chinese Labor in California, 1850–1880*, 1963, p. 12.

[15]Charles Caldwell Dobie, *San Francisco's Chinatown*, 1936, p. 51.

[16]Paul Jacobs, Saul Landau, and Eve Pell, *To Serve the Devil, Colonials and Sojourners*, vol. 2, 1971, pp. 129–32.

[17]Him Mark Lai and Philip Choy, *Outline History of the Chinese in America*, 1972, p. 50.

[18]Gabriel Kolko, *Railroads and Regulations 1877–1916*, 1965, p. 1.

[19]Cited by Milton Meltzer, *The Chinese Americans*, 1980, pp. 14–15.

[20]Lai, *op. cit.*, p. 57.

[21]Chiu, *op. cit.*, p. 47.

[22]Lai, *op. cit.*, pp. 72–76.

[23]Carey McWilliams, *Factories in the Field*, 1971, p. 71.

[24]Chiu, *op. cit.*, p. 86.

[25]*Ibid.*, pp. 89, 93.

[26]*Report of the Joint Special Committee to Investigate Chinese Immigration* (44th Congress, 22nd Session, 1876–1877, Senate Report 689), p. 554.

[27]Chiu, *op. cit.*, p. 115.

[28]Alexander Saxton, *The Indispensable Enemy*, 1971, p. 7.

[29]Miriam Allen de Ford, *They Were San Franciscans*, 1941, pp. 195–96.

[30]*Report of the Joint Special Committee, op. cit.*, p. 668.

[31]Reverend Otis Gibson, *The Chinese in America*, 1877, p. 400.

[32]Cited in Joan B. Trauner, "The Chinese as Medical Scapegoats in San Francisco 1870–1905," *California History Magazine*, Spring 1978, p. 72.

[33]Herbert Hill, "Anti-Oriental Agitation and the Rise of Working-Class Racism," *Trans-Action Magazine*, January–February 1973, p. 45.

[34]Coolidge, *op. cit.*, p. 504.

Chinese in the United States 1850–1910
(Coolidge, p. 501; and U.S. Census Reports)

Year	Estimated Chinese in U.S.	Estimated Chinese in Cal.
1852		25,000
1860	34,933	34,933
1870	63,199	49,277
1880	105,465	75,132
1890	107,488	72,472
1900	89,863	45,753
1910	71,531	36,248

Total U.S. Immigration 1861–1905
(Coolidge, p. 504)

Year	Total	% Chinese	% European & British No. Amer.
1861–70	2,377,279	2.7	95.8
1871–80	2,812,191	4.4	94
1881–90	5,246,613	1.2	97.5
1891–1900	3,687,564	0.4	96.6
1901–05	3,833,076	0.3	95.2

[35]Hill, *op. cit.*, p. 50.

[36]Genthe, *As I Remember*, p. 10.

[37]Amelia Ransome Neville, *The Fantastic City*, 1932, p. 178.

[38]Genthe, *As I Remember*, p. 59.

[39]*Ibid.*, pp. 40–41.

[40]Dorothea Lange, *The Making of a Documentary Photographer*, 1968, p. 28.

[41]Genthe, *As I Remember*, p. 41.

[42]*Ibid.*, p. 41.

[43]*Ibid.*, p. 46.

[44]Arnold Genthe, "Rebellion in Photography," *Overland Monthly* 43, no. 2 (August 1901): 96.

[45]Genthe, *As I Remember*, p. 35.

[46]*Ibid.*

[46]*Ibid.*

[47]*Ibid.*

[48]Genthe, *As I Remember*, pp. 34–35.

[49]For two examples, see Peter Pollack. *The Pictorial History of Photography*, 1969, p. 312; and Jerry Patterson, "A Review of His Life and Work," in *Arnold Genthe 1869–1942* (exhibition catalogue, 1975), by the Staten Island Institute of Arts and Sciences, 1975, p. 2.

[50]Thomson, *China and Its People in Early Photographs* (Dover reprint, 24393–1, of *Illustrations of China and Its People*), introduction (no page number).

[51]Genthe, *As I Remember*, p. 38.

[52]William Webb and Robert A. Weinstein, *Dwellers at the Source: Southwestern Indian Photographs of A. C. Vroman, 1895–1904*, 1973, pp. 10–14.

[53]Genthe, *As I Remember*, pp. 35–36.

[54]*Ibid.*, p. 37.

[55]*Ibid.*, pp. 38–39.

[56]*Ibid.*, p. 39.

[57]Dobie. *op. cit.*, p. 220.

[58]Genthe, "Rebellion in Photography," p. 99.

[59]Arnold Genthe, *Old Chinatown*, 1913, p. 199.

[60]Genthe, *As I Remember*, p. 43.

[61]Christopher M. Lyman, *The Vanishing Race and Other Illusions: Photographs of Indians by Edward S. Curtis*, 1982, p. 53.

1 STREET LIFE

The streets of Tangrenbu were vibrant with a curious and colorful mix of Chinese and non-Chinese. Stores that served the residents were interspersed with those that depended on tourists. The fish and poultry markets radiating aromatic and pungent smells, curio-shop bazaars, itinerant peddlers, huge flowered lanterns, gold-red-and-black signs, and so much more—all this served as the interface between the white world that visited and the Chinese world whose home this was. It was on this public turf, the streets, that Arnold Genthe took his photographs. Despite Genthe's often idealized and romantic notions of the Chinese community, his images, while they show us this interface, at the same time manage to carry us beyond the superficial impression of a monolithic Chinese people in a monolithic Chinatown. When these photographs are printed full-frame without retouching, we begin to see the tremendous richness, the variety, the nuances of the life of the quarter. Instead of reconfirming what we feel we already know about American Chinatowns, these images challenge us to reconsider stereotypical notions. With the aid of informed historical commentary, the photographs come alive, teaching us a lesson in the largely forgotten visual history of Tangrenbu.

For the occasional non-Chinese visitor, the streets of Chinatown were an exotic adventure full of the mystery of the unknown, promising surprises and thrills. The colors, the smells, the language, and the customs seemed so totally foreign to Western sensibilities. Would they see an opium den? What exactly was in the food they were eating? What interesting gifts could they buy for their loved ones? To a large degree the Chinatown that tourists came to see was not the real, everyday quarter, but the quarter as it was fervently imagined by non-Chinese writers, journalists, missionaries, and concerned individuals on both sides of the "Chinese Question." Tangrenbu was characterized as simultaneously a romantic, melodramatic, wicked, and dangerous place, full of decadence, evil, and disease. Paid guides offered to take the curious to the darkest spots of the quarter. For outsiders, Chinatown was perceived as an escape from the humdrum. It was a quick vacation.

For Chinese residents, however, Tangrenbu, composed of ten blocks of buildings, streets, and narrow alleyways, was at once a living community and a ghetto prison.

Chinatown was a home base, a safe place to rest. The rhythm, sounds, colors, and space were comfortable. The streets were full of life where old friends and familiar enemies could be found. The streets offered news, entertainment, gossip, and solace. It was a place to hang out, a place to work, a place to demonstrate deep-felt convictions. Male "bachelor" workers dominated the streets. On special occasions, a wealthy merchant with his family could be seen, and even more rarely the quarter's few women could be spotted outdoors getting a break from their confined existence behind closed doors. But to venture too far beyond the boundaries of Tangrenbu without official business was to invite harassment and possible injury. Wei Bat Liu*, an "old-timer" interviewed by Victor and Brett de Bary Nee in their classic oral history of San Francisco's Chinatown, *Longtime Californ'*, recalled:

> "In those days, the boundaries were from Kearny to Powell, and from California to Broadway. If you ever passed them and went out there, the white kids would throw stones at you. . . . One time I remember going out and one boy started running after me, then a whole gang of others rushed out, too."[1]

Gim Chang* also remembered these childhood fears:

> "I myself rarely left Chinatown, only when I had to buy American things downtown. The area around Union Square was a dangerous place for us, you see, especially at nighttime before the quake. Chinese were often attacked by thugs there and all of us had to have a police whistle with us all the time. I was attacked there once on a Sunday night, I think it was about eight P.M. A big thug about six feet tall knocked me down. I remember, I didn't know what to do to defend myself, because usually the policeman didn't notice when we blew the whistle. But once we were inside Chinatown, the thugs didn't bother us."[2]

The militant, often violent anti-Chinese movement was still strong at this time. Samuel Gompers, the first president of the American Federation of Labor, spearheaded much of the movement to have Chinese permanently excluded from immigrating to the United States, a movement culminating in the law passed by Congress in 1904. He made fiery speeches claiming the "yellow peril" was still a threat to white working men and women. A pamphlet he coauthored, *Some Reasons for Chinese Exclu-*

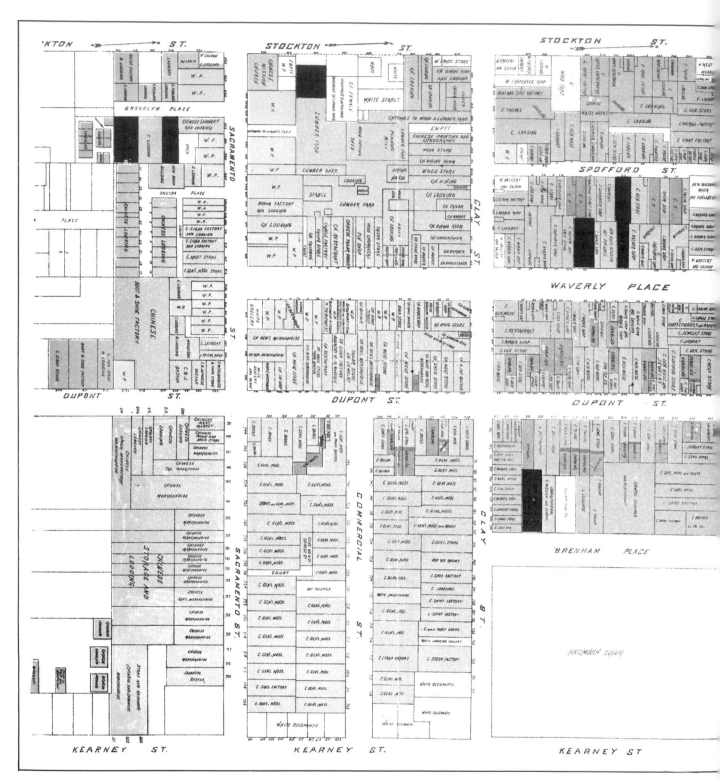

Fig. 3. Map of Old Chinatown. The commercial spine of Chinatown was Dupont Street between California Street (left edge of map) and Broadway ("Broadway St." on this map). Dupont Street was renamed Grant Avenue after the earthquake, but Chinese residents still call it "Dupont" in Cantonese. The Italian North Beach area and the notorious "Barbary Coast," with its rowdy, seamy night life, bordered the northern edges of Tangrenbu (north is to the right on this map). To the east lay the Hall of Justice, commercial warehouses, and the docks. On the southern border of the quarter, along Sacramento and Dupont Streets, were located white prostitutes and shooting arcades. Above Stockton Street were the posh mansions and hotels of Nob Hill, which overlooked the entire area. (From Willard B. Farwell, *The Chinese at Home and Abroad*, 1885.)

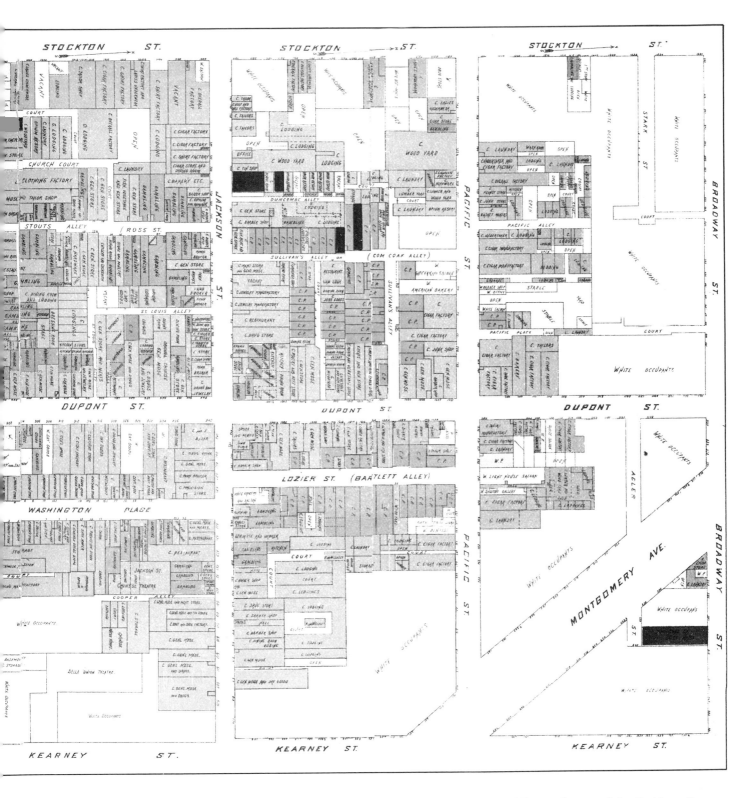

sion: *Meat vs. Rice; American Manhood Against Asiatic Coolieism, Which Shall Survive?*, published in 1902, was widely circulated throughout the country. The violence committed against Chinese who ventured outside the borders of Chinatown was not simply the mischievous pranks of misguided "hoodlums" but, far more signifi cantly, one of the several ways in which the dominant powers of the San Francisco community kept the Chinese "in their place."

The brick Italianate buildings and wooden structures that lined the streets of Tangrenbu were inherited from the San Francisco building boom of the 1850s and 1860s. The Chinese, as they came to dominate the area, brought their own sense of space, design, and aesthetics by modifying the buildings and open areas, thereby claiming the quarter as their own. Balconies painted with greens and yellows were added and bedecked with potted plants. Metal and canvas canopies jutted out from storefronts, and lanterns of various shapes and sizes hung everywhere. Within the strictly imposed boundaries space was

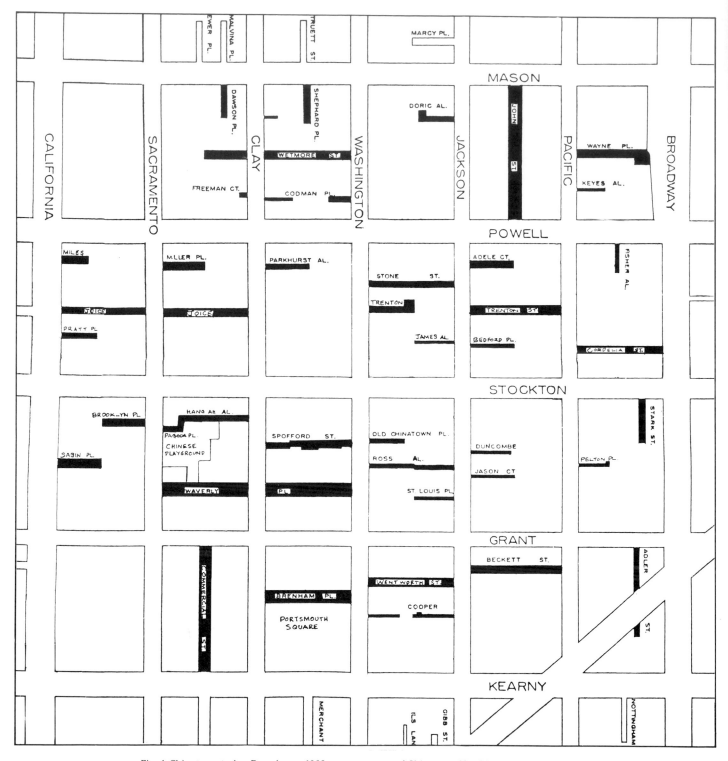

Fig. 4. Chinatown today. Based on a 1982 map, courtesy of Chinatown Neighborhood Improvement Resources Center, San Francisco.

at a premium. Buildings were constantly modified to make more room. Previously unused basements became stores and residences. Closed wooden constructions projecting from window frames were connected by outdoor stairways and ladders. The rooftops, hung with laundry, were here and there divided by picket fences to serve as protection from raiding police or neighborhood feuds.[3]

In the early morning fog, the markets bristled with activity. Fresh fruits and vegetables were being brought to the produce and other food markets on Dupont and other streets. Fish and poultry were being sold in "Fish Alley." The many itinerant peddlers in the quarter would be setting up on their favorite doorstep or street corner. Throughout the day, dry goods would be unloaded from the docks and carted up by dollies and horse-drawn wagons along Washington and Clay Streets to their destinations in the general merchandise stores and warehouses on Dupont, Sacramento, Clay, and Commercial Streets. All day long, along the roomier edges of Tangrenbu around lower Clay, Pacific, and Stockton Streets, workers could be seen hunched over their benches in basements and storefront factories making shoes and boots, sewing garments, and assembling brooms. Retired "old-timers" would sit on Portsmouth Square and watch the children with their nannies and mothers. Along Dupont Street, tourists visited the growing number of curio shops that displayed items ranging in price from a few pennies to thousands of dollars. During mealtimes, basement restaurants would be filled with workers having rice and noodle dishes and other inexpensive fare, while merchants would be dining on the floors above.

When darkness came, the clacking of mahjong tiles could be heard behind closed doors, and the alleys were filled with those seeking entertainment and relief from the long day's work. Ross Alley buzzed with gamblers. Sullivan's and Bartlett Alleys were busy with lonely men seeking singsong girls and prostitutes. And the theaters on lower Jackson Street and Washington Street off Waverly Place were filled with noisy spectators checking out the development of plays that went on for several nights. Each street had its own special character, different at different times of the day and night.

Waverly Place, for instance, was a two-block-long street nestled in the heart of Tangrenbu. Its Chinese name was Tianhoumiaojie (Tin Hau Miu Gaai), after the Goddess of Heaven, Tianhou, protector of fishermen, travelers, sailors, actors and prostitutes; her temple was erected at 33 Waverly Place (see Plate 12). The street was also given the nickname of "Fifteen Cent Street," referring to the numerous Chinese barbershops lining the two blocks. The barbershops were open for business when they put out a wash pan placed on a wooden rack outside their door (such a rack is seen next to the two onlookers in Plate 9). The queues the men wore were imposed upon the Chinese during the rule of the foreign Manchu Qing Dynasty (1644–1911). Chinese men regularly went to these barbers to have their foreheads shaved, their hair cleaned, braided, and oiled, and their ears scraped clean. In China not to wear a queue was a sign of defiance to the Manchus, punishable by severe penalties. A well-kept queue was very important as long as the man wanted to keep the option of visiting or returning to China. Wearing the queue, therefore, was not simply a matter of appearances but had important social and political implications. The constant flow of residents coming to Waverly Place and its seclusion from the main thoroughfares made it an ideal location for peddlers to hawk their wares. Political rallies were often held in this area for the same reason. Prohibited from involvement in the American political process, Tangrenbu residents were deeply involved with political developments in China. From the late 1890s up to 1911, China's reformist and revolutionary parties competed for the sympathies of San Francisco overseas Chinese.

Tangrenbu also had seasonal rhythms created by the ebb and flow of migrant workers. The vast orchards, farms, and ranchos of the surrounding valleys laid off up to three-quarters of their workers from September to November, and again from February through April. The late-winter appearance of thousands of these men was always a signal that the Lunar New Year was approaching. This was the major holiday of the year, at which time stores and residences had to be cleaned and all accumulated debts paid. Sometimes Tangrenbu was so overfilled with the unemployed that the bunks in the family halls were used in shifts.

Although Tangrenbu residents did not own the entire area, according to various estimates from one-twelfth to one-third was actually Chinese property. The ten-block grid was unlike any other section of the city.[4] It was a distinct community, neither traditionally Chinese nor simply American. Its special character was born of an impassioned conflict between stubborn white-racist hostility and the tenacious desire of the Chinese to survive and remain in the United States. As the photographs richly reveal, the street life that Arnold Genthe photographed bore the birthmarks of this odd conflictual relationship.

Notes

[1]Victor G. and Brett de Bary Nee, *Longtime Californ': A Documentary Study of an American Chinatown*, 1973, p. 60.

[2]*Ibid.*, p. 72.

[3]Ernest Peixotto, *Ten Drawings in Chinatown*, 1898, p. 3.

[4]Coolidge estimates that in 1904 Chinese owned only 25 of 316 lots in Chinatown (Mary Roberts Coolidge, *Chinese Immigration*, 1909, p. 411). In contrast, John Castillo Kennedy claims that one-third of the land was owned by Chinese in 1906 (John Castillo Kennedy, *The Great Earthquake and Fire, San Francisco, 1906*, 1963, p. 238.)

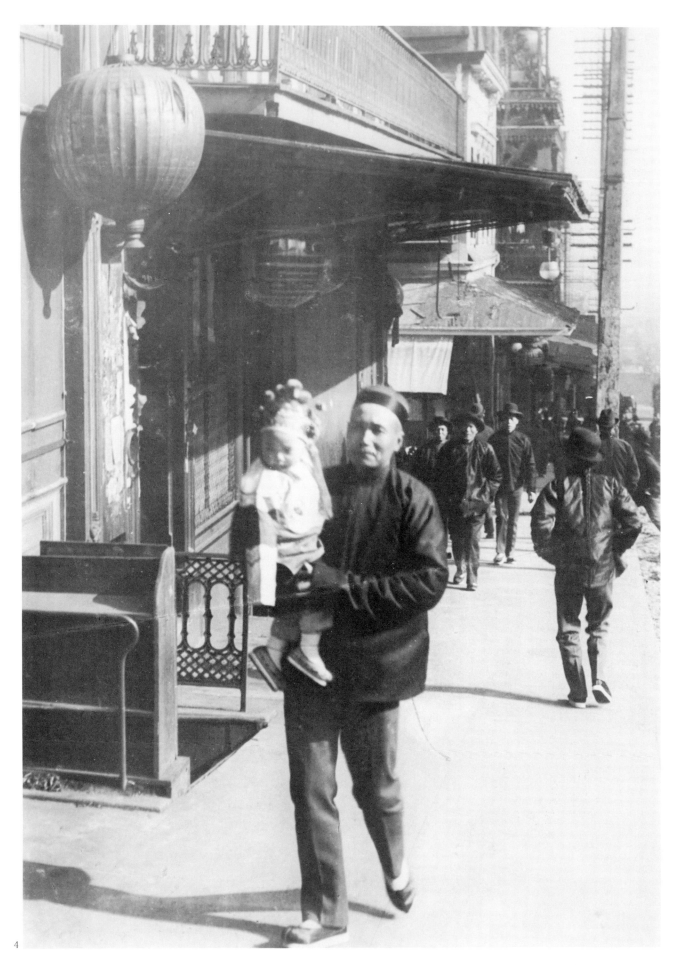

4

5

PLATE 4. "New Year's Day in Chinatown." Nearly half of Genthe's Chinatown photographs were taken during some community holiday. The merchant and child are walking westward up Clay Street just above Waverly Place. The lantern directly in line with the boy's head is a sign for the Siyi (Sei Yap), or Four Districts, Association located at 820 Clay Street. **PLATE 5.** Dupont Street (400 block), between Pine and Bush Streets, looking south. Genthe misleadingly titled this photograph "Dupont Street Entrance to Chinatown." Chinatown lies in the direction opposite to that toward which the photograph looks.

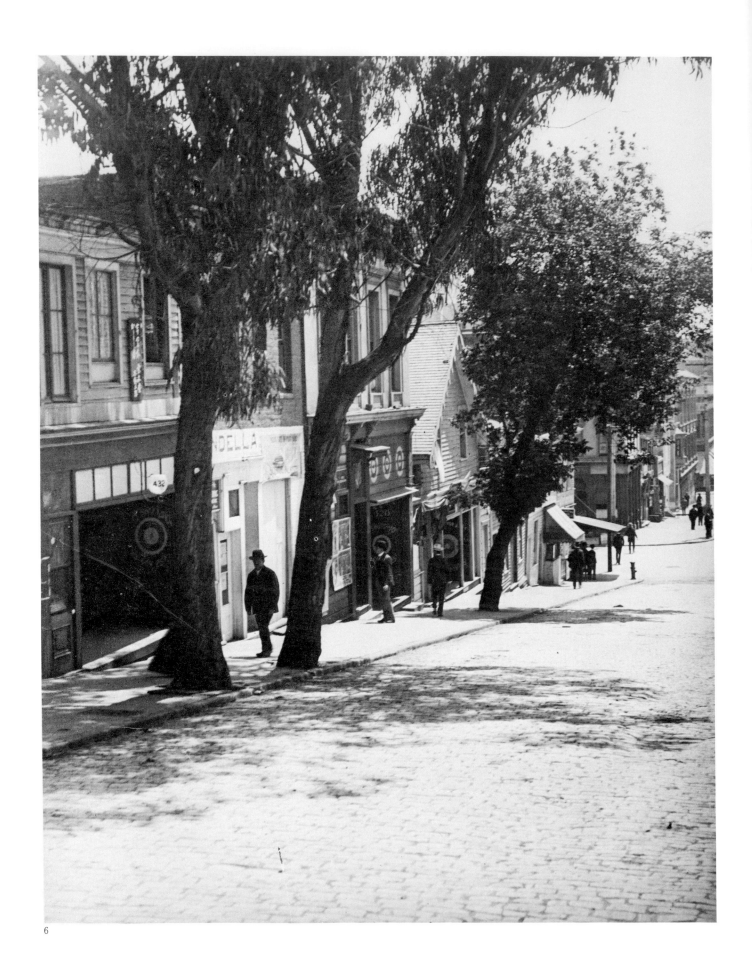

6

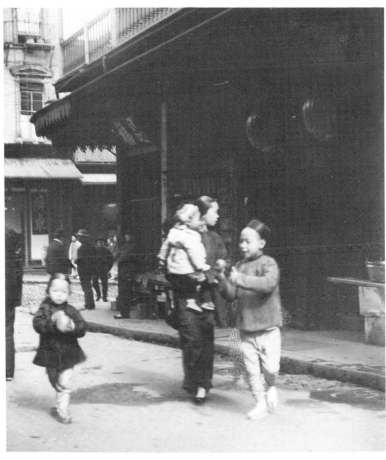

7

PLATE 6. Southern edge of Chinatown. Numerous shooting galleries attracted men and boys from all over the city. White prostitutes sat behind half-opened windows, seeking business. **PLATE 7.** "Brothers and Sisters." Waverly Place off Washington Street. A child's leg, directly behind the boy on the right, has been etched out of the negative. **PLATE 8.** A "rags, bottles, sacks man" (Genthe's title: "Where Beauty and Squalor Mingle"). West side of Waverly Place, looking north toward Washington Street. Some Chinese, but mainly Italian, men would drive through the streets of Tangrenbu buying used clothing, bottles, sacks, and other miscellaneous items for recycling. After the earthquake, the occupation was taken over entirely by Italians because white junk dealers refused to buy from Chinese. The Italians, with a heavy accent, would sing out the words, "Rags, bottles, sacks, rags, bottles, sacks." A story is told that some old-timers who could not understand their English very well thought they were saying, "*Laih baai sei, laih baai sei,*" which is Cantonese for Thursday. Thus they assumed that the man would be returning every Thursday. The practice of collecting refuse was to continue until World War II. The fancy clothing worn by the woman and children suggests that this photograph was taken during Chinese New Year. Close inspection of the upper right-hand portion of the photograph reveals that Genthe etched out part of a telephone pole; perhaps he felt that telephones were technologically out of keeping with the image of an isolated and exotic Chinatown he wanted to convey.

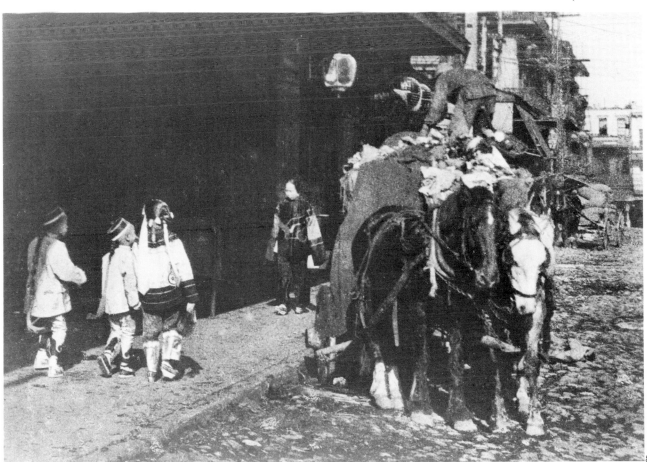

8

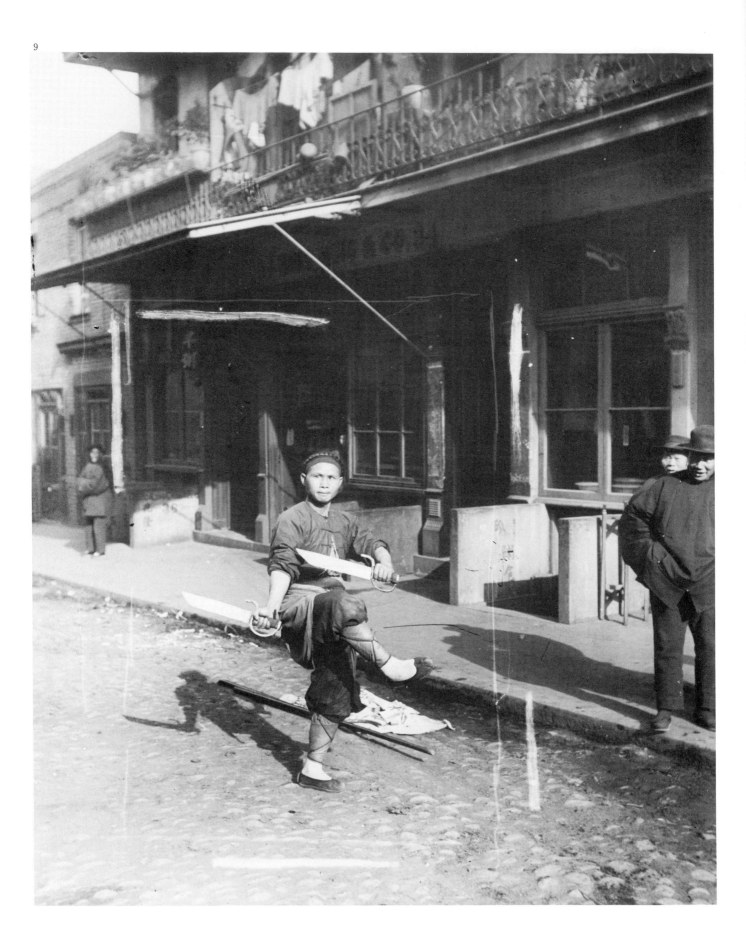

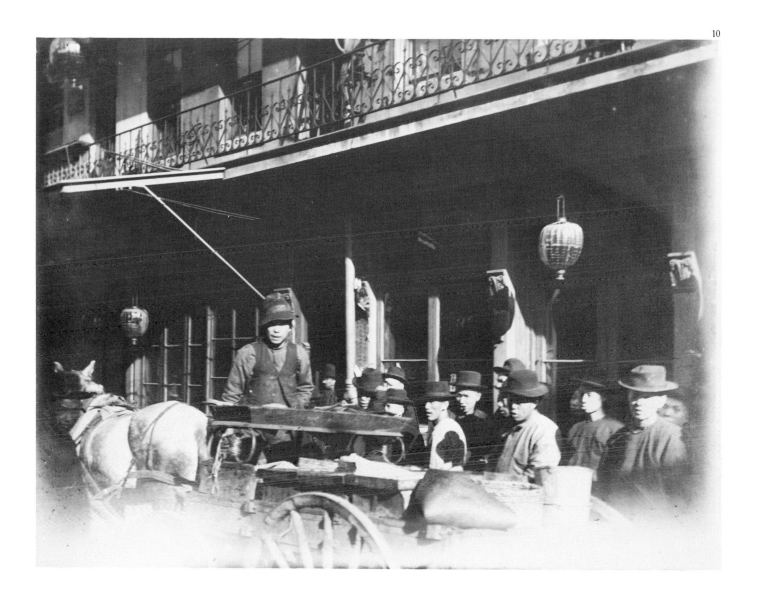

PLATE 9. "The Mountebank," "The Pekin Two Knife Man," "The Sword Dancer"—Genthe's various titles for this portrait of Sung Chi Liang*, well known for his martial-arts skills. Nicknamed Daniu, or "Big Ox," referring to his great strength, he also sold an herbal medicinal rub after performing a martial-arts routine in the street. This medicine, *tiedayanjiu* (*tit daa yeuk jau*), was commonly used to help heal bruises sustained in fights or falls. This scene is in front of 32, 34, and 36 Waverly Place, on the east side of the street, between Clay and Washington Streets. Next to the two onlookers on the right is a wooden stand which, with a wash basin, would advertise a Chinese barbershop open for business. The adjacent basement stairwell leads to an inexpen-

sive Chinese restaurant specializing in morning *zhou* (*juk*), or rice porridge. **PLATE 10.** Bob Lim, on wagon, and his older brother, in light-colored tunic, selling animal remnants. Their father worked at a slaughterhouse at Hunter's Point and salvaged pig intestines, cow stomachs, duck and chicken feet, and other discarded organs for sale in Chinatown. Genthe mislabeled another version of this photograph (Plate 1) "The Fish Peddler." It is possible that he actually did know what these brothers sold but did not give an accurate title for fear of offending his "polite" gallery audiences. The photograph was taken in front of 32 Waverly Place, slightly south of where the snapshot of Sung Chi Liang was taken. (See Plate 1 and discussion on page 11, above.)

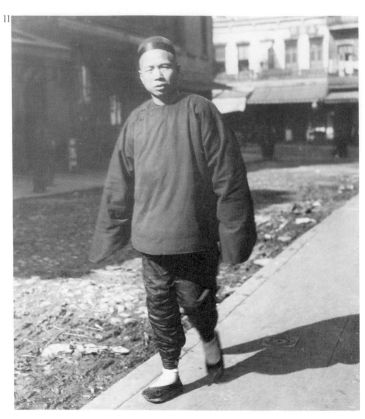

PLATE 11. "A Merchant," strolling on Waverly Place. The photo looks north toward Washington Street. This man is wearing very expensive clothing for everyday wear, indicating that he is wealthy. His hat is of finely woven silk and his pants and shoes are especially ornate. The special quality of his dress can be better appreciated when compared to the simpler, more common dress of the men gathered around Bob Lim's wagon. PLATE 12. The facade of Tianhou's temple is brick painted in pastel colors and veined to look like marble. The second floor, where the main altar was generally located, had a balcony with the names of several temples specializing in other deities. Genthe called this photograph "In Front of the Joss House." The term *joss*, a pidgin Americanization of the Portuguese *deus* ("god"), was used to describe Chinese temples. According to Ching Wah Lee, "Chinese consider it incestuous to be intimate with a member of the opposite sex bearing the same surname. To avoid such embarrassments the ladies of the night will call themselves Daughter of Tien Hou, and asked of their surnames will say 'I'm a Tien,' there being no such surname" (Ching Wah Lee, "Chinese Temples in North America," in *A History of the Chinese in California: A Syllabus*, ed. Thomas Chinn, H. Mark Lai, and Philip P. Choy, 1969, pp. 73–75). PLATE 13. This and the following three views, although not taken at the same time, form a panorama of the busy intersection of Dupont and Jackson Streets. The baroque-style Globe Hotel, now occupied by Chinese, stood on the northwest corner, from which tours of Chinatown often started. Jackson Street was the "red light" district of Chinatown. Genthe's title for this picture in *Old Chinatown* is "A Slave Girl in Holiday Attire." "Slave girl" was used loosely to designate Chinese women sold on contracts. This woman is said to have been an especially beautiful and popular prostitute. It was fairly unusual for a woman to walk unescorted in public.

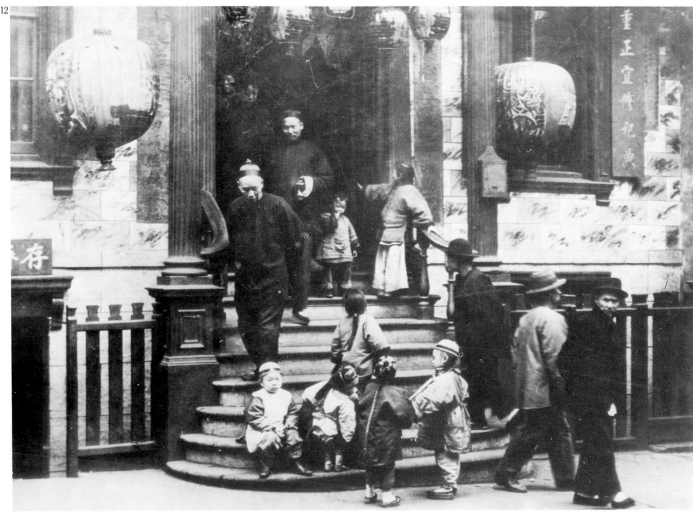

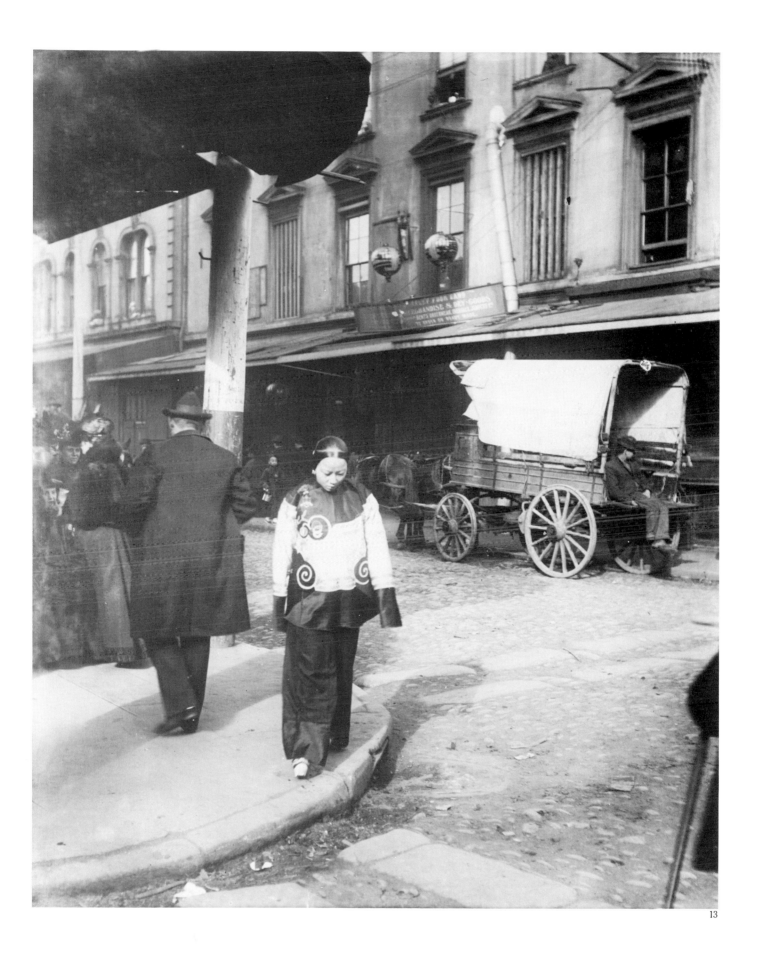

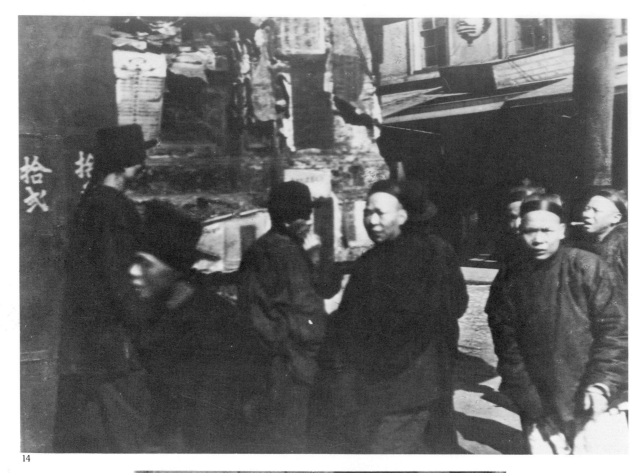

14

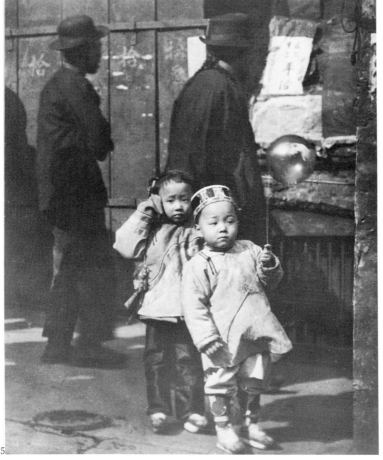

15

16

PLATE 14. This photograph, which Genthe unfairly entitled "Loafers," was taken a few feet over from the preceding image. The four men wearing a common type of cap appear to be merchants walking together. Layers of Chinese posters and notices cover the building wall. The man on the far right is smoking a cigar that was most likely made in Chinatown. **PLATE 15.** These two children in holiday dress seem to be observing festival firecrackers exploding nearby. The design on the boy's hat is a repetition of the Chinese word for long life. This was taken in front of the same wall as "Loafers." The men in the background are reading the wall posters. **PLATE 16.** A group of five girls dressed in holiday finery, walking west up Jackson Street. The "To Let" sign indicates that the boarded-up stand is not owned by Chinese. Each plank has one or two characters indicating in what order the boards are to be placed. From left to right they read "one" through "thirteen," with special homonymous characters for "one," "two," "three," and "ten."

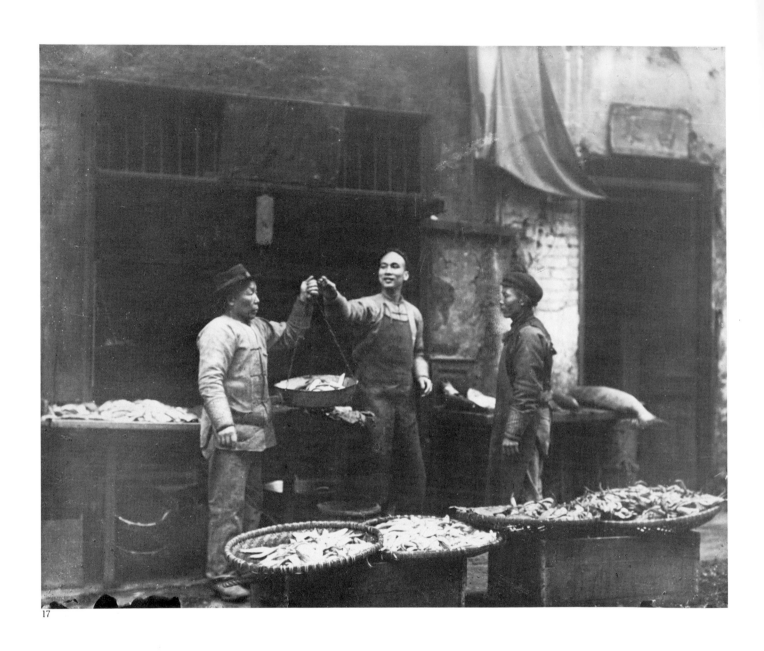

17

PLATE 17. Chanqu (Chong Tsui; "Prosperous Assemblage") fish store, 5½ Washington Place. Though this street was popularly known as "Fish Alley," it bore the poetic Chinese name of Dehejie (Tak Wo Gaai), "Street of Virtuous Harmony," after a store once located there. This was the major site of meat, poultry, and fish markets in Tangrenbu. Nearby Washington Street, along with Clay Street the main artery for goods entering Chinatown, had a wharf at its foot that was also the point of entry for many Chinese immigrants. Fong*, a laborer interviewed in *Longtime Californ'*, had his own recollection of Washington Street: "Washington, it is so goddamn wet, it used to be cobblestone and full of telephone poles. And it's so wet that the lines between the cobblestones were all molded because of the horse manure, people spit on it, the wets from the horses, and plus the fog, daily fog. The street was never, never dry, never" (Nee, p. 99). PLATE 18. Fish and poultry store, "Fish Alley." Freshly killed chickens are hanging from the rack, with wooden chicken crates visible in the background. Fish are displayed on the table to the right. An American-made scale is hanging in the upper left-hand corner of the photograph. (Genthe's title for this photo was "Fish Alley.")

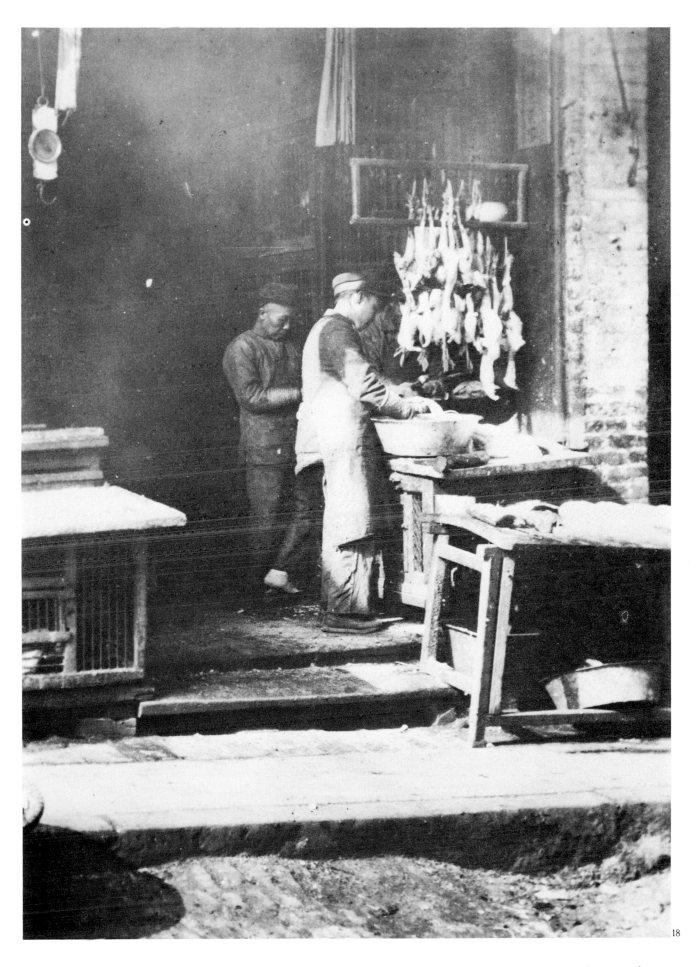

18

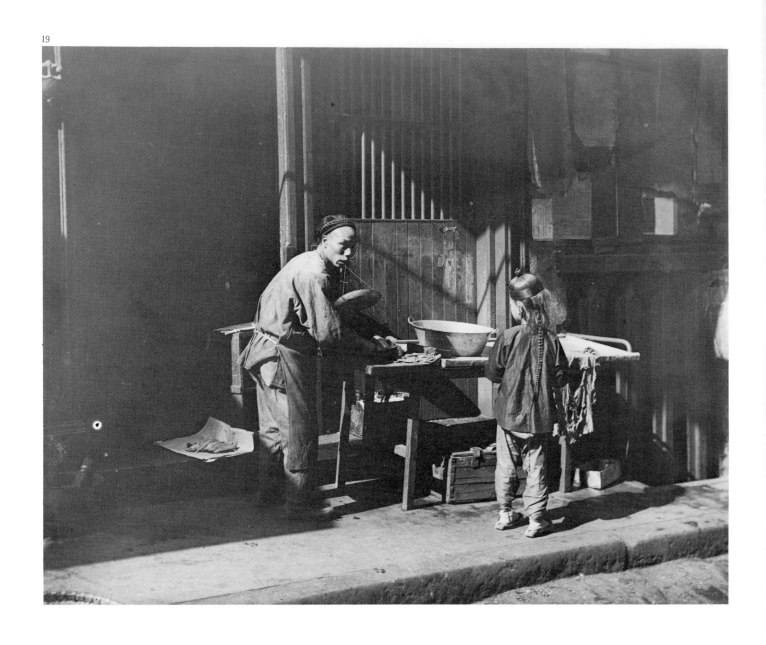

PLATE 19. Man cleaning fish, "Fish Alley." Fish fillets can be seen on the newspaper by the doorstep. The man's queue is neatly wrapped around his head to keep it out of the way. The boy's shaggy and unkempt queue offers a striking contrast. (Genthe mistakenly entitled this photo "The Butcher.") **PLATE 20.** "The Fish Dealer's Daughter" is a portrait of rare and simple beauty showing Genthe at his best. The girl's tattered clothing and gloves on both hands clearly indicate that she works hard, proba-bly assisting her father in carrying the wicker shrimp baskets shown behind. It is highly likely that this photograph was taken not in Chinatown but at Point San Pedro's Chinese shrimp camp. In 1897, the San Francisco publication *The Wave* published a number of photographs that had been taken by Genthe of this camp. Such villages provided Chinatown merchants with dried shrimp for export back to China and to sell in "Fish Alley."

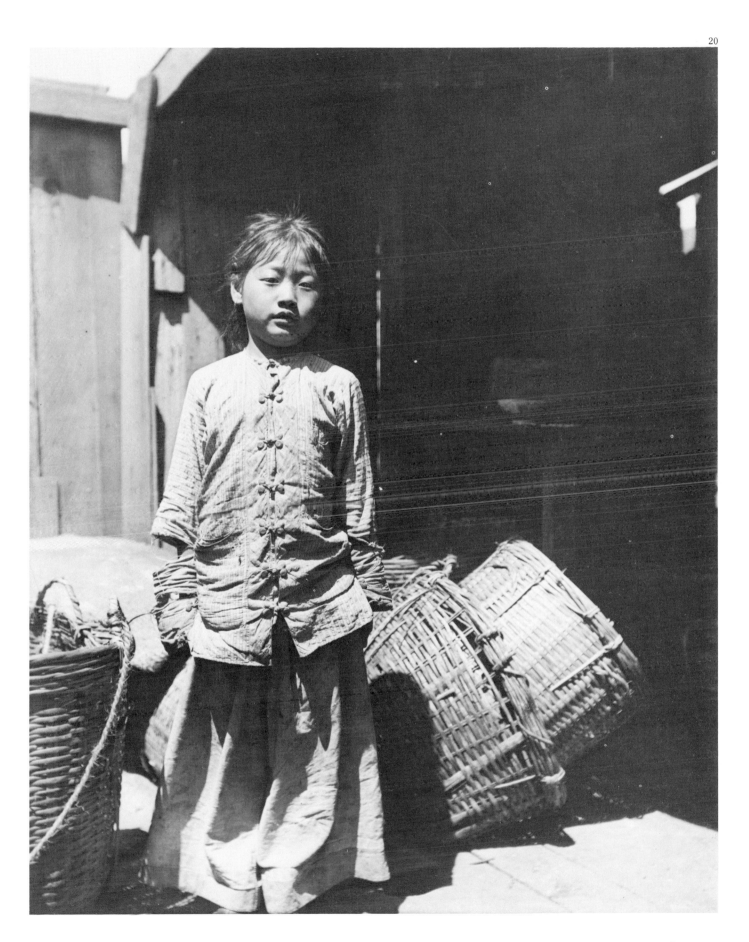

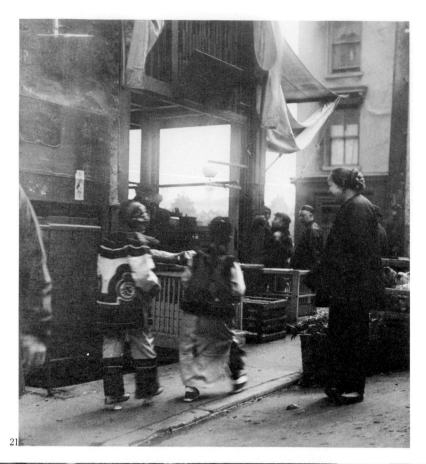

21

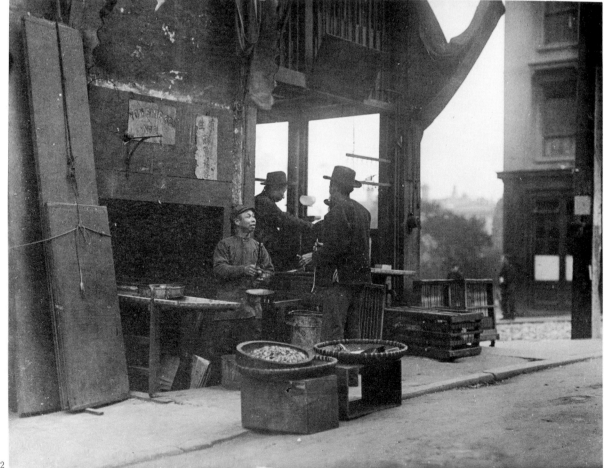

22

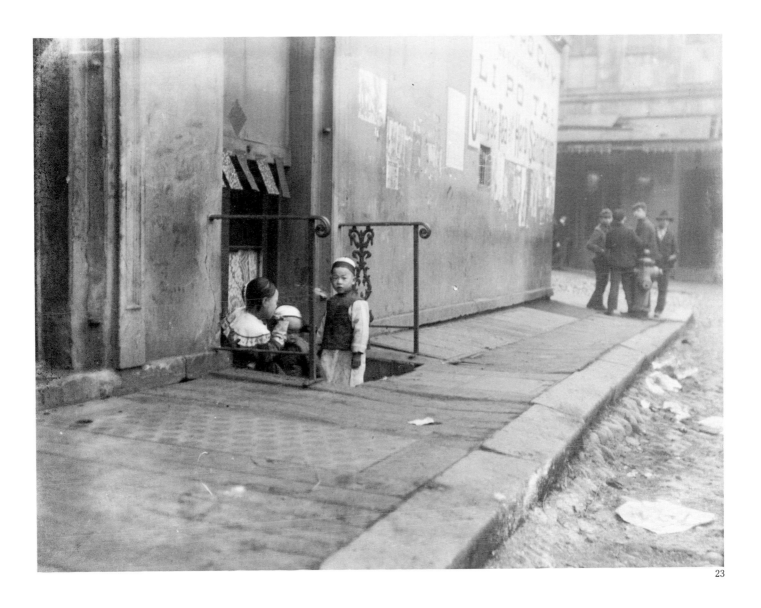

23

PLATE 21. One Washington Place. Although this photograph and the next show the same corner store with Washington Street and Portsmouth Square in the background, the name of the store is different in each (there was a rapid turnover of small businesses in Chinatown). In this plate it is the Sun Lun Sang* Co. Caged chickens are clearly visible on the right. The photograph was probably taken during New Year's, because the children are dressed in fancy holiday clothing. The simply dressed woman looking on is probably a house servant to a wealthy merchant family. PLATE 22. One Washington Place. In this view, taken sometime after 1897, the store sign reads "Yow Sing* & Co., No. 2." The man in the basement stairwell is holding a Chinese scale (cheng). The wooden panels on the left are used to board up the storefront after business hours. The corner store across the street at 871 Washington Street is a Chinese drug and herb store formerly run by Li Po Tai*. PLATE 23. Brenham Place, off Washington Street. This photo was taken right around the corner from "Fish Alley." The "Chinese Tea and Herb Sanitarium" at 871 Washington Street extended its business to non-Chinese clientele, as a sign written in English would indicate. Dr. Li Po Tai, a former occupant, and his assistants reportedly saw from 150 to 300 patients a day. Patients journeyed from all over the country to be diagnosed and treated by him. Before his death in 1893 he is said to have been earning approximately $75,000 a year (Chinese Historical Society of America, Bulletin, March 1973).

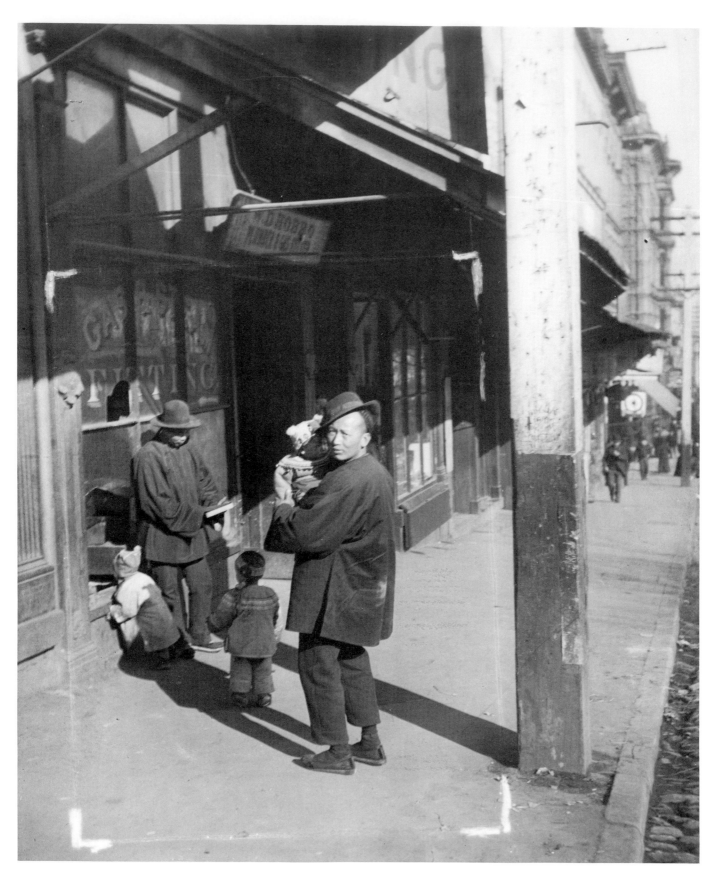

PLATE 24. W. D. Hobro, "Gas & Steam Fitting," 728 Washington Street, across from Portsmouth Square, ca. 1897. Hobro ran a lucrative plumbing business serving the Chinatown area. Chinese were not allowed into the plumbers' union until the late 1950s. In *Old Chinatown* this photo was entitled " 'He Belong Me.' " The bull's-eye sign further down Washington Street indicates a shooting gallery. This block was only half Chinese.

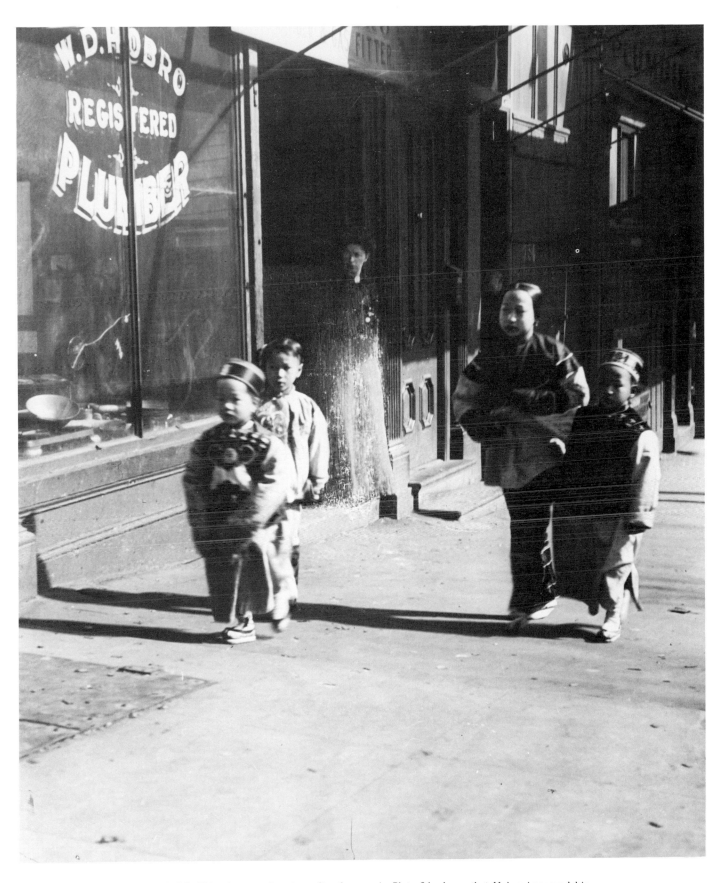

PLATE 25. This photograph, taken after the one in Plate 24, shows that Hobro improved his storefront and expanded next door, adding 730 Washington Street. The Chinese children are in holiday dress. A white woman (standing in the doorway) is half etched out. This incomplete and unsuccessful touch-up explains why this print was never released to the public.

2 MERCHANTS AND FAMILIES

The Chinese merchants and traders who first came to California in the later 1840s and the 1850s were primarily from the Sanyi (Saam Yap), or Three Districts, and the Zhongshan area immediately surrounding Canton. Nanhai (Namhoi) and Panyu (Punyu) were the wealthiest districts in all of Guangdong Province. Economic activities varied from farming rich agricultural lands, raising silkworms, and breeding fish, to manufacturing silk textiles, making ceramics for internal and export markets, and other types of commerce. Sanyi and Zhongshan merchants and craftspeople spoke what was considered a more refined city dialect than their poorer, peasant Siyi (Sei Yap), or Four Districts, neighbors, from which over 80 percent of the Chinese immigrants in North America originate. A number of these Sanyi merchants were among the rising class of *compradores*, Chinese who acted in business matters on behalf of Western trading companies. The California Sanyi merchants, therefore, had experience in dealing with Western businessmen and came to California to pursue further this kind of lucrative contact.

In China, official Confucian ideology established many restrictions upon the merchant class, founded on the belief that a class devoted to unfettered pursuit of material profit would upset the social stability of the state. Merchants were supposed to be kept under strict regulations by the civil-service administrators of the state. However, as the British and other Western imperialist powers penetrated China's major ports, merchants dealing with Western trading companies gained unprecedented prestige and power. Outside of China, Chinese merchants and traders found much more freedom to trade and turn large profits without worrying about state-imposed sanctions. These merchants quickly assimilated the necessary language and business skills to pursue their material interests successfully. They established trading posts at key ports throughout the Pacific Ocean. The pioneer San Francisco merchants displayed a shrewd business sense. Led by Zhongshan native Norman As-Sing*, they held a meeting in December 1849 at the Canton Restaurant in the Chinese Quarter, as it was then called, and hired Selim E. Woodsworth, a respected San Francisco lawyer, to represent them. These merchants quickly learned English and American ways, became skilled at American-style business transactions, and developed strategies for public

relations with the general San Francisco population. The "China Boys," as they were dubbed by the press, made it a point to participate in the first celebration of the admission of California into the Union, and of Washington's Birthday, Independence Day, and other American holidays. This type of behavior helped establish positive relations with the San Francisco public. The *California Courier* expressed a sentiment common among "respectable" whites when it stated: "We have never seen a finer-looking body of men collected together in San Francisco. In fact, this portion of our population is a pattern for sobriety, order and obedience to laws, not only to other foreign residents, but to Americans themselves."[1] Cornelius B. S. Gibbs, a marine-insurance adjuster, echoed the high praise Chinese merchants enjoyed among white business circles in 1877:

> As men of business, I consider that the Chinese merchants are fully equal to our merchants. As men of integrity, I have never met a more honorable, high-minded, correct, and truthful set of men than the Chinese merchants of our city. I am drawn in contact with people from all nations, all the merchants of our city, in our adjustments. I have never had a case where the Chinese have attempted to undervalue their goods or bring fictitious claims into the adjustments.[2]

The stores and offices that these merchants opened soon became the basis of real and symbolic power in the growing regional community of Chinese living in the American West.

As the number of Chinese immigrants increased, the businesses catering to their needs expanded and diversified. A hierarchy of businesses developed along economic and district-of-origin lines. Wealthier Sanyi tended to control the larger, commercially successful companies, such as import-export firms. Nanhai District people monopolized the men's clothing and tailoring trade, in addition to butcher shops. Neighboring Shunde District folk controlled the overalls and workers' clothing factories. Chinese hailing from the Zhongshan District, the second largest population of Chinese in California, controlled the fish businesses and fruit-orchard work, and predominated in the woman's garment, shirt, and underwear sewing factories. The Siyi, or Four District people, by far the largest and poorest group of Chinese,

controlled the low end of the business pecking order in occupations such as laundries, small retail shops, and restaurants. Up until World War II, class affiliations within Tangrenbu were largely predetermined by district of origin. Sanyi not only had an affinity for larger-scale businesses, but they consolidated their economic base in the more lucrative industries within the community. In sharp contrast, Siyi came from a poorer region of Guangdong Province and could not enter the Sanyi-dominated industries. They went into low-capital small businesses which could be more easily set up but made relatively little money.

The dream of finding "golden mountains" was shared by merchants and workers alike. The ways, however, in which their dreams could be realized were totally different. Chinese laborers found jobs wherever they could, and if they were lucky they made good and steady money. In sharp contrast, established merchants acquired small fortunes. They sold supplies and provided needed services to workers, they collaborated with American companies in contracting labor for emerging Western industries; and they catered to the desire of the city's rising social elite for luxury goods imported from China. As anti-Chinese hostilities grew and workers were forced into the residential enclaves surrounding Chinese stores, the merchants gained more and more power over the growing Tangrenbu community. The possibility of Chinese workers' being accepted as equals by white workers faded in the 1870s and vanished in the 1880s. Chinese workers came to depend more and more on the merchants who were adept at dealing with Americans and could speak and write English. As Chinatown grew, the power of the wealthy businessmen extended from brokeraging jobs to providing food and supplies, and to building district associations that provided shelter and social activities for the unemployed and recent arrivals.

In the traditional Chinese social structure, the paternal, extended family was the basic unit of government. In America, among the first community organizations established were clan associations, based on shared surnames, and *hui guan*, or district associations, based on one's place of origin. Whereas state officials dominated local politics in China, the wealthiest merchants, through their organization called the Chinese Six Companies, wielded control in San Francisco and eventually all other Chinese communities across the country. The Six Companies, later officially named the Chinese Consolidated Benevolent Association, soon became accepted by the Chinese as their formal representative to white San Franciscans. The chairman (service was in rotation) was called "the mayor of Chinatown" by outsiders. This domination of merchants over the social and political life of Chinese workers combined with economic power to forge a mighty influence on everyday life in Tangrenbu. For American Chinese in general, merchants became the predominant model of success. For the worker, upward mobility meant the saving of hard-earned wages and the starting of a small business, such as a laundry, fish stand, or truck farm. If the business proved successful and enough money was saved, then he had the option of sending for members of his family to join him and/or of further expanding his operations.

To the San Francisco social and political elite, the circles in which Genthe circulated, the Chinese merchant was the epitome of the "good Chinaman," who was con-stantly contrasted with the low-class "coolie" worker. Doxley's 1897 visitor's guide to San Francisco reflected this widely held notion in an extremely idealized description of a wealthy merchant:

> John Chinaman, aristocrat, makes New Year's calls. He is a gorgeous creation for this function. A big, handsome Tartar, tall for a Chinaman, finely proportioned, lithe in his movements with skin like old-gold satin, trousers and tunic of the richest brocade, in vivid greens, reds, and purples—behold him sketched from life this fine spring morning! A heavy, square-linked gold chain, set with precious stones, hangs about his neck and falls against his tunic front. His white stockings are fine silk, and his ivory-white and pale green sabots are gold-banded between the uppers and soles. His queue is glossy black and of fine length: he carries it looped about his hand as he walks, with the grace of a woman with a light hold upon her skirts. This fine oriental product is a merchant prince of Chinatown, worth piles of money. He imports the costliest of wares—ebony and ivory cabinets and other pieces that cost mints of money, wonderful table china and vases, embroideries upon silk, screens that only those with plethoric purses can dream of for a moment.[3]

The elite circles staunchly supported the rights of Chinese merchants to remain in this country. Not only did they identify with this Chinese elite along class lines, but, on a more practical level, the San Francisco business community realized that friendly relations with these merchants were the key to future trade with the Chinese empire. Thus, as the "Chinese Question" was hotly debated in senate chambers and anti-Chinese and anti-monopoly violence erupted in the streets, what came to be at issue was not whether *all* Chinese should be accorded equal rights as specified in the United States Constitution. Rather, the debate centered on what basis exclusion should be determined. Maintaining that all Chinese were unassimilable into Western civilization, working-class anti-Chinese forces defined the problem racially and wanted all Chinese excluded and even evicted. Business interests, on the other hand, conceded that Chinese workers were dispensable, especially in light of the great influx of European immigrants then competing in the labor market. They steadfastly asserted, however, that Chinese merchants were different, an assimilable and higher level of being, and therefore should be allowed to stay. Local and national business interests prevailed. Not only did the Chinese merchants escape unscathed from antimonopoly agitation, but they secured their interests in trade with China. The 1882 Chinese Exclusion Act prohibited workers from further immigration, but allowed merchants and their wives, teachers, students, diplomats, and visitors to enter the country freely.

The Exclusion Acts accorded merchants the "privilege" of bringing over their wives. What was a basic and unquestioned right of white immigrants, regardless of social standing, became a privilege reserved only for wealthy Chinese immigrants. Although these regulations hardly accorded unusual American rights to the Chinese upper class, in the context of the womanless, male-worker society of Tangrenbu, the right to have a wife and family in this country came to be a fabulous privilege. "In those days," Tom Yuen relates in *Longtime Californ'*, "one thing about Chinese men in America was you had to be either a merchant or a big gambler, have a lot of side money, to have a family here. A workingman, an ordinary man, just can't!"[4] To have a wife meant that there could be Amer-

ican-born children, who would qualify as American citizens. To have a family meant that there was a future in the United States. To be deprived of having a family meant constantly looking back to China for solace and hope, while living in a bachelor society in America.

Arnold Genthe had some contact with wealthy Tangrenbu merchants. His description of opulent festival dinners gives us some insight into the impressive riches that some of these merchants commanded:

> Sometimes one of the big merchants would ask me into his sanctum where he would show me his treasures—a delicately carved crystal, a rare jade, or a peach blow vase. Occasionally I was invited to a festival dinner, where the men sat at table in silken robes and did the eating and drinking while the women, in gorgeous coats and pantaloons and jewelled headdresses, sat behind them, content if their lords and masters regaled them with an occasional tidbit or a sip of tea. These dinners were epicurean events, for the upper class Chinese are gourmets, and the cooks are artists. . . . The true virtue of these feasts was their absence of grease, so that no matter how many courses there were, one left the table without feeling that one had eaten too much.[5]

Class privileges, however, did not entirely shield merchants from racial hostility. They experienced a different level of discrimination. They enjoyed living in four- to five-room apartments, possibly around the "Chinese Nob Hill" section on the 900 block of upper Clay and Sacramento Streets, and may even have possessed the ultimate community status symbol of owning a sofa. Nevertheless, merchants could not send their children to California public schools, they had a difficult time settling claims with delinquent white customers, and, despite legal guarantees, they were constantly harassed by customs agents. Merchants and their families responded to the continued racism in contradictory ways. The majority of big merchants still looked toward imperial China and shared the workers' feeling that if China had been a strong nation like

Japan, overseas Chinese would not be experiencing such degrading treatment. Many merchants supported the Baohuanghui, a reform political party led by Kang Youwei and Liang Qichao, which urged the restoration of the monarchy and opposed the corrupt dowager empress Cixi, who had usurped the throne from the rightful heir. Kang and Liang made three trips to America between them, soliciting funds for the party (see Plate 35). Others among Tangrenbu's elite benefited from the missionary work of Christian churches and advocated the Americanization of Chinese according to white Anglo-Saxon Protestant standards. Ng Poon Chew* (Wu Panzhao), the founder and editor of the major San Francisco Chinese daily *Chung Sai Yat Po** (*Zhongxiribao*; "China-West daily newspaper"), cut off his queue and donned Western clothing. While advocating the assimilation of Western culture, he also looked toward China. But instead of supporting the tradition-bound monarchy, his hopes were fixed on a thorough break with the past and the formation of a Western-style republic. Although radicals such as he formed a faction within the community that was a definite minority at this time, their views were especially appealing to younger, American-born Chinese.

Genthe's photographs provide us with telling moments that suggest the working of these dynamic forces pushing and tugging at Tangrenbu's upper class.

Notes

[1]Thomas Chinn, H. Mark Lai, and Philip P. Choy, eds., *A History of the Chinese in California: A Syllabus*, 1969, p. 10.

[2]*Report of the Joint Special Committee to Investigate Chinese Immigration* (44th Congress, 22nd Session, 1876–1877, Senate Report 689), p. 530.

[3]W. Doxley, *Doxley's Guide to San Francisco*, 1897, pp. 121–22.

[4]Victor G. and Brett de Bary Nee, *Longtime Californ': A Documentary Study of an American Chinatown*, 1973, p. 18.

[5]Genthe, *As I Remember*, p. 39.

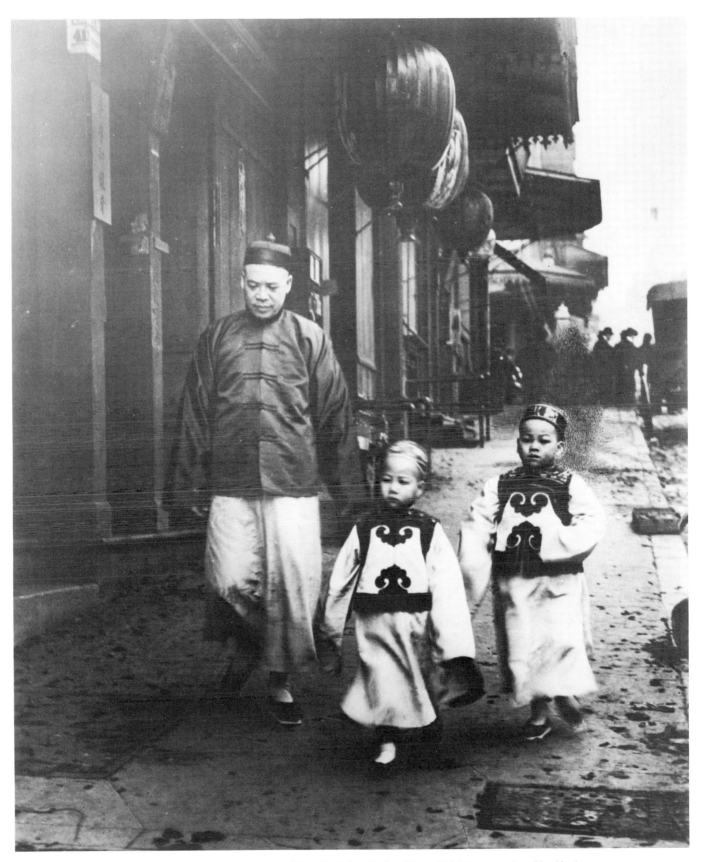

PLATE 26. "Children of High Class." Lew Kan* (Lee Kan) walking with his two sons Lew Bing You* (center) and Lew Bing Yuen* (right). Lew Kan was a labor manager of Chinese working in the Alaskan canneries. He also operated a store called Fook On Lung* at 714 Sacramento Street between Kearney and Dupont. Mr. Lew was known for his great height, being over six feet tall, and his great wealth. The boys are wearing very formal clothing made of satin with a black velvet overlay. The double mushroom designs on the boys' tunics are symbolic of the scepter of Buddha and long life.

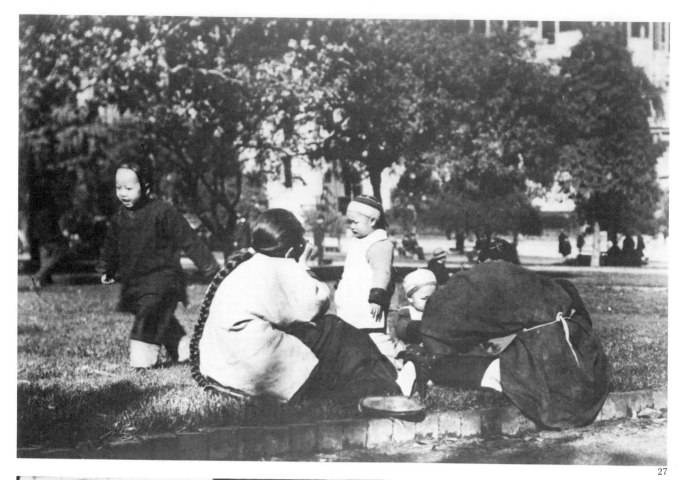

27

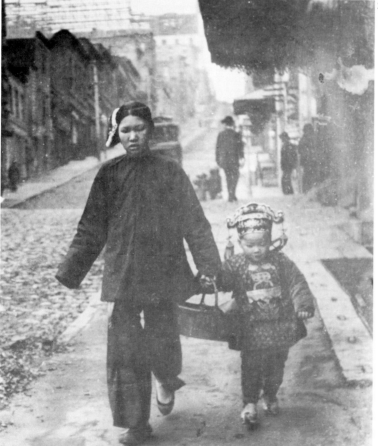

28

PLATE 27. "A Picnic on Portsmouth Square." This photograph shows Lew Kan's four other children. The woman on the left is his oldest daughter, who had a hunchback and never married. She and a family servant are shown here attending her three younger sisters. The two girls in the center are twins. **PLATE 28.** "Carrying New Year's Presents." This woman is a servant to the Lew family. The boy in New Year's dress is Lew Bing Yuen, the older son, who also appears in plate 26. The woman's relatively plain dress, in contrast to the boy's fancy clothing, indicates that she is not the boy's mother or sister. **PLATE 29.** "Waiting for the Car" (ca. 1904). The Sue family at a Dupont Street corner. Mrs. Sue is shown with her eldest daughter, Alice, with Elsie sandwiched between them. Her brother-in-law is holding Harris. Alice is wearing strings of pearls and semiprecious stones on her headdress. Mrs. Sue is wearing a black silk-on-silk embroidered outfit. Married women generally wore dark, subdued clothing that distinguished them from prostitutes. Elsie and Harris are wearing leather shoes; however, Alice and her mother wear Chinese-style footwear. Mr. Sue, who died after the 1906 earthquake, ran a *doc sic guun*, or "boarding house," which fed male workers at nine in the morning and four in the afternoon, while Mrs. Sue took in sewing. (Information provided by Alice Sue Fun.)

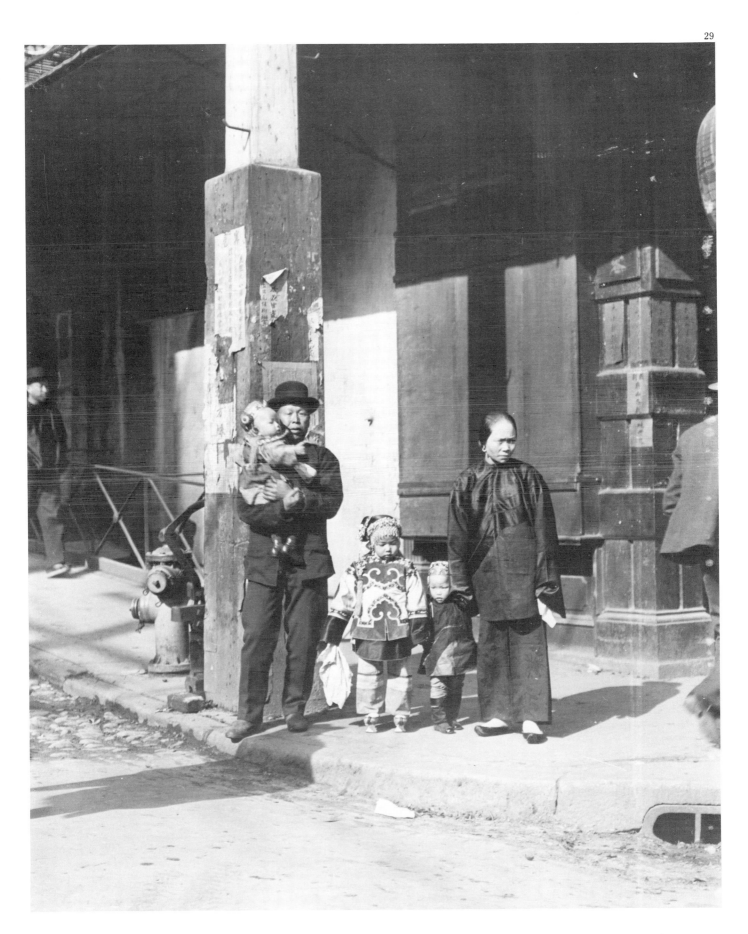

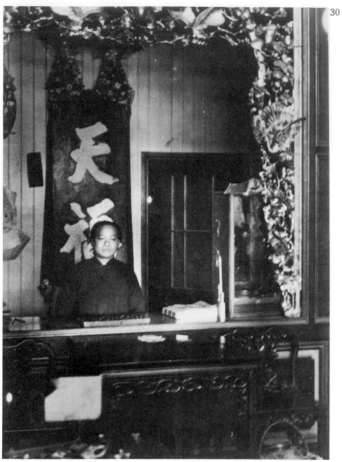

PLATE 30. "A Goldsmith's Shop." Tin Fook* (Tianfu; "Heavenly Fortune") jewelry store, 727 Jackson Street, owned by the Chew* (Zhao) family. Seen in this rare indoor shot are the typical carved and gilded sign, the intricate gilded carving of symbolic animals framing the counter, and the teakwood furniture imported from Vietnam. Mr. Chew, a Sanyi gold miner, opened Tin Fook as a cooperative store serving Chinese miners. At that time the store was located on the waterfront, off Kearney Street between Washington and Clay. Chinese miners would regularly deposit their gold in his safe at no interest. (General provision stores also commonly served in this manner as banks.) When they accumulated enough gold or wanted to return to China, these miners would have Mr. Chew make various gold objects to sneak past the customs officials. He frequently made gold belts and gold chains which could be sewn into the seams of clothing. It is said that once he made a solid gold frying pan which was blackened with soot to make it look authentic. Tin Fook reportedly had a sterling reputation among Chinatown residents. **PLATE 31.** Sammy Tong* and his father, wearing matching silk robes. The elder Mr. Tong came to California in the 1870s when he was nine years old. At that time he started working at a Chinese boot and shoe factory, cleaning up after the other workers. American lawyers taught him how to speak English, which put him in the position of representing the Palace, Fairmont, and Saint Francis hotels in hiring Chinese workers. He had ten children, of which Sammy was the eighth. They lived on Spofford Alley in a small storefront in which their beds folded out from the walls. Mr. Tong eventually became a sales representative for Pacific Gas and Electric, selling incandescent lamps in Chinatown. He died in 1924. Sammy Tong played the role of the Chinese servant in the popular 1960s television program "Bachelor Father." (Genthe's title for this photograph: "In Softly Gaudy Colors.") **PLATE 32.** "Young Aristocrats." The Louie* brothers, Jam* and Wah*, observing a toy peddler. Little cars, rickshaws, and animals are displayed on the curbside. Their father was a very successful merchant who was involved in establishing a Chinatown Branch of the Bank of Canton in 1907. The Louie brothers' dress contrasts sharply with the plain cloth dress of the boy standing next to them.

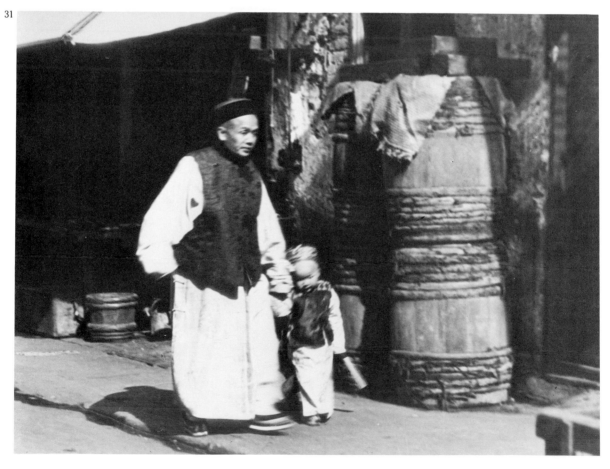

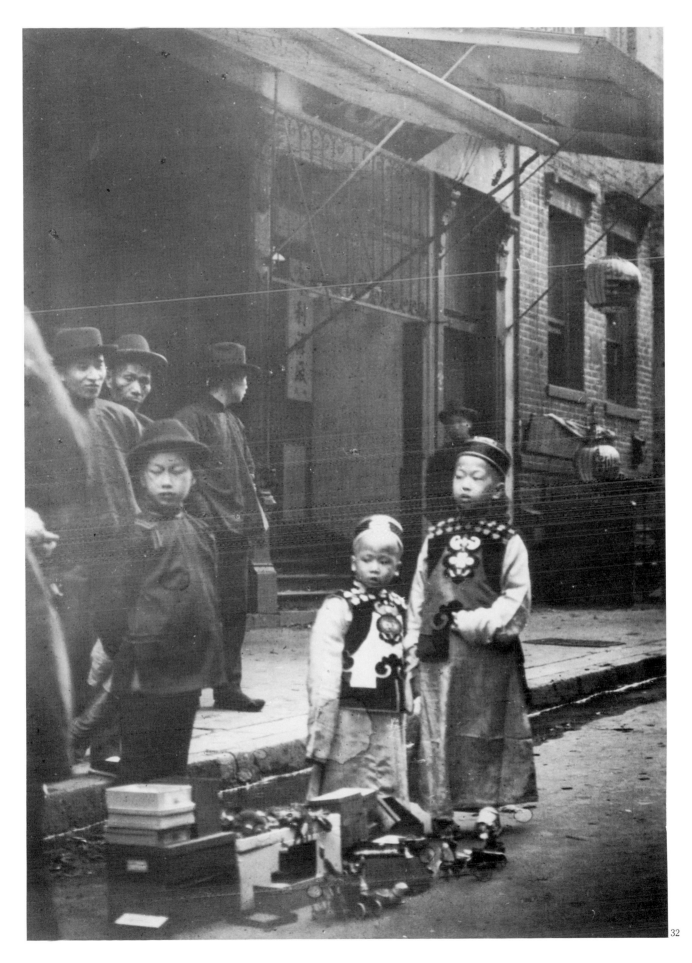

32

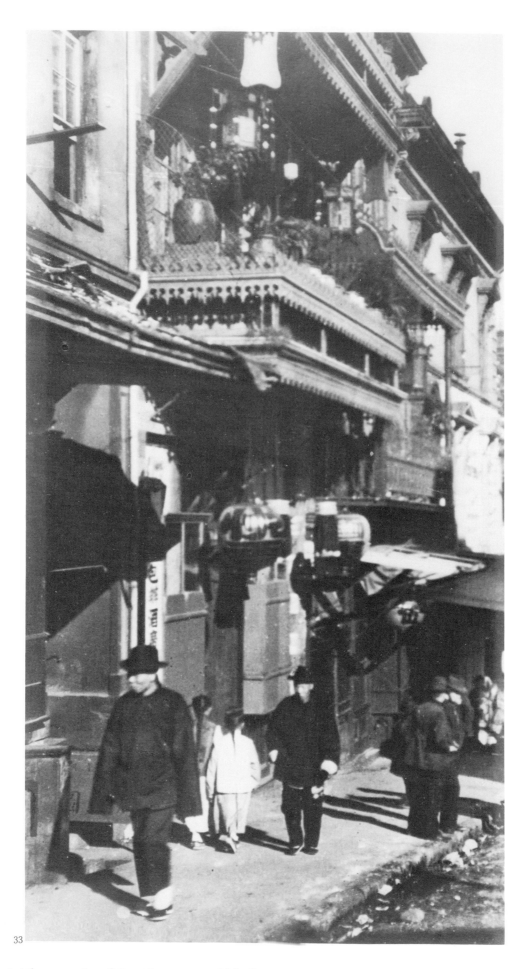

33

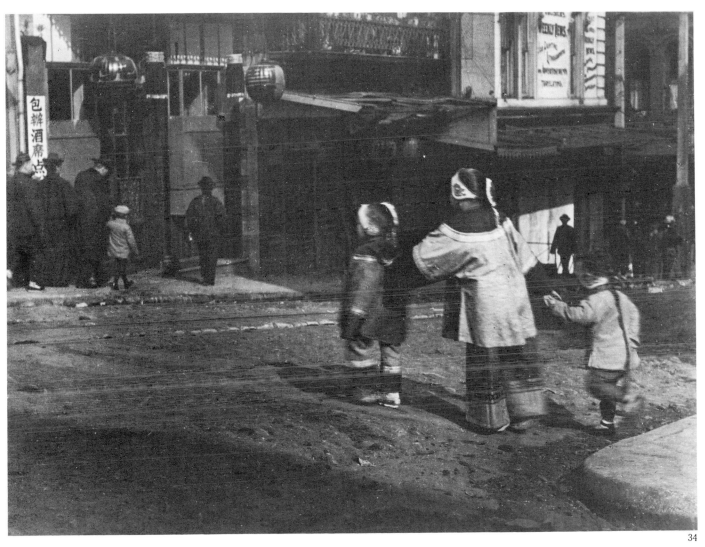

包辨酒席

34

PLATE 33. The Yoot Hong Low* (Yuexianglou) Restaurant, 810 Clay Street, between Dupont Street and Waverly Place. Big restaurants such as Yoot Hong Low occupied several floors of a building. Often the basement would serve simple rice and noodle dishes to Chinese workers and unemployed on wide benches and simple wooden tables. The middle floors would house the kitchen and have more elaborate menus for small businessmen, shop owners, and tourists. The luxurious top floor was usually reserved for the Chinatown elite and their guests. It was a status symbol among fancier restaurants and wealthier temples to paint the exterior walls with light colors veined to simulate marble, a prized stone in Chinese architecture. (Genthe's title was "The Street of Painted Balconies.") **PLATE 34.** "The Crossing." The three children in holiday dress cautiously cross Clay Street at Waverly Place. The trolley tracks traversing Clay made the thoroughfare a dangerous place for children. The Yoot Hong Low Restaurant is visible on the left.

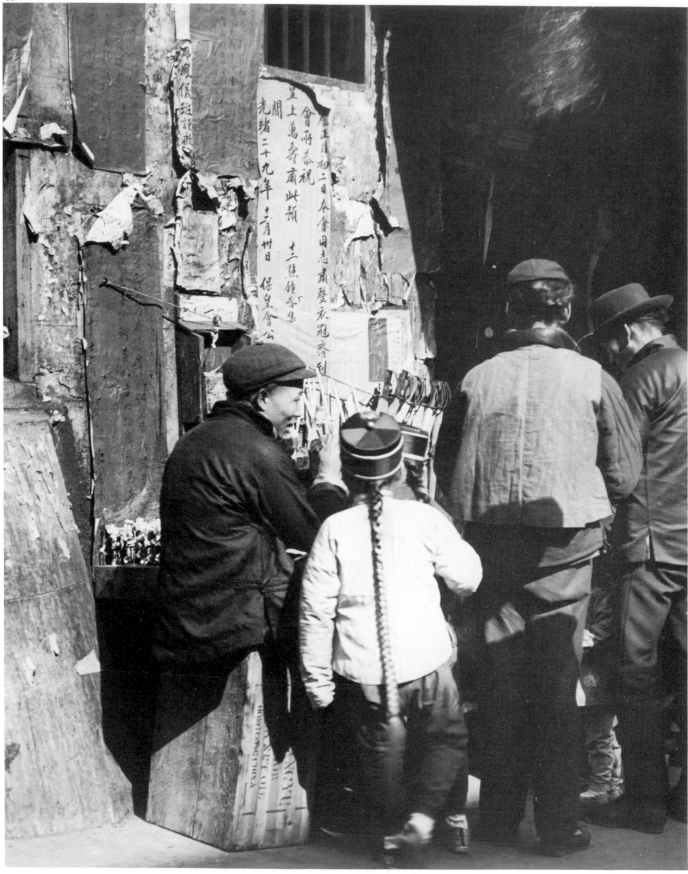

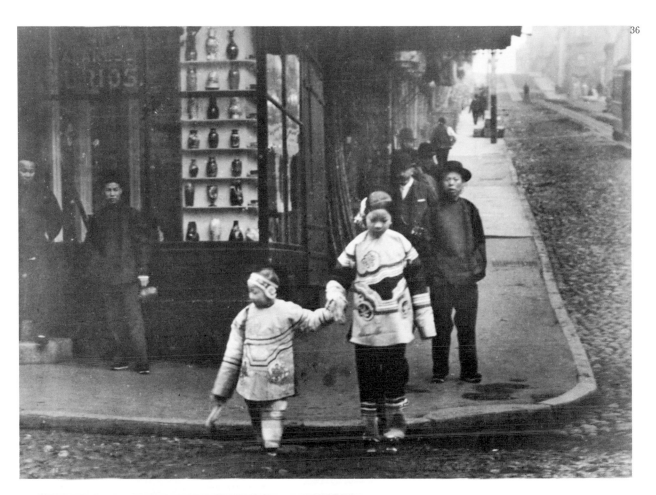

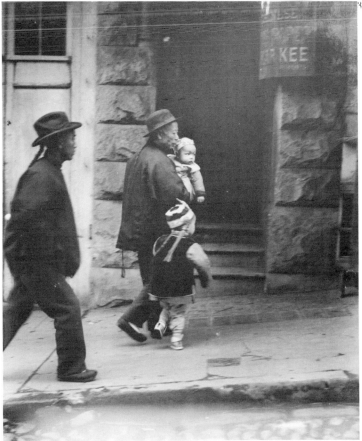

PLATE 35. Directly above the seated man selling toys and snacks is a poster for the Baohuanghui (Bou Wong Hui) or "Protect the Emperor Society," which was established by the noted Chinese reformers Kang Youwei and Liang Qichao. This political party advocated the restoration to the throne of the young emperor Guangxu, whose position had been usurped by the dowager empress Cixi. It also called for extensive reforms to modernize the country. There were chapters in Chinatowns throughout North and South America. **PLATE 36.** "At the Corner of Dupont and Jackson Streets." Two girls wearing embroidered holiday wear are crossing the street. The store behind them is a "Chinese and Japanese Curios" store located at 924 Dupont Street, southwest corner. The good-quality, expensive vases in the window display and the sign in English indicate that the store catered especially to tourists. Some such stores were owned by Japanese, but the main reason that both Chinese and Japanese goods were sold in the same store was that the general public could not distinguish between the two cultures. **PLATE 37.** "Dressed for a Visit." This photograph happens to capture the sign for the "Chinese Newspaper/War Kee" at 803 Washington Street, just west of Dupont Street. The *War Kee** was founded in 1875. Although the names J. Hoffman and Chock Wong* appear as the publishers of the first issue, a Yee Jenn* has been cited as the founder. The *War Kee*, which was the first successful Chinese weekly published in Tangrenbu, folded in 1903.

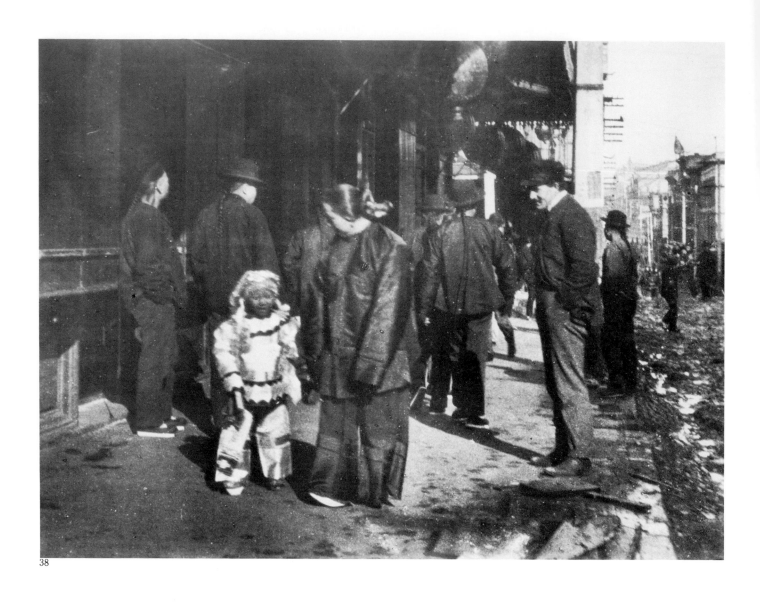

38

PLATE 38. "An Afternoon Airing" on Dupont Street. The crying girl is dressed in New Year's clothing and is walking with her amah, or "nanny." **PLATE 39.** This photograph shows another amah holding a child and walking down Dupont Street looking south. A figure behind the woman's head is etched out of the glass negative. The parents of the children in both this and the preceding photograph were wealthy enough to have a house servant to take care of them.

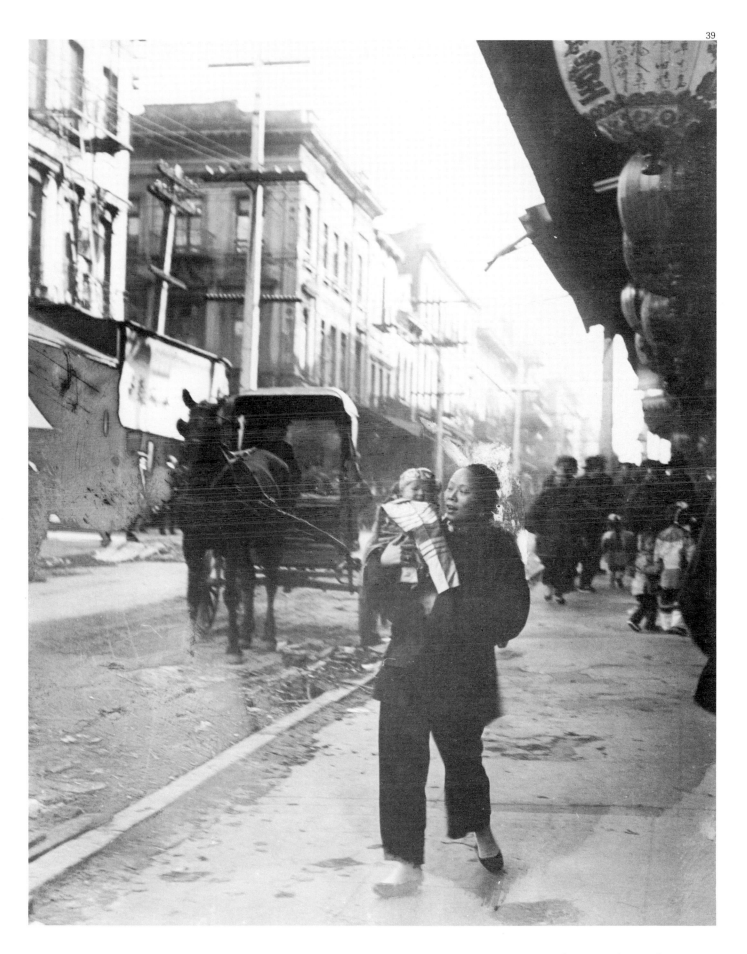

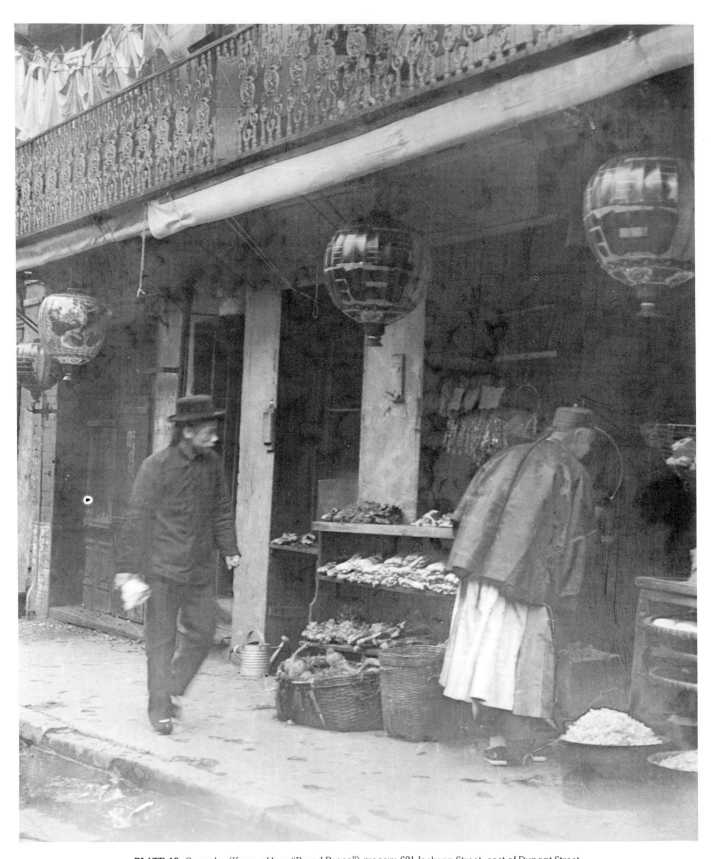

PLATE 40. Guanghe (Kwong Hop; "Broad Peace") grocery, 621 Jackson Street, east of Dupont Street. The continuity of display styles between this photo and the next indicates certain standards by which grocery owners abided. The lanterns at the right and center indicate the store's name. The lantern second from the far left has two phoenixes drawn on it. Phoenixes traditionally symbolize joy and happiness. (Genthe's title: "Marketing.")

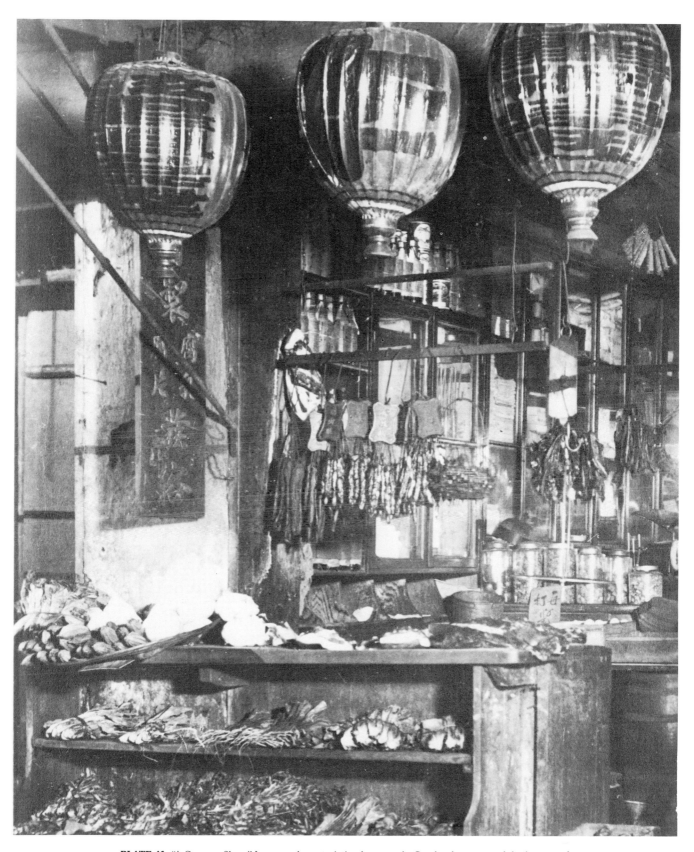

PLATE 41. "A Grocery Shop." In an uncharacteristic photograph, Genthe documented the bounty of another grocery display. Cured dried beef and sausages hang from metal racks amid jars of dried foods and fresh vegetables. Bitter melon, Chinese cabbage, chives, and lettuce are visible on the outdoor shelves. In the glass cabinets indoors, bottled, packaged, and canned goods are neatly lined up. Packaged goods were imported from China, but the prepared and dried meats and fresh vegetables were supplied by local Chinese outfits. The lacquered lanterns give the store's name. Lights were often hung inside the globes and turned on at night.

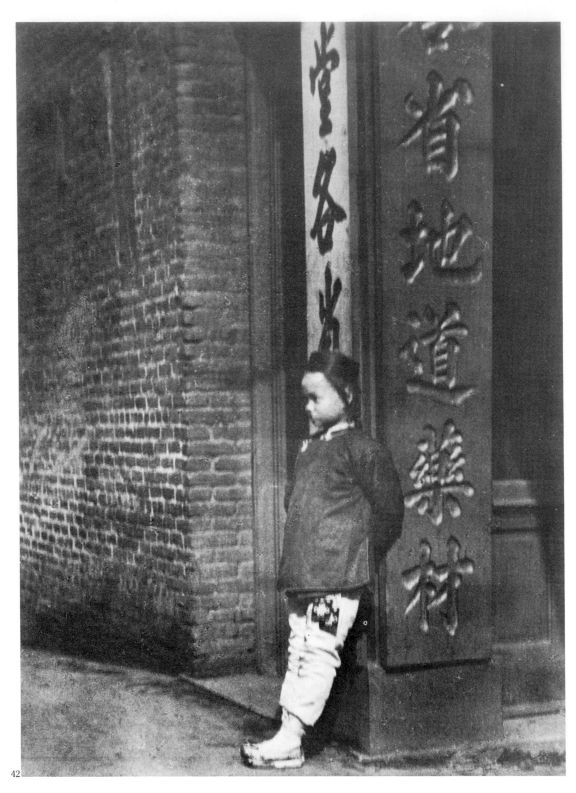

42

PLATE 42. "The Drug Store Sign." The sign advertises special medicines from each province of China. The numerous Tang-renbu pharmacies featured hundreds of organic herb and animal extracts, primarily imported, used for centuries in Chinese medicine. Chinese doctors were sometimes based in the stores themselves. A number of drugs such as quinine, digitalis, and ephedrine were used by Chinese doctors long before Western medicine discovered their curative value. **PLATE 43.** Xing-chunling (Hahng Cheun Yuhn; "Apricot Spring Orchard") drugstore sign, Sacramento and Dupont Streets, northeast corner. The name derives from a folktale about a benevolent doctor from Lushan who refused monetary payment for curing his patients,

but accepted remuneration in the form of apricot trees for his property. **PLATE 44.** Tongantang ("All Peace Hall") drugstore, 1002 Dupont Street, off Jackson. Chinese pharmacies have traditionally been well-respected community institutions with much the same prestige as doctors in modern Western culture. Wealthier merchants did occasionally seek treatment from white doctors for surgical care, which was not practiced in Chinese medicine. Chinese were generally barred from access to San Francisco's hospitals and were unfairly blamed for many of the plagues that affected the city. Racist policies eventually forced Chinese businessmen to build their own clinic within Tangrenbu in 1900.

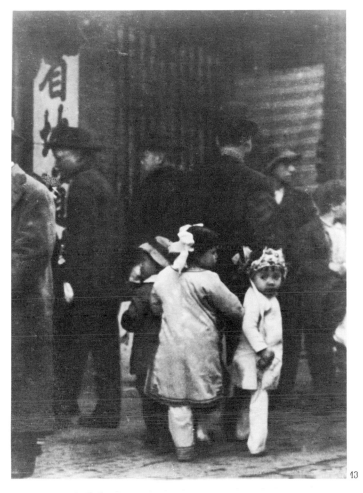

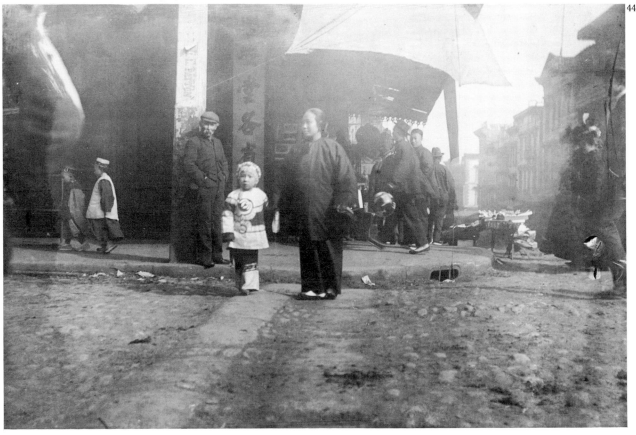

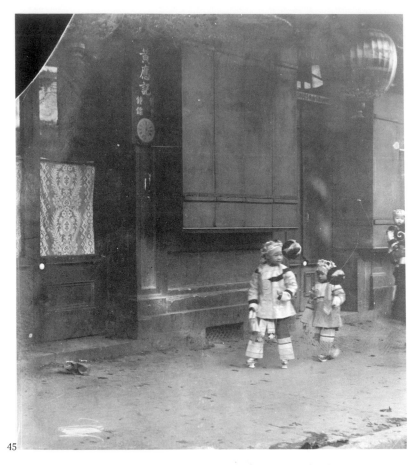

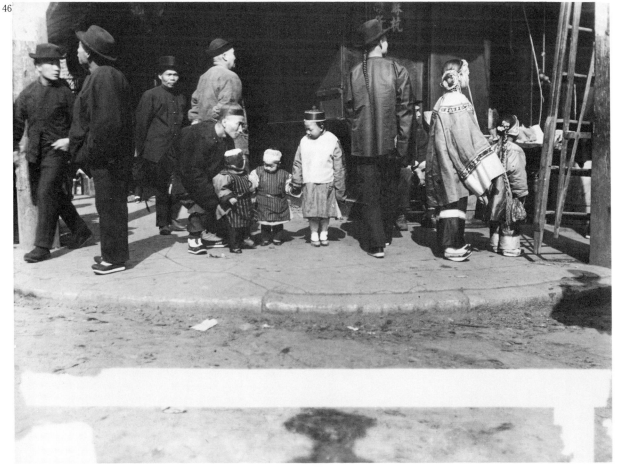

45

46

PLATE 45. Huangyingu, clock and watch repair store, 956 Dupont Street. Small specialty stores requiring skilled craftsmen formed a small but significant infrastructure within Chinatown. To judge from the dress of the children and the boarded storefront, the shop is closed for New Year's. Genthe's hastily taken photograph (entitled "Tiny, Yellow Flowers of the World") was cropped down in *Old Chinatown* to include only the two girls, omitting the store sign. **PLATE 46.** Corner of Dupont and Washington Streets. The merchandise store behind the crowd was named Tongtai, 900 Dupont. It featured specialty items from the cities of Suzhou and Hangzhou. The father and three children huddled in front of the store are not in holiday dress despite the festive costumes of the woman and girl on the right. This photo, entitled "The Children's Hour," illustrates that perhaps occasionally workers' families as well as merchants' could enter the United States. Genthe's shadow can be seen below his white crop marks.

3 WORKERS AND BACHELOR SOCIETY

The 1880s through the early 1900s were dismal, devastating times for Chinese workers in America. Anti-Chinese mobs and labor unions conspired to drive thousands of workers from the California farmlands of the Sacramento and San Joaquin Valleys; the coal mines of Rock Springs, Wyoming; the northern California logging port of Eureka; the entire cities of Seattle and Tacoma, Washington; and a host of other areas. The population of quarters in which thousands of Chinese once lived dwindled to hundreds. The San Francisco customs office witnessed the exit of many workers who had saved up enough money for their passage back to China. Many left for good, others were left waiting in Guangdong for the xenophobic storm to subside. The 1888 Scott Act capriciously revoked the reentry permits of some 20,000 Chinese laborers who were visiting China but had every intention of returning to the United States. Chinese workers evacuated the Western countryside, they either migrated eastward, in search of less hostile communities in which to find work and settle, or clustered in the segregated, but safe, urban centers defined as Chinatowns. In the 20-year census period within which Arnold Genthe took many of his Tangrenbu photographs, from 1881 through 1900, the Chinese population of San Francisco dropped precipitously from 26,000 residents to merely 11,000. The torrent of racial violence forced the enactment of legislation stating that Chinese workers could not immigrate into America and that Chinese women could not join their worker husbands who were already here. This, combined with anti-miscegenation laws prohibiting Chinese from marrying whites, effectively reduced the number of Chinese workers and isolated them from the rest of the population. Angrily reflecting upon this period, one Chan Kiu San* aptly stated in 1904: "They call it exclusion; but it is not exclusion, it is extermination."[1]

In a position very different from that of propertied merchants, Chinese workers had only their labor to sell and were especially vulnerable to occupational eviction. As racist trade unions pushed Chinese out of ranches, railroads, and construction work, owners pulled in blacks, Apache and Yaqui Indians, Mexicans and Cholos (Latin-Americans of mixed Indian and European extraction), Italians, Greeks, Austrians, Portuguese, Hawaiians, Hindus, Puerto Ricans, Filipinos, and Japanese. Hundreds of young white women were brought in at great expense to replace Chinese in factory and domestic-service work.[2] The basic relations of labor with capital remained essentially the same; the single difference was the race or nationality of the workers. Chinese workers descended the hierarchy of skilled trades, ending on the bottom of the socioeconomic ladder. Even the Chinese-owned factories suffered steady decline. As a child, Jack Wong*, a carpenter, noticed the inability of Chinese factories to acquire the knowledge and capital necessary to compete with burgeoning mainstream industries:

> "When I first came in, there were three broom manufacturing companies in Chinatown, and they were producing the majority of brooms in the Bay Area. But the industry was deteriorating because the price of making a broom by hand was so high. You see, in Chinatown we lacked the capital to install the new machinery they were getting in the mechanized factories, and we lacked the knowledge of industrial techniques. So, unfortunately, the broom factories ceased to exist and as a result I saw the men in Chinatown lose about 100 or 150 jobs."[3]

Many other Chinese were tossed out of jobs. The "old-timers," who in their prime were building railroads, mining, and working in factories, were hardest hit. They had no place to go but Tangrenbu and would hang around stores and Portsmouth Square, getting odd jobs at the fish market and grocery stores. Some earned a marginal existence from peddling odds and ends on the streets of Chinatown. The younger men worked as migrant laborers traveling from town to town, keeping one step ahead of idleness. Tom Yuen describes in *Longtime Californ'* his father's experiences just after 1900: "Chinatown was his home base, that was the safest place. In the summer he went out to Watsonville and picked fruit. In November he was cutting sardines in Monterey. He went up to Alaska to the salmon canneries in wintertime and then he got back to the valley again in time to harvest the asparagus in the spring."[4]

Steady work was at a premium. It was considered a high-status job to work as a house servant for wealthy whites. Laundry work was also desirable because, despite long laborious hours and small profits, workers were fairly independent and didn't have bosses con-

stantly hovering over them. What had previously been considered "woman's work" in the East became the virtually exclusive province of Chinese in the West. As the fierce struggle of American industrialization unfolded, the "Chinese Question" was resolved by exclusion; now white labor wrestled with Japanese and other nonwhite groups that were being recruited into the labor market. The Chinese were left in the backwaters of American economic development. Marginal work and joblessness was a bitter experience for many during these transitional decades. These harassed workers were forced to rely on themselves, and the Tangrenbu culture they created valiantly resisted the debilitating forces of these hard times.

In order to survive, Chinese "bachelor" workers wove a tightly knit society to take care of each other's needs. Cooperative living and eating arrangements were developed for mutual benefit. Wei Bat Liu* describes the manner in which his family clan banded together in San Francisco after the earthquake:

> "In 1913, all the cousins from the Liu family in my village had one big room so all the members could fit in it, and we slept in that room, cooked in that room, one room. Anybody who had a job had to sleep outside the room, because he could afford to rent space and get a bed for himself. Anybody who couldn't find work slept in the beds in this room. At the end of the year, all the members would get together and figure out all the expenses. The ones that slept in the room most were willing to pay a little more. But even the ones who didn't sleep there were willing to pay something for the upkeep of the room."[5]

Unemployed workers would pool their change and buy a sack of rice for their room. "We got by on what you'd call soul food," Johnny Wong* quips. "You could walk down to the butcher shops near Italian town and with a purchase of 2½¢ worth of beef, they'd throw in the parsley and green onions free. I guess that's something the world will never see again—2½¢ worth of pork and 2½¢ worth of beef."[6] Crates tossed out by stores would be salvaged and used as tables, cabinets, and firewood. Evenings were punctuated with storytelling. Fong, a laborer, explained to the Nees that:

> "Everything, anything that comes along to our minds we made a story out of it, and chat. . . . Any subject that comes along. For instance, one time I had an argument with one guy about taxicabs. I came back to him with some news, I said, 'You know, the taxicab used to go by the meter, but now you can go across town, the whole thing all the way through San Francisco for a dollar. And it doesn't matter how many people there are, that's what they claim.' So this guy here, he got hot head and he argued with me, said, 'You're crazy. No such thing!' And he argued with me. He said, 'You mean to tell me you gonna carry coupla bars of gold up a hill, would you be willing to carry one bar or would you be willing to carry five? Like five passengers in a car.' I said, 'Now look, this is going a little too damn far! You're talking about carrying gold and I'm talking about taxicab!' See, he's absolutely a thickhead. See, I mean we talked about everything."[7]

After long 16-, sometimes 20-hour workdays, there was time only for sleep. On Sundays, men would get together, swap stories, complain, and play mahjong. If they had some money in their pocket they might smoke some opium, gamble a little, visit a prostitute, or attend the Chinese theater.

The deep camaraderie that developed among workers was most clearly to be seen in the tightly organized workers' guilds, the clan and district associations, and the tong secret societies. The overwhelming majority of Chinese workers were from the poorer Siyi area of Guangdong Province. Over half of these people came from the Taishan district alone. The anti-Chinese racism of the trade unions, and even of socialists, cut off all possibilities for Chinese workers to identify with other workers along broad class lines. The notable exception to this attitude was that of the syndicalist Industrial Workers of the World (IWW), which actually recruited two Chinese socialists in the early 1900s to translate some of their literature. Siyi workers did not come to identify with the American working class. They expressed their class consciousness by building organizations that reflected their interests. A single Chinese worker could have belonged to a network of support groups that looked after his various everyday concerns. Laundry, factory, and other labor guilds were organized to regulate competition and protect workers from bosses. Clan and district associations provided for basic everyday survival needs, and the secret societies harbored irrepressible social and political desires. Those workers that remained in Tangrenbu built a bachelor society of tremendous internal strength and mutual support. The hostility of the outside world was met with a countervailing solidarity from within.

Arnold Genthe did not understand this world, nor was he allowed into it. Nevertheless his photographs offer us glimpses into this rich and sustaining culture.

Notes

[1]Mary Roberts Coolidge, *Chinese Immigration*, 1909, p. 302.
[2]*Ibid.*, p. 384.
[3]Victor G. and Brett de Bary Nee, *Longtime Californ': A Documentary Study of an American Chinatown*, 1973, p. 61.
[4]*Ibid.*, p. 22.
[5]*Ibid.*, pp. 64–65.
[6]*Ibid.*, p. 70.
[7]*Ibid.*, pp. 70–71.

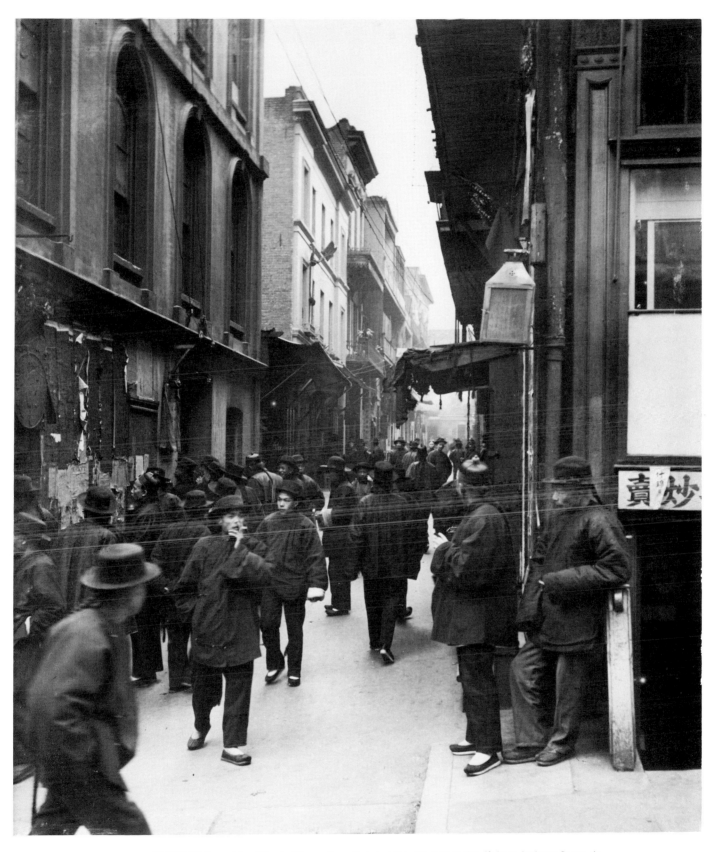

PLATE 47. Ross Alley (Stouts Alley or Ross Street on the old map in Fig. 3) from Jackson Street. As evidenced by the traditional papier-mâché garlands hanging above the doorway on the building to the right, this photograph was taken around New Year's, when seasonal workers were laid off, inundating Chinatown streets with thousands of idle workers. Their cotton tunic tops and cloth shoes are Chinese, but the pants and felt homburg-style hats are strictly Western. Genthe's title, "The Street of the Gamblers (by day)," is accurate insofar as Ross Alley had many gambling rooms, but it unfairly ascribes a sinister quality to these men.

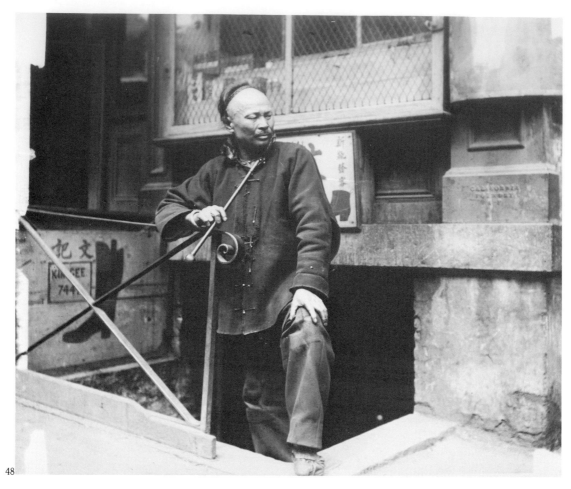

48

49

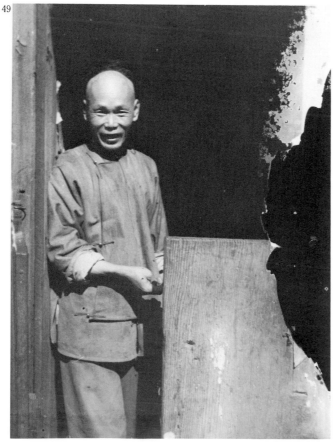

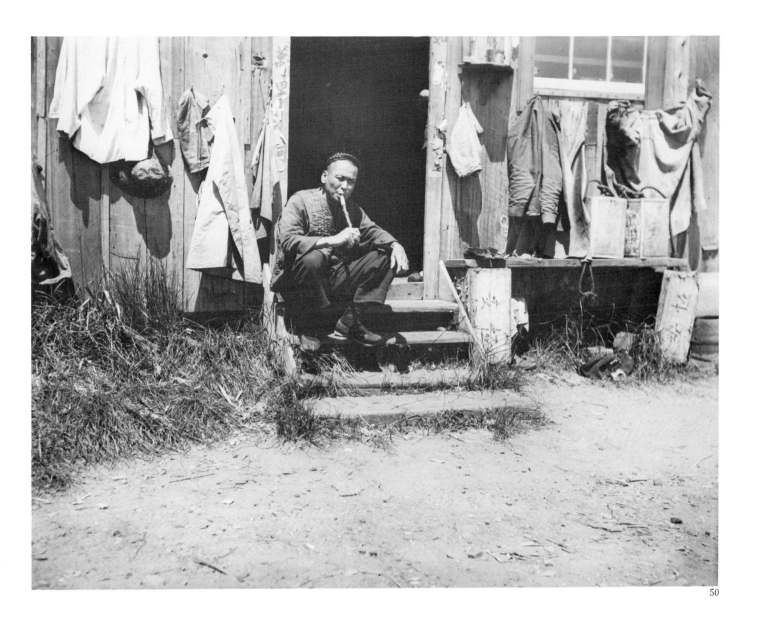

50

PLATE 48. "The Shoe Maker," Kin Gee* (Wenji) shoe factory, 744 Clay Street basement, between Dupont and Brenham. This worker's tattered leather outfit and slipper set off his confident stance and expression. His queue is wrapped around his head and he holds a tobacco pipe in his right hand. In the *Old Chinatown* version of this print the English "Kin Gee" is cropped out of the photo. The printed type on the far right- and left-hand margins of the print are film-developing instructions that are still stuck to the glass negative. PLATE 49. "The Chinese Cook, Grinning from the Doorway." PLATE 50. Worker's shack. (Genthe's title: "Pipe Dreams.") This man is puffing on a pipe made from a tree branch. His queue is wrapped around his head and he is wearing a padded vest. Several men probably shared these living quarters. The hat on the left was of a type commonly worn by fishermen. It is possible that this was a laundry outfit, as suggested by the tin cans used for buckets on the right. This shack possibly was located on the outskirts of Tangrenbu, around Pacific Street, or outside of Chinatown altogether.

Workers and Bachelor Society 65

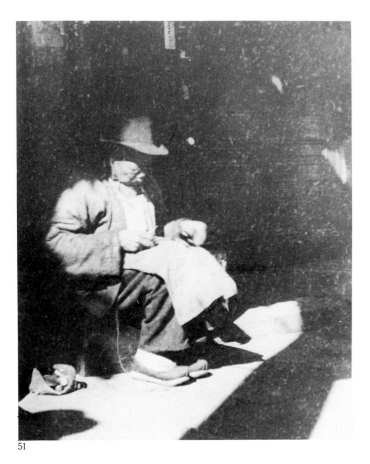

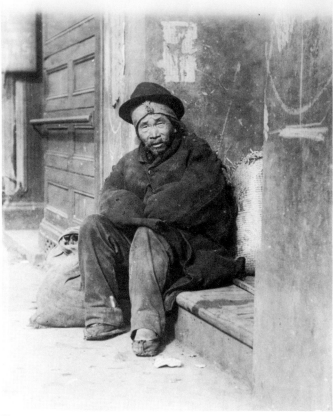

51

52

PLATE 51. "The Pipe-Bowl Mender." The man is wearing wire-rim spectacles. His tools are placed on a sack to the left. Peddlers would generally claim a doorstep or curbside corner as their spot and open up shop. Older workers who didn't have the strength to perform hard labor any more often worked as peddlers. **PLATE 52.** "The Paper Gatherer." The Wenhuashe, or "Society of the Splendors of Literature," hired this man to collect any refuse paper with writing on it. It was considered a crime for any paper with writing on it to be tossed away. This attitude reflected a deep cultural respect for literature and learning. The paper gatherer picked up scraps from the streets and sidewalks, and stopped at deposit boxes located throughout Chinatown. He would bring the paper to special incinerators, and the ashes would be sent on boats to be tossed into the ocean outside the Golden Gate Bridge. The practice ended shortly after the earthquake. **PLATE 53.** Ross Alley from Jackson Street, ca. 1898. The wooden box affixed to the wall on the left was for disposing of paper scraps. Genthe inaccurately entitled this photograph "Reading the Tong Proclamation." According to many guide pamphlets and books written during this time, these notices proclaimed who would be the next victims of tong "hatchet men." In actuality, they reported a variety of community news. **PLATE 54.** This underexposed photograph catches two men reading handwritten wall notices. One flyer advertises, in Chinese, a Western doctor. Wall posters were an effective and totally public form of communication. As a result of the proliferation of printed media, however, the practice of using these wall notices tapered off by 1915.

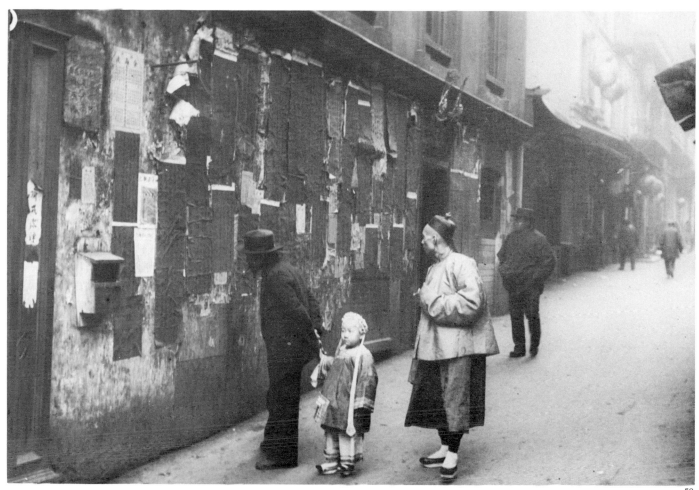

53

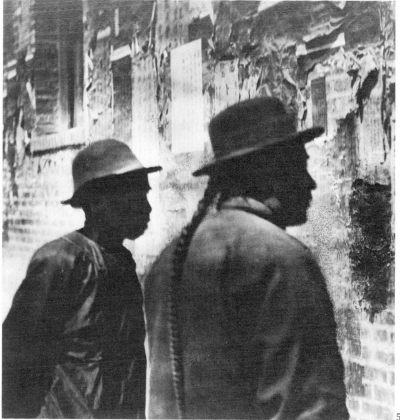

54

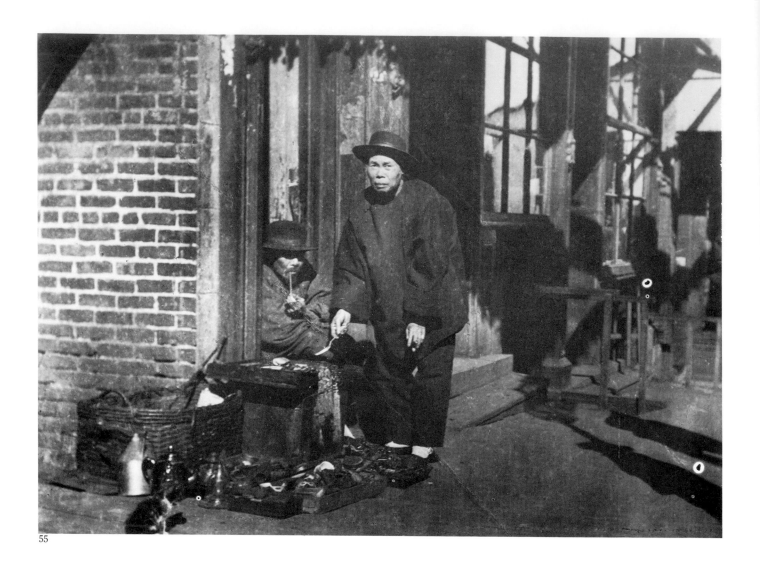

55

PLATE 55. "The Tinkers" and kitten. The man standing is holding a fork and bending over a display of used teapots, a wire birdcage, cloth tassels, and various odds and ends. The man with a mustache is wrapped snugly in a blanket and smoking on a tobacco pipe. Most itinerant peddlers were retired laborers. **PLATE 56.** "The Wild Cat." The cat is flanked by freshly killed fowl. Wildcat meat was a key ingredient in various home remedies. The meat, which was pickled in wine jars with various kinds of ingredients, was said to build courage. Tong fighters would often drink this "wine" before doing battle. A mix of wildcat, chicken, and snake was said to be an excellent aphrodisiac. Because of these prized attributes of the wildcat, the selling of its meat was quite lucrative. Wing Chew*, the son of the original owner of the Tin Fook jewelry store, used to disappear into the mountains for a few days and bag a wildcat for sale in Chinatown. One of the men in the background is an itinerant fortune-teller. **PLATE 57.** "The Fortune Teller." Street fortune-tellers sitting at their collapsible wooden tables were a fairly common sight in Chinatown. Gamblers would often consult these men. The sign announces to passersby, "Divine your life." Many tourists frequented these fortune-tellers, and postcards often featured them. They shook cylindrical boxes until one of the sticks marked with divinatory signs spilled out.

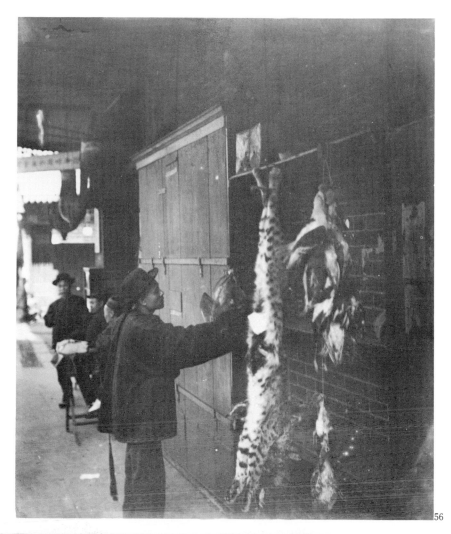

56

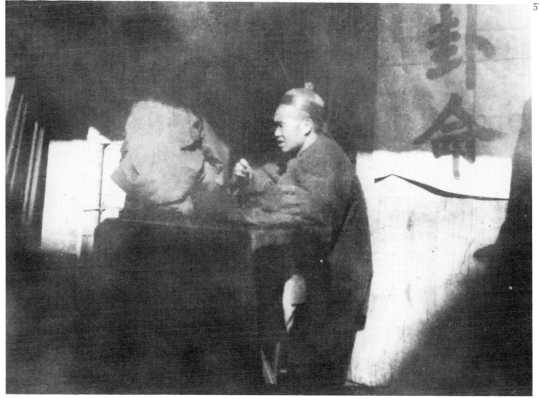

57

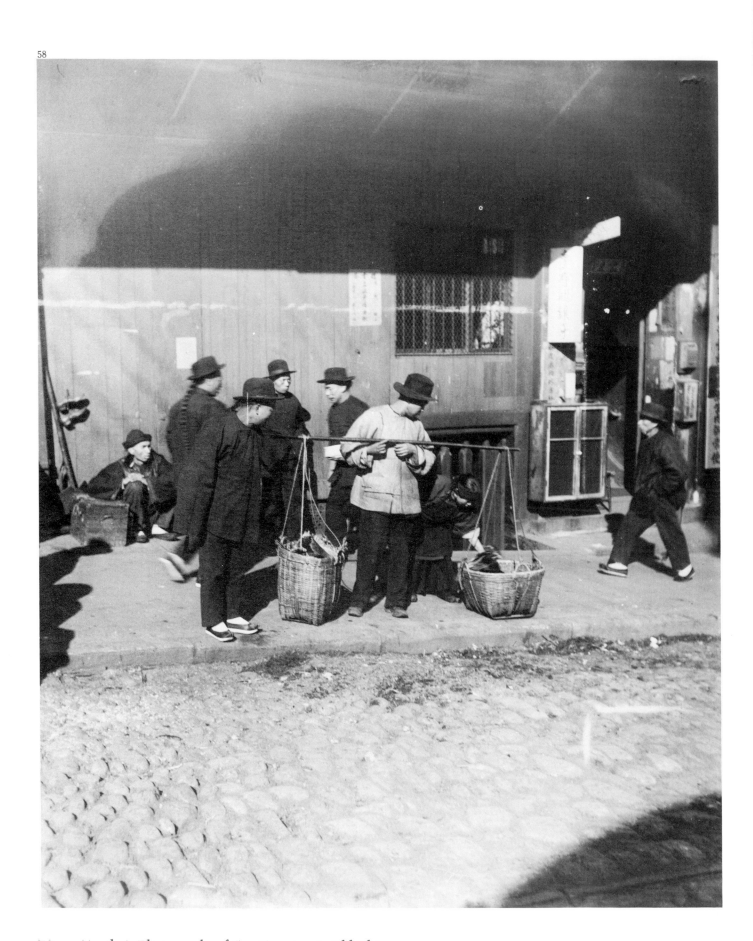

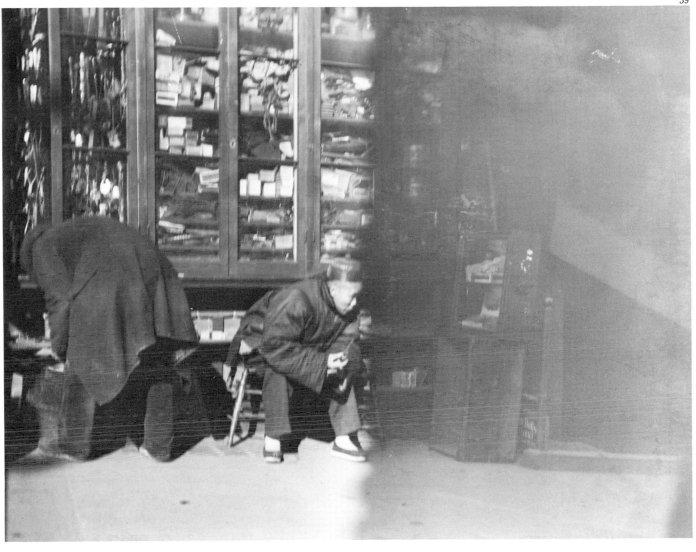

PLATE 58. Peddlers, 754 Washington Street, below Dupont. At the center of the photograph is a man selling chickens. It was customary to break the chickens' wings so they could not flap out of the wicker baskets. The peddler sitting on the left is probably a cobbler, as advertised by the pair of leather shoes hanging from his pole. (Genthe mistakenly entitled this photograph "The Vegetable Peddler.") **PLATE 59.** Street stand. Enclosed in the locked glass cabinets is an array of hardware and household items. After business hours, vertical planks would be fitted across the cabinets and locked in place with an iron bar. While this stand could hardly rival merchants' stores, operating this type of elaborate outdoor stand was a step up from being one of the poorer street-corner peddlers.

PLATE 60. Jewish balloon man on Dupont Street. Not all Chinatown peddlers were Chinese. This man was a figure popular with children throughout the area. His helium-filled balloons had animals stenciled on them. Several white novelty peddlers on Dupont Street sold to tourists visiting Chinatown and the Barbary Coast. In contrast to the often antagonistic relations between the Chinese and the Irish and Italians, little conflict occurred between Jews and Chinese. Reportedly, two German-Jewish brothers, known as the "Sa Ling Brothers," ran a store on Dupont Street and even spoke fluent Cantonese.

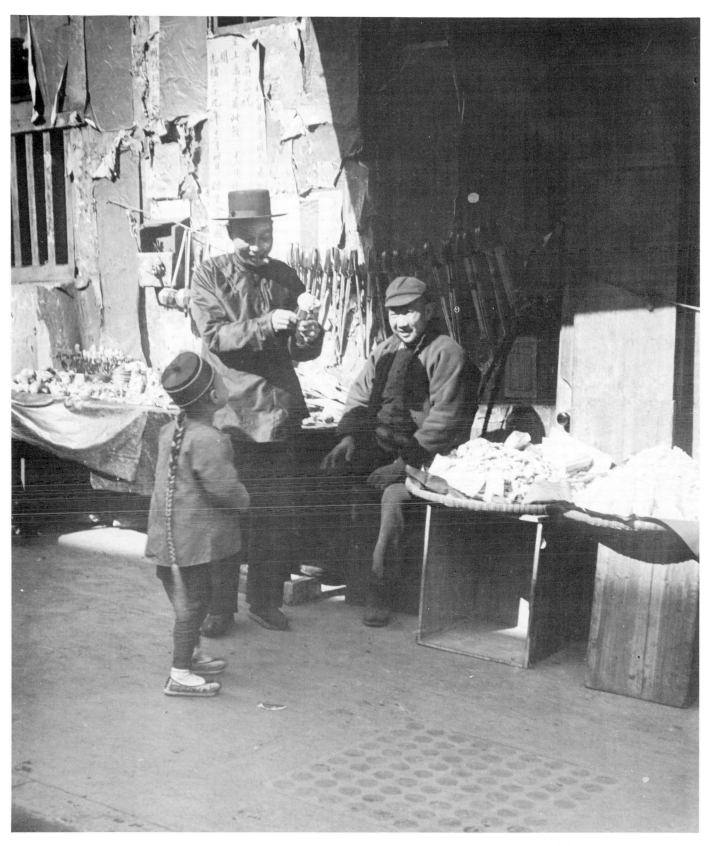

PLATE 61. Washington Street off Dupont, 1904. This photograph and the next two show the stand also seen in Plate 35. As evidenced by the posters, all were taken around the same time. Displayed are peanuts in the shell, dried lychees, and numerous toys. The man with the cigar in this plate is demonstrating a noise making papier-mâché animal figure. (Genthe's title: "The New Toy.")

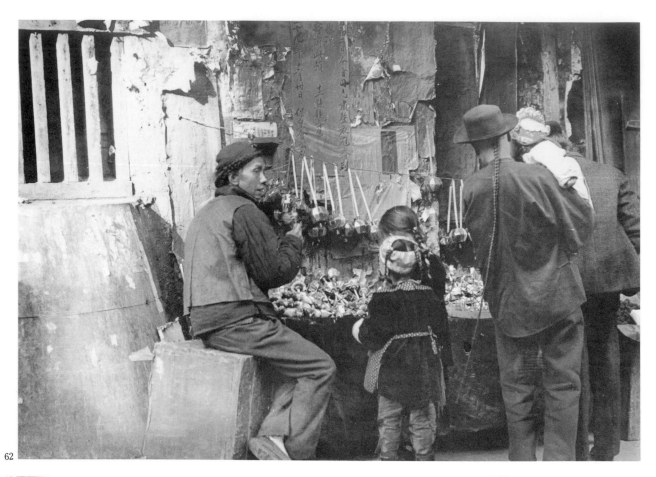

62

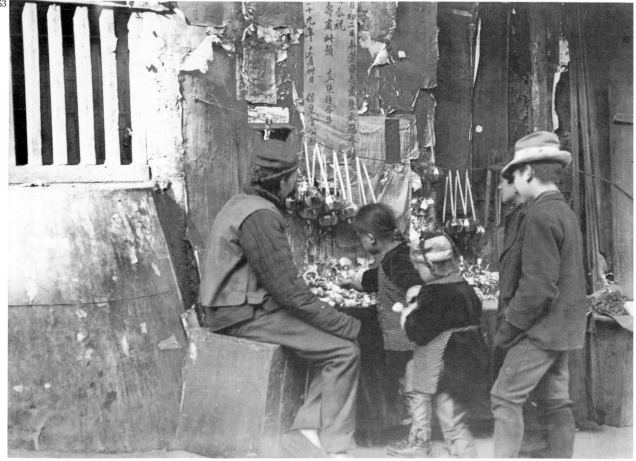

63

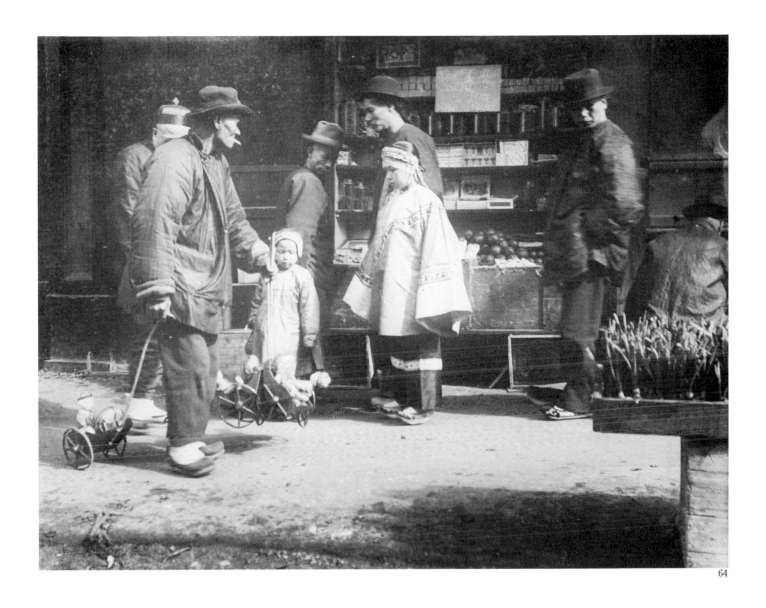

64

PLATE 62. Toy merchants. Sheathed swords and maces hang from the string against the wall. These objects were facsimiles of those weapons as seen in Chinese operas performed at local theaters. PLATE 63. Toy merchants. This stand catered not only to Chinese youngsters and adults, but to non-Chinese as well. PLATE 64. "The Toy Peddler" (unretouched version). The elderly man in front is selling Chinese dolls sitting in rickshaw carts. In an effort to make the background concession stand appear more exotic and foreign, Genthe etched out the English words "Chinese/Candies/5 Cts./Per Bag" and published this photo in *Old Chinatown* with Chinese words written in. Cigars, dried lychees, Chinese apples, and various jarred candies are displayed. To the immediate right is the edge of a curbside stand selling Chinese narcissus.

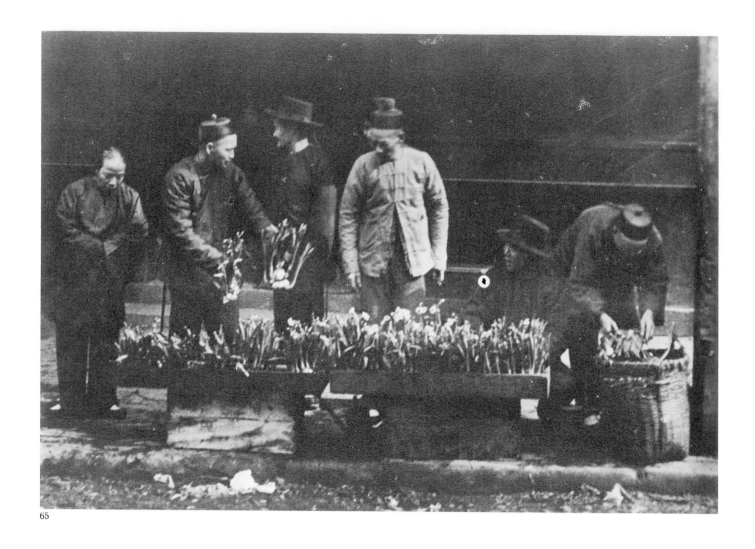

65

PLATE 65. Selling New Year's narcissus or *shuixianhua* (*seui sin faa*), Washington Street, west of Dupont Street. This man may be Zeng Juchuan, who had quite a local reputation for his accomplished skill in growing this delicate plant, a popular traditional centerpiece for New Year's celebrations. Genthe inaccurately entitled this photo "The Lily Vendor." **PLATE 66.** "On Dupont Street." The white narcissus with their yellow centers would be placed in clay pots, without soil but on a bed of pebbles. Each green stalk would have a red paper ring attached to it. **PLATE 67.** "The Cellar Door." The two children are playing, in everyday dress, in front of a typical basement restaurant that workers and unemployed would frequent. The words that are visible advertise beef porridge, fish, and wonton. Whereas tourists and merchants ate at fancier restaurants with more ornate interior decor, the great majority of Tangrenbu residents ate at these inexpensive, simple establishments.

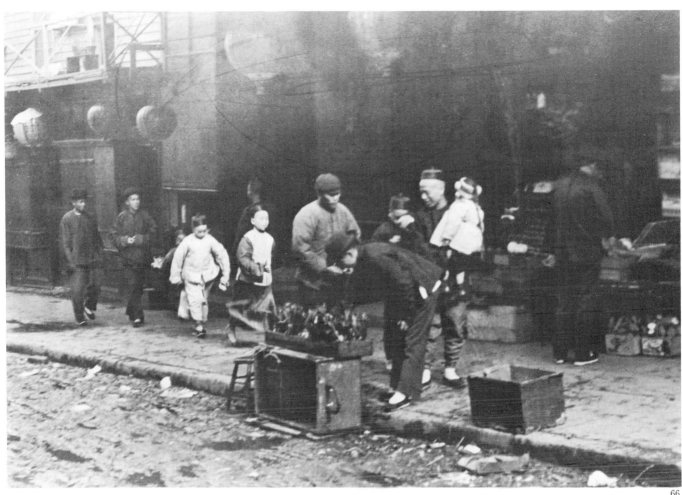

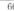

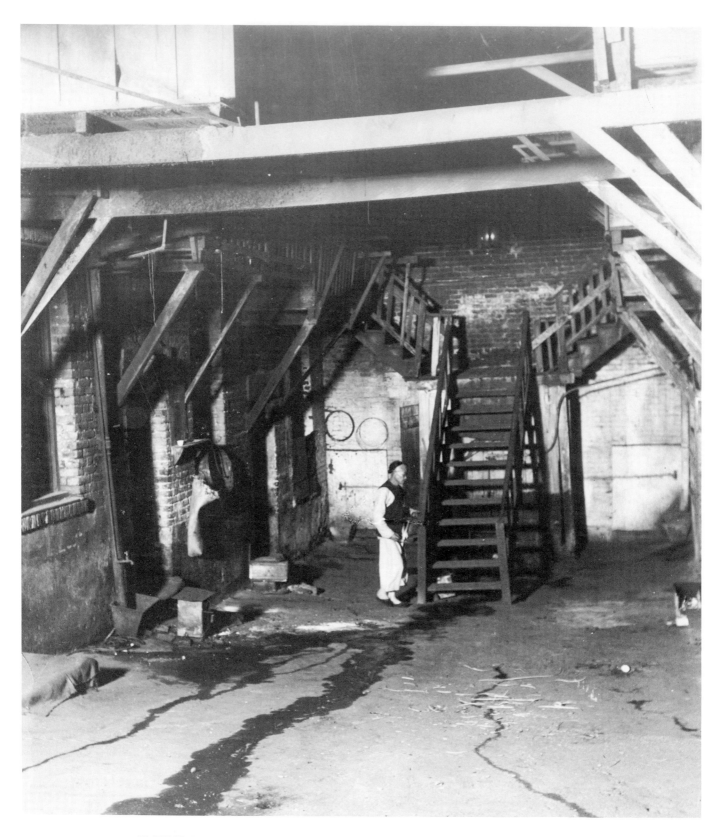

PLATE 68. Datianjing, or "Big Courtyard," behind 618 and 620 Jackson Street, across from Cooper Alley, was surrounded by three crowded tenement buildings and the rear of several Jackson Street stores. Hundreds of elderly and unemployed men lived in this quarter. The courtyard itself served as a common space equipped with a public kitchen housed in a wooden shed. These men were among the poorest residents of Chinatown. In order to survive they banded together, sharing what they had, living and eating cooperatively. Several such tenement/courtyard configurations existed in Chinatown. Tourist guidebooks would often mention this spot and jokingly called it the Chinese "Palace Hotel." Genthe called this picture "The Devil's Kitchen (by night)." A Chinese movie theater presently occupies the (allegedly haunted) space.

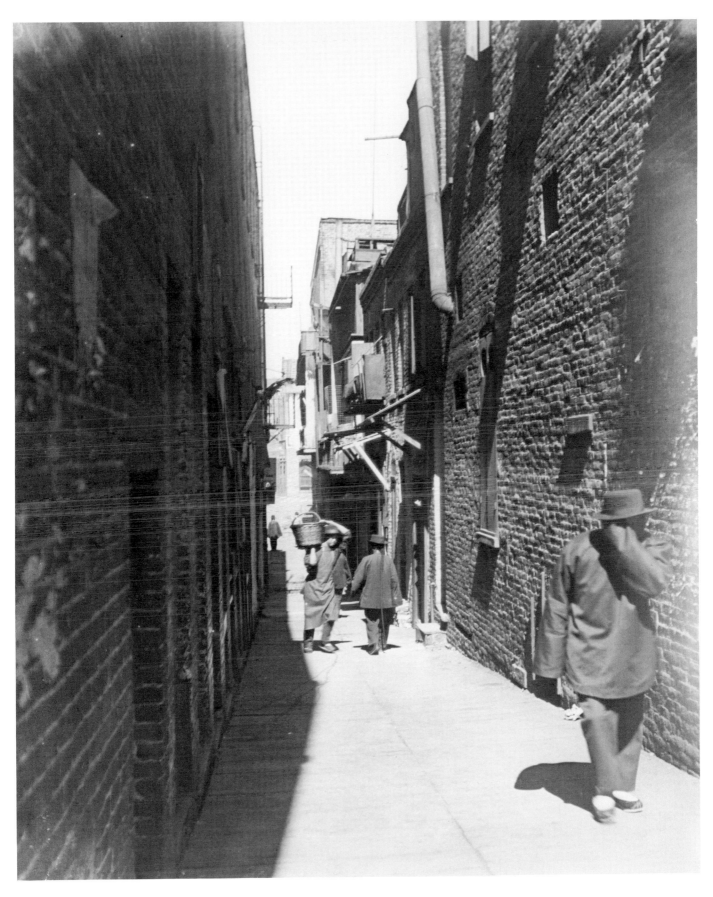

PLATE 69. St. Louis Alley, looking toward Jackson Street. Many migrant workers lodged here during the off seasons. The man in the foreground is shielding his face from the camera, obviously uncomfortable with a stranger taking his picture. (Genthe's title: "No Likee.")

4 THE RISING SPIRIT

In a May 1869 *Harper's Weekly* centerfold, the completion of the transcontinental railroad is commemorated with a telling graphic entitled, "The Great Link Connecting Europe and Asia across the American Continent." Framing the illustration of a railroad train are individuals representing all the world's peoples, shown in a pilgrimage to Columbia, the Greek-goddess-like symbol of the United States, after which the now-better-known Statue of Liberty was apparently modeled.[1] The message conveyed by this graphic was intended to be both symbolic and very real. Columbia was seen by the architects of American expansionism as the symbol of purity, justice, and civilization. The United States, with its developing industries, was seen as the shining beacon for the nations of the world. The completion of the transcontinental railway link culminated the almost century-long dream of the nation's founding fathers, as well as the hopes of earlier European traders, to find a quick, inexpensive route for trade with China and Asia. In fact, the annexation of the Pacific Northwest and California was originally thought of as providing America with "windows to the Orient."[2] The railroad made it possible to avoid the long and costly journey down and around Cape Horn at the tip of South America. The actual realization of this link of American trade with Europe and Asia was critical for the continuation of profitable American industrial development. Late-nineteenth-century America was reeling from a series of economic downturns causing serious unemployment and general social unrest. Samuel Gompers, the anti-Chinese president of the American Federation of Labor, characterized the system as being driven by a single anti-social obsession: "production, production, production, faster, greater, the impulse, the thought and the motive of the capitalist class."[3] American "manifest destiny" expansionists such as Josiah Strong saw the solution to these domestic conflicts in the exporting of the problem abroad. In 1885 he stated: "Overproduction compels a quest for 'ultimate supremacy' in the 'markets of the world.' . . . The United States is to be 'the mighty workshop of the world,' and our people 'the hands of mankind.' "[4] China represented a vast new market to sell factory-produced goods, such as cotton; surplus grains, such as wheat; and processed raw materials, such as oil. In return, Chinese goods could be brought back and sold to curious and increasingly acquisitive American consumers. San Francisco thus became one of the nation's largest ports, second only to New York City.

For Chinese in the American West, the completion of the railroad foreshadowed not a coming prosperity but the beginning of greater unemployment and racial antagonism, plus a direct assault upon their long-held cultural values and customs. Although the railroad served primarily as a trade link with the East, it also brought hundreds of thousands of recent European immigrants, who agitated against and displaced Chinese workers. The prime role of Chinese in America shifted, in the decades following the 1882 Exclusion Act, from providing an exploitable labor force to develop the Western economy, to serving as potential Christian converts and consumers of American-made goods. Pro-Chinese San Franciscans, led by such missionaries as the Reverend Otis Gibson, and later Donaldina Cameron, maintained that Chinese could and would be assimilated into what they considered the more enlightened American Christian way of life; whereas anti-Chinese forces argued that "heathen Chinese" were altogether racially inferior and could not be assimilated into what they were incapable of comprehending. For white American organized labor, which came to spearhead the anti-Chinese forces in the 1890s and early 1900s, the barring of Chinese and other Asian workers was vital to their strategy of gaining greater concessions from San Francisco-based capitalists. The pro-Chinese forces, however, had one eye on the Chinese in the United States and the other eye on China. The missionaries envisioned China as a nation of Christian converts, and those based in San Francisco sought to convert and train Chinese ministers in America with the motive of eventually sending them to China. American businessmen and government officials were also interested in how willingly and quickly Chinese in America adapted to American customs and habits, thereby integrating into American society. They were not only concerned about the ill-treatment of Chinese in America jeopardizing United States "open door" trade relations with the Chinese government, but they also looked upon Chinese in this country as representative buyers. Therefore, as good businessmen the more they knew about and associated with Chinese, the more they could assess what would and would not

sell. They could also develop Tangrenbu merchants as representatives of American businesses in China. From the pro-Chinese trade and missionary perspective, the key to China lay in the successful conversion of Chinese Chinese into American-oriented Chinese. And Tangrenbu was a perfect testing ground.

The response within Tangrenbu to outside pressures to be assimilated into American culture was predictably mixed. Merchants had families, thereby maintaining the possibility of carrying on the family-centered traditions of their homeland. The wealthier merchants kept a semblance of the traditional upper-class culture in their furniture, dress, and life-style. Their wives generally followed traditional roles that restricted them to the house and the raising of children. The children in turn were exposed to the Chinese language and customs, which provided for some continuity with the homeland culture. Some Chinese-American youths were even shipped back to China for schooling. Chinese merchants had the economic resources and the family base to choose selectively how much of the traditional culture they wanted to maintain or forget. Workers, however, had to be far more pragmatic in order to survive. If they had families back in their home villages, then their home base was still China. Their primary hope for maintaining ties with the traditional culture was somehow to bring over actual sons or extended-family "cousins," who brought the local culture with them, thus renewing contact with and memories of China. Merchants were willing to assume, for a fee, fatherhood of "paper sons." Secret societies, known in America as tongs, also circumvented federal immigration laws by smuggling Chinese across the Mexican and Canadian borders and from the Caribbean into the United States.

This lopsided bachelor society, despite continued efforts to overcome discriminatory regulations, could not realistically carry on traditional family relations and proved especially vulnerable to alternative forms of cultural identification which could help improve their situation in America. Disenchanted workers and unemployed began to form their own social, economic, and political counterculture within the cracks of the merchant hegemony. The tongs came to confront directly the Sanyi merchant domination of the community. And, totally unlike their tong brethren, a small but increasingly significant minority of Chinese embraced Christianity and Western culture as the road to their salvation.

While merchants controlled the commercial and established realm of social organizations in Tangrenbu, a growing underground network of tongs spoke to the passions and anger of primarily Siyi workers. In sharp contrast to clan and district associations, tongs enrolled members according to interests and needs. After working 16 to 20 hours a day, six days a week, workers would eagerly flock to Tangrenbu to find solace, escape, and relaxation. Deprived of traditional outlets and comforts, many of these men would gamble heavily, visit their favorite prostitute, catch part of the latest Chinese opera, or maybe smoke some opium. Merchants had little to do with this subculture, which they considered corrupt and contemptible. In the 1860s and 1870s, the Six Companies regularly collaborated with United States Customs officials to attempt to send back Chinese prostitutes, though without success.[5]

The tongs came to control the leisure-time operations within Chinatown, forming a separate economic base within the community. This substructure supported a network of the community's discontented, ranging from professional gamblers to tong gunmen to political radicals. The tongs were the main organized arena in which workers expressed their anger and frustration. Tongs attracted rebels. Elmer Wok Wai*, repulsed by his father's cold-hearted sale of his younger brother and older sister for personal profit, ran away from home and the garment factory his father owned to work in a tong-dominated gambling house. Disgraced by Wai's new job, his father disowned him. Wai eventually got involved in tong rivalries and was put up by the Hop Sing* tong to kill a Sun Ying* gunman.[6] Injustices not dealt with in the legitimate spheres of Tangrenbu were dealt with in this alternative space. Tong wars, wildly sensationalized by the San Francisco press, were often the most militant expression of lashing out at the established Tangrenbu social order and attempts at rectifying deeply felt social injustices. Many intertong skirmishes were over control of gambling, narcotics, and prostitution. Class conflict, however, came frequently to the foreground between the mercantile interests of the affluent Sanyi district merchants and of the Siyi small businessmen and tongs. Siyi resentment of and anger at the Sanyi domination of Tangrenbu had been percolating since the community's origins. In 1894 Sanyi people refused to defend a Siyi man arrested for murder and all hell broke loose. Siyi boycotted Sanyi stores in retaliation and even formed a rival merchants' guild. Fung Ching*, a powerful Sanyi boss, known to the San Francisco public as "Little Pete," ordered the unleashing of a reign of terror against the Siyi. He was credited with having arranged 50 Siyi killings. Twelve Siyi tongs merged to wage all-out battle with the Sanyi and were finally able to assassinate Fung Ching in 1897. The boycott was eventually broken two years later when Li Hung Chang, foreign minister of the Chinese government, intervened by arresting homeland relatives of Siyi people in America, threatening the lives of these relatives if the killing continued. Although the boycott ended, it signaled the end of absolute Sanyi dominance of the community.

To the American public, the tongs personified their fears of the "yellow peril." Tong gunmen were characterized as the devil incarnate. Anti-Chinese forces, extrapolating from these perceptions, claimed that the Chinese were as a race totally unassimilable to white Christian morality. A Mr. Duffield, a San Francisco police officer, expressed this stereotypical notion when asked by an 1878 state-senate committee: "How is this population [Chinese] as to criminal propensities?" He responded: "They are a nation of thieves. I have never seen one that would not steal."[7] Counterposed to these extremely negative images were the "good Chinamen," who included the wealthy, aristocratic merchants and a small group of Chinese Christian converts often satirically referred to as "rice bowl Christians."

Although precise statistics are nonexistent, the great majority of Chinese who immigrated to the United States were not Christians. Ching Wah Lee has estimated that at least 50 percent of the early Chinese arrivals were Buddhists, and all practiced an eclectic mix of local-deity worship, ancestor worship, Taoism, and Buddhism. Religious practice was very much an individual concern and there was no public proselytizing.[8] Individuals paid respect to the local gods with whom they most wanted to

identify. Among the most popular were those figures endowed with great fighting strength, compassion, and loyalty, such as the defiant and mighty Guangung, the God of Literature and Valor (peace and war); Tianhou, the Goddess of Heaven, who protected fishermen, sailors, travelers, and prostitutes; and Beidi (Bak Ti), the God of the North, who vanquished 10,000 demons with his sword. Shrines were erected in commemoration of the historical heads of clans, who were respected for their great deeds. And both Buddhism and Taoism stressed the virtue of transcending the hardships of everyday material existence to attain a state of higher being and awareness. The temples that were erected wherever Chinese were to be found served as important spiritual institutions that maintained a semblance of continuity with their homeland. Christian missionaries, however, viewed these institutions as pure, unadulterated "heathen paganism," which had to be wiped out. The Reverend Otis Gibson, a dedicated Protestant missionary based in San Francisco, and for a time a fervent supporter of Chinese immigration to the United States, articulated the prevailing Christian attitude:

> The coming of so many idolaters to this Christian land has brought new and grave responsibilities upon the Christian Church. The heathen, for whose conversion to Christianity the Church has long been praying—the heathen to whom the Church has occasionally sent a representative, a messenger, a missionary of the blessed Gospel—one hundred and fifty thousand of those very heathen, God has now, by his most wonderful providence, brought to these Christian shores, to these United States of America. . . . While the principal attention of the Church has been directed to the far-away "pagodas and zenanas and decaying heathenism of India," and she has been sending her sons and daughters in force to preach the Gospel to the waiting Hindoos—subjects of a Christian government—God himself, in spite of the counsel of men, has been bringing Chinese heathen in tens and scores of thousands, and planting them upon this Christian soil. And these heathen, without let or hindrance, have here erected their temples and altars of idolatry, and have instituted in the heart of all the towns and cities of the Pacific Coast the worship of gods made with men's hands.[9]

Protestant missions established the only English-language learning programs in Tangrenbu. They also ran shelters for Chinese women and organized social activities, in addition to conducting regular Sunday services. Often contacts with white Christian families at these events would gain Chinese workers house-servant jobs. The truly committed and devout converts were encouraged to proselytize among "unseeing" Chinese. This self-righteous and aggressive denominational pressure alienated many members of the community, who were offended and angered by this assault on their culture and sensibilities. The missionaries were nevertheless successful in attracting individuals within the community who were totally disaffected from the main community

organizations and were particularly interested in learning American ways. These Chinese took the radical step of cutting off their queues and donning Western dress, an action that drew derisive comments from their fellow Chinese, insulting these individuals as "little Japs" or *fangui*, meaning foreign devils.[10]

For the small native-born population of Chinese-Americans the missions provided an entry into American society and culture. In 1895, the predominantly Christian organization, Native Sons of the Golden State, was formed to fight for the civil and political rights of Chinese-Americans. Ng Poon Chew graduated from the San Francisco Theological Seminary in 1892, and became pastor of the Chinese Presbyterian Church. Bolstered by monies from the Church, he was able to found the influential Chinese-language daily *Chung Sai Yat Po**. Protestant churches offered an alternative power base to those of the established merchants and underground tongs. Church money enabled converted Chinese to wield an institutional influence on Tangrenbu disproportionate to their small numbers. Chinese Christians often advocated a wholesale rejection of traditional customs and looked to the West for political guidance. They proved especially receptive to the call for revolution in China led by Dr. Sun Yat-sen*, who as a young boy in Hong Kong had been baptized by American missionaries. Sun advocated the ending of thousands of years of imperial rule and the establishing of a republic. Ng and other Chinese Christians soon filled the ranks of the moderate wing of Sun's revolutionary party, the Tongmenghui.

Ironically the totally dissimilar Tangrenbu subcultures of the Christians and the rebellious tongs found common ground in their mutual antagonism to the established social order in Tangrenbu and China. Together they created a new, rising spirit within Tangrenbu, a spirit that would profoundly change the character of the community in the coming years.

Notes

[1]*Harper's Weekly*, New York, May 29, 1869, pp. 344–45.

[2]Thomas McCormick, *China Market*, Chicago, 1967, p. 18.

[3]*Ibid.*, p. 22.

[4]*Ibid.*, p. 21.

[5]Reverend Otis Gibson, *The Chinese in America*, Cincinnati, 1877, pp. 143–47.

[6]Veta Griggs, *Chinaman's Chance: The Life Story of Elmer Wok Wai*, New York, 1969, pp. 61–80. The reference to a "Sun Ying" tong in this book does not sufficiently identify an actual tong operating during this time period.

[7]California State Senate, *Chinese Immigration, Its Social, Moral and Political Effect*, Sacramento, 1878, pp. 32–33.

[8]Ching Wah Lee, in a private interview in San Francisco, California, October 1979.

[9]Gibson, *op. cit.*, pp. 158–59. Gibson later abandoned his "pro-Chinese" immigration stance to join anti-Chinese forces.

[10]Pardee Lowe, *Father and Glorious Descendant*, New York, 1943, p. 13.

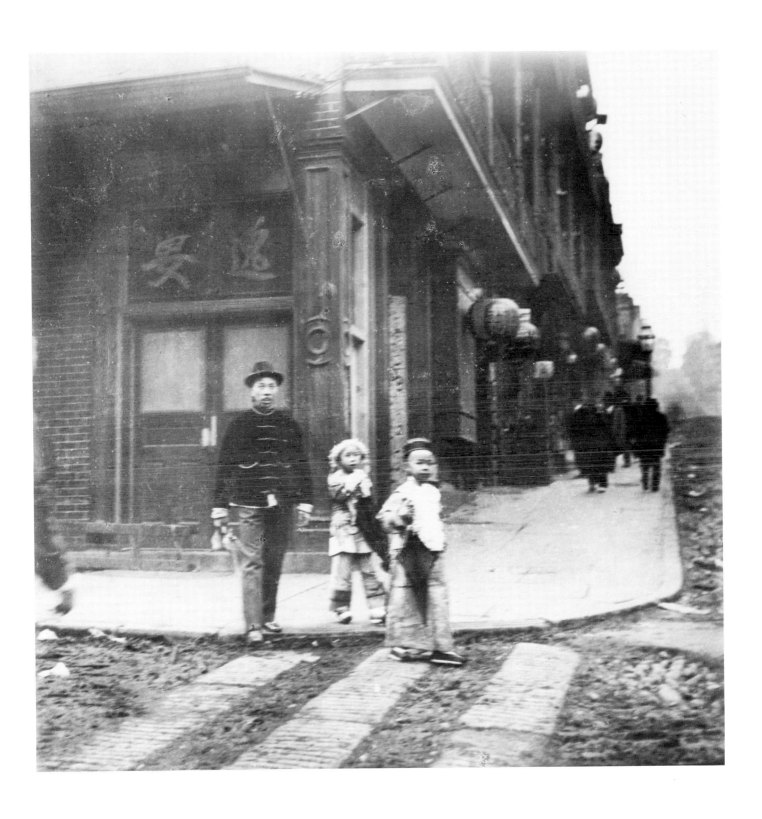

PLATE 70. Gambling hall, Jackson Street corner. The father, dressed in a fancy suede jacket, and his two children, in holiday dress and carrying Western umbrellas, are passing in front of the Anyi gambling house. Anyi translates literally as "Indolence." This crude but direct name attracted professional gamblers and men who wanted to escape from their long hours of labor and troubles.

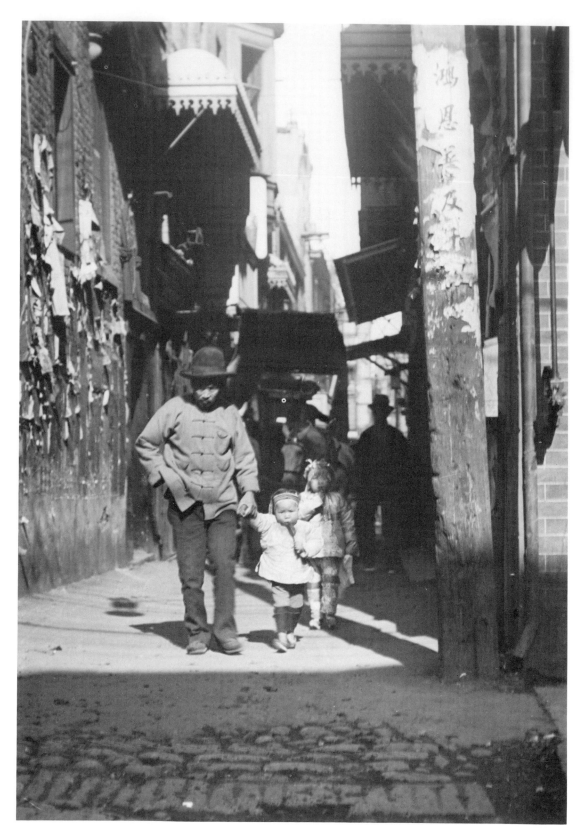

PLATE 71. Ross Alley from Washington Street. (Genthe's title: "The Alley.") An underground culture flourished along the narrow alleys and in the back rooms of Tangrenbu. While the merchants controlled the major avenues of commerce and transportation, the tongs controlled the alleys. Ross Alley was lined with establishments for playing popular gambling games, such as *pi gow* * (*baigepiao*)—lottery tickets, or "the white pigeon ticket," much like the American game of keno—*fantan*, in which bets were waged on how many of a pile of beads would be left when reduced by fours; and *caifa*, a riddle guessing game. Brothels, housing Chinese prostitutes, lined Bartlett's Alley and Sullivan's Alley. Opium "resorts" were concentrated on Duncombe Alley. For many outsiders this underground culture had an air of the sinister about it. For the Chinese it was simply an everyday fact of life, bound up with the survival of the community.

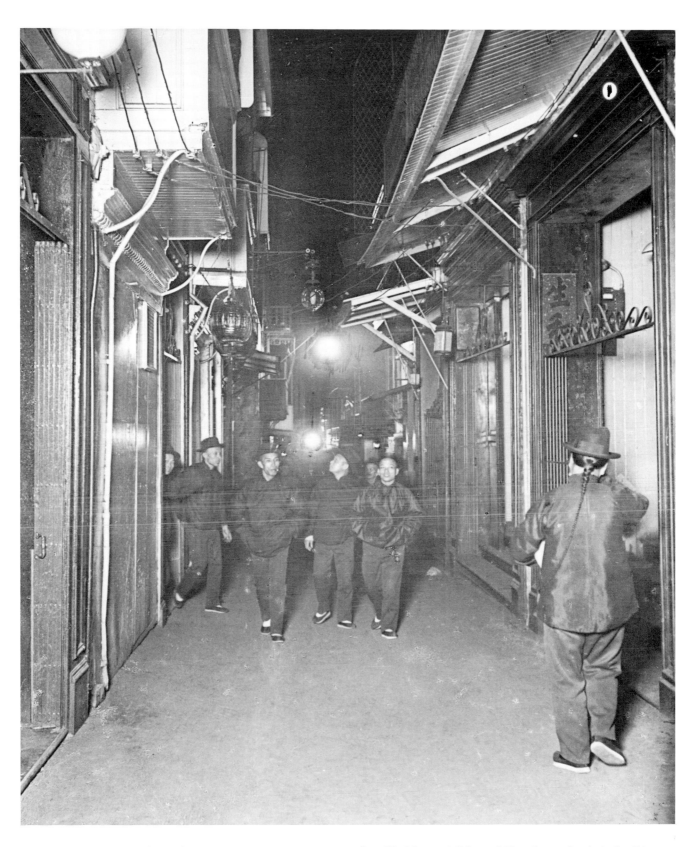

PLATE 72. Ross Alley (at night). Genthe tried to capture scenes of Chinatown's active nightlife with shots like this of Ross Alley. Here he was able to photograph men who were obviously in a relaxed, happy mood. In *As I Remember*, Genthe writes about Ross Alley's "rows of sliding solid iron doors to be clanked swiftly shut at the approach of the police" (p. 33). Genthe's title for this photo was "The Street of the Gamblers (by night)."

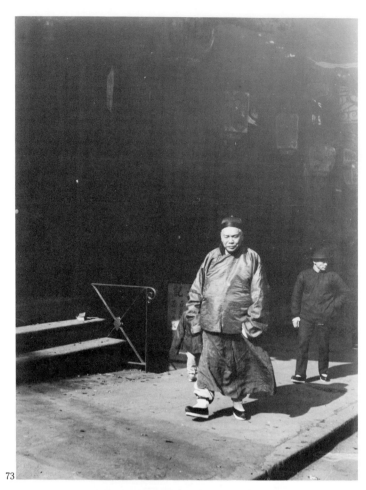

PLATE 73. "Merchant and Bodyguard." The powerfully built man dressed in traditional silk robes has been described as a tong leader. Whether he was a tong leader, a wealthy merchant, or both, his dress and carriage convey a strong presence. Tong leaders came to rival the power of wealthy merchants. The man following the merchant or tong leader is said to have been his bodyguard, protecting him from the attack of a rival tong. In this photograph the two men are passing under ornate cloth lanterns that indicate a pawnshop business. **PLATE 74.** Opium addict. (Genthe's title was "The Opium Fiend.") The man's queue is wrapped around his hat. His clothing is ragged and unkempt. Although it is difficult to determine how many opium addicts actually existed in Chinatown, they did not constitute a high percentage of the community's population. Chinese tended not to frequent American bars and more often indulged in a smoke of the pipe in much the same way as many Americans occasionally drank to relax. **PLATE 75.** "The Little Mandarin." While focusing on the father and child (only the child was pictured in *Old Chinatown*), Genthe inadvertently captured the sign for a basement opium room poetically named Hungfa, or "sudden rise of a mountain torrent." Opium dens were wildly sensationalized in the American press. They had their share of addicts, but the majority of users stopped by only occasionally to find temporary refuge and get a quick high. It is also important for perspective to keep in mind that in the nineteenth century it was common for many Western medicines and cure-alls to contain opium or an opium derivative. The importation of opium into Tangrenbu was controlled by the tongs.

73

74

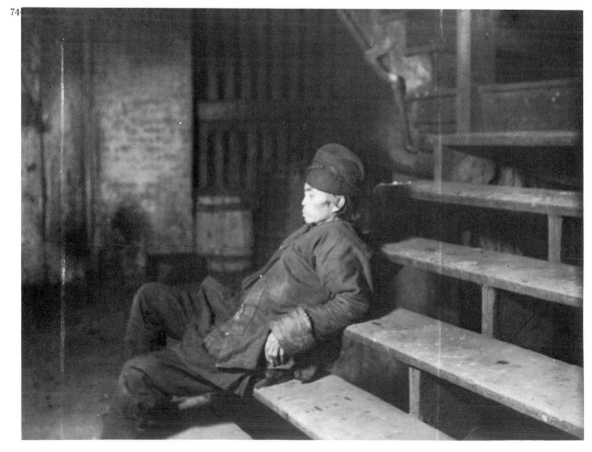

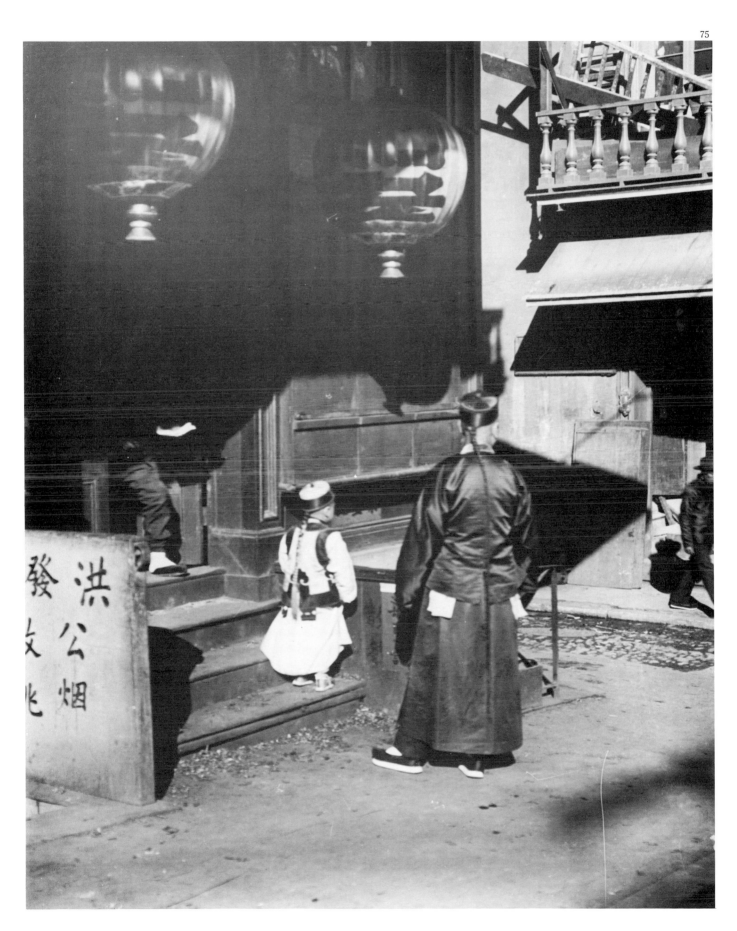

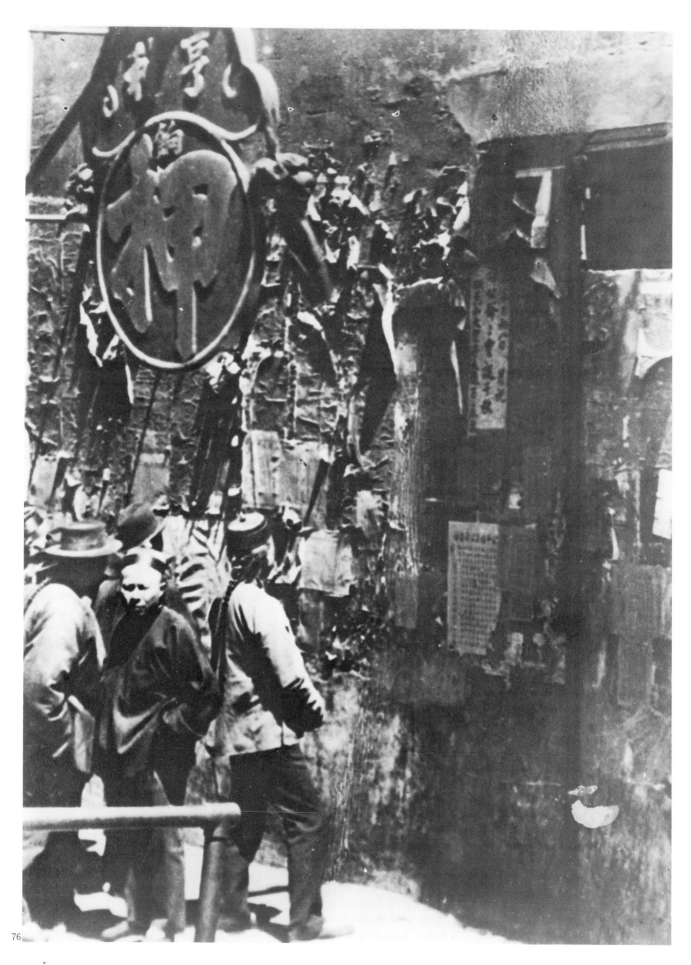

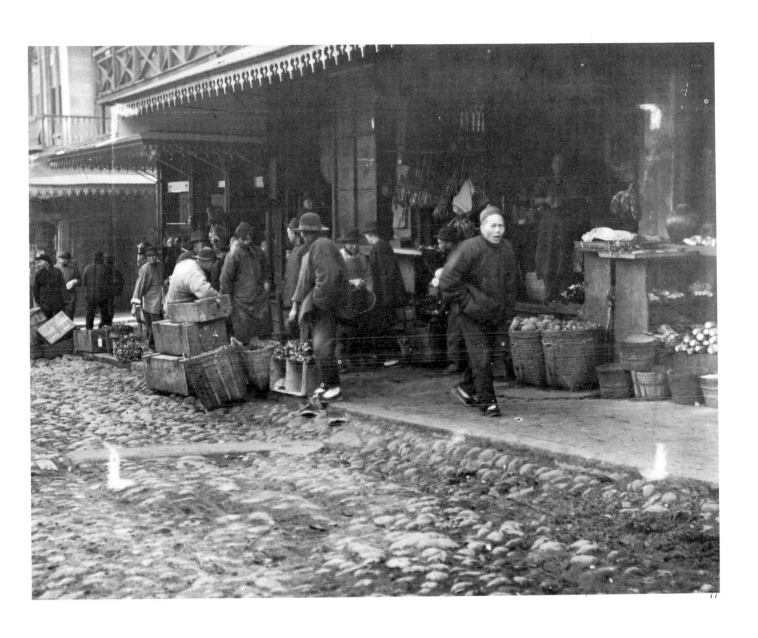

PLATE 76. "The Sign of the Pawn Shop." The Hong Lee* (Hengli; "Pervasive Profit") pawnshop, 830 Washington Street at Ross Alley. Amid the gambling rooms where savings were quickly lost, pawnshops thrived. Pawnshops had very high counters upon which the item to be pawned would be placed for inspection by an unseen shop worker, hidden behind the counter for security purposes. Often a man visiting his favorite prostitute or singsong girl would stop by the shop and pick up a present. Genthe developed his collection of jades by frequenting these stores.

PLATE 77. Kong Wo* (Gunghe) Pawnbroker, 639 Jackson Street, is the middle store with glass windows. "Fish Alley" is in the background. This shop is sandwiched between two grocery stores. Pawnbrokers were primarily located on Jackson and Washington Streets, near the major concentration of gambling rooms. (Genthe's title: "The Morning Market.")

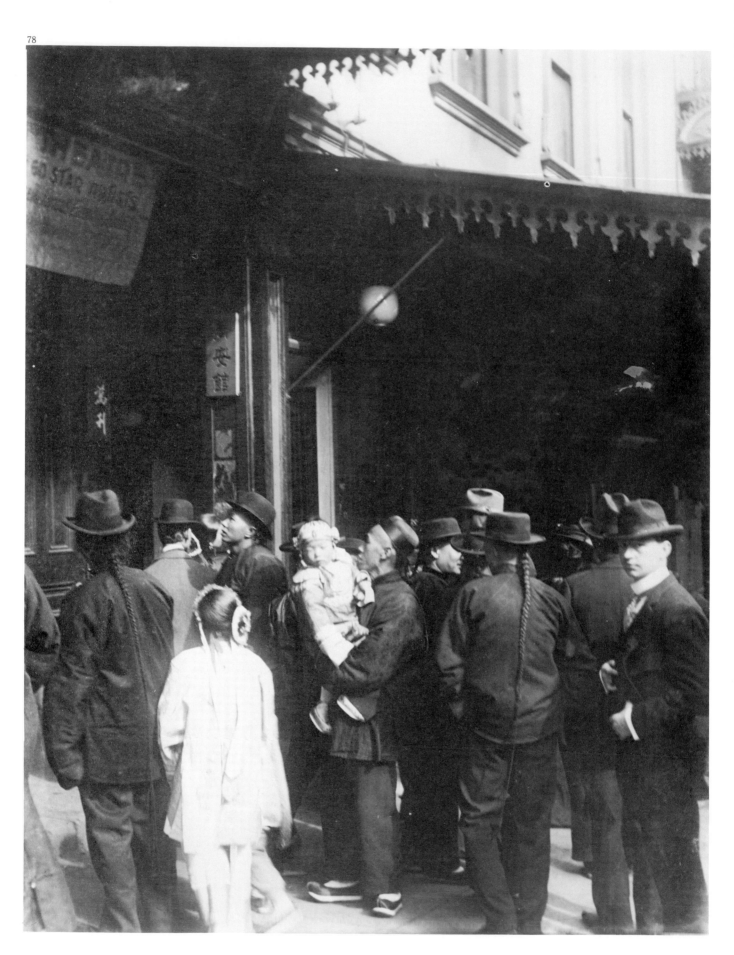

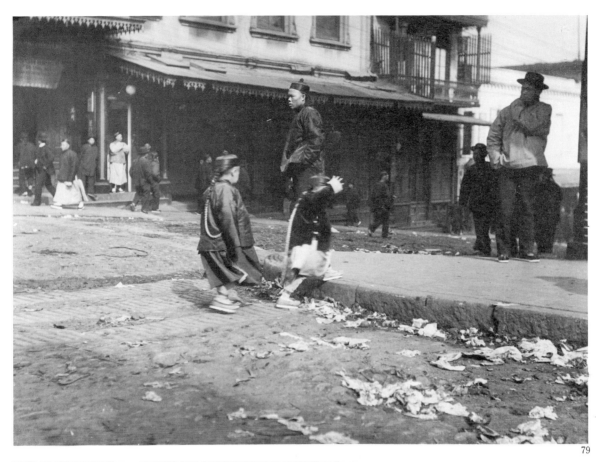

79

80

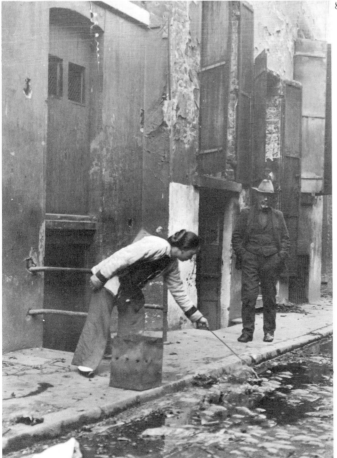

PLATE 78. "New Year's Day Before the Theatre," 814 Washington Street, at the Dangui, or "Red Cassia," Theatre, off Waverly Place. This was one of two active Chinese theaters, each of which seated several hundred people. Traditional Chinese operas would go on for several nights in a row. Choice box seats were reserved for merchants and their families, while most workers sat on plain wooden benches. **PLATE 79.** Across the street from the Dangui Theatre. The theater was a very important social and cultural institution in Chinatown. Some theater owners paid regally for well-known actors from China to perform on their stages. As early as 1852, a troupe of jugglers and acrobats played to a packed house at the American Theatre on Sansome Street. Outdoor Chinese puppet shows with live orchestras were even seen by passersby in some of the squares surrounding Tangrenbu. This photograph was entitled by Genthe, perhaps fancifully, "Fleeing from the Camera." **PLATE 80.** This woman is burning special prayer papers in the square incinerator can. This is a Buddhist ritual practiced twice a month, at half-moon and full moon. Genthe entitled this photograph "The Street of the Slave Girls." Although there was no street by that name in English or Chinese, the highest concentrations of Chinese prostitutes were on Bartlett Alley and Baker's (or Sullivan's) Alley. The woman shown in this photograph is wearing very plain work clothes, and it is difficult to say if she was a prostitute or housewife.

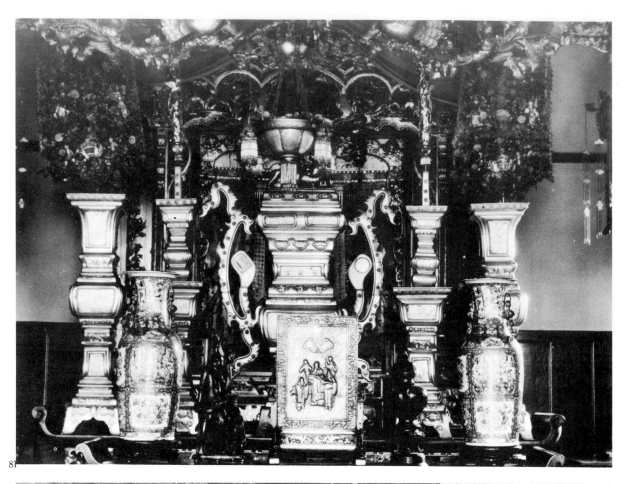

81

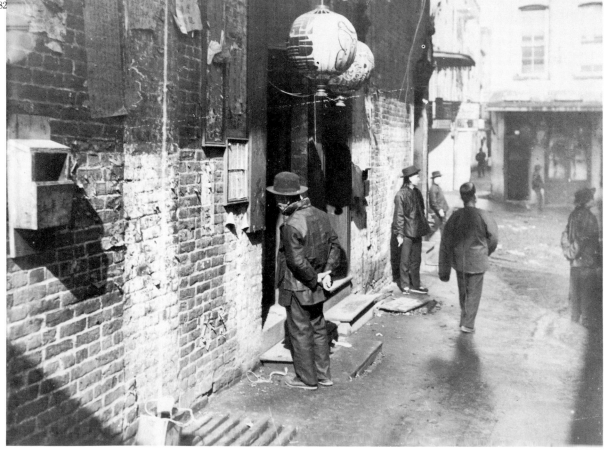

82

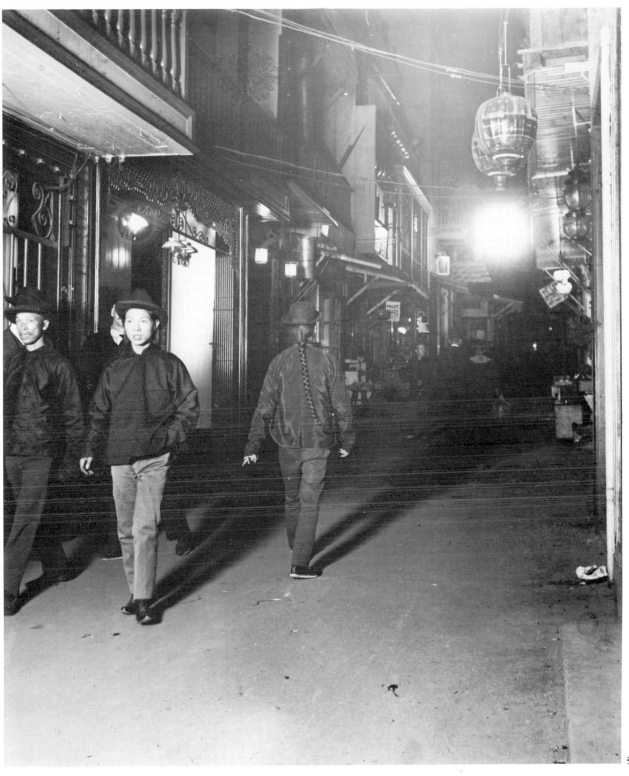

83

PLATE 81. Tianhou altar (see also Plate 12) at the entranceway to the main altar directly behind it. Placed upon the two ornate teakwood tables are assorted pewter vessels and carved wooden cult objects. Contrary to Western forms of worship, the Chinese attitude toward religion was not denominational. A person could worship Buddha and several patron deities, and at the same time cite Taoist parables. This attitude was carried to some degree into the Chinese acceptance of Christianity. **PLATE 82.** "Doorways in Dim Shadows." Guanyin Temple entrance, Spofford Alley (Spofford Street on the map) looking toward Washington Street and Church Alley (Church Court on the map). The temple of Guanyin, Buddhist goddess of mercy, was one of the less heavily endowed ones, as evidenced by its unadorned alleyway entrance. The box on the left was a collection box for refuse paper with writing on it (see Plate 52 for more details). **PLATE 83.** Old Longgang Temple lanterns, 4 Brooklyn Place, near Sacramento Street. This temple was sponsored by the four combined associations of people with the surnames Liu, Zhang, and Zhao. Clan temples featured tablets of ancestors and noted historical clan leaders. Could the second figure from the left actually be not a young man, but one of those storied rebellious women who would occasionally dress up as men to walk through the streets without drawing unwanted attention?

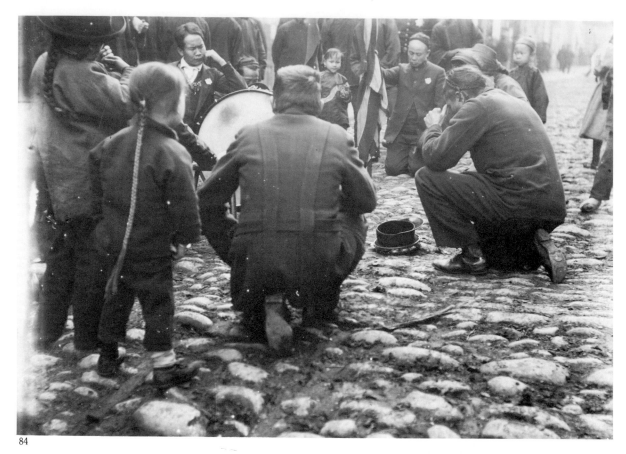

84

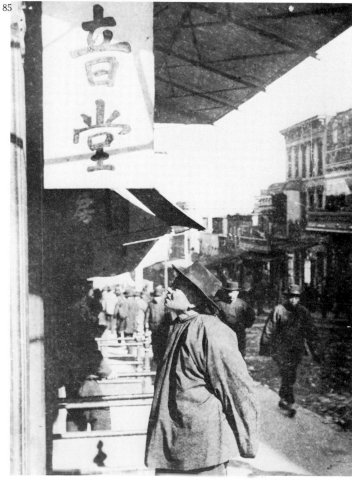

85

PLATE 84. "The Chinese Salvation Army." The Chinese chapter would march through the streets performing religious songs in Chinese and English. The man with his back shown and the man leaning on the bass drum have Western hairstyles, indicating a radical departure from the norm. All are wearing Western clothing. The bonneted woman to the right of the circle was probably a white salvationist officer, in charge of the small Chinatown chapter. The man at the bass drum is Fong Sec*, who graduated from the University of California at Berkeley. He returned to China in 1906, and the following year went to Beijing. There, in 1908, he became the chief English-language editor of the influential *Commercial Press*. After returning to the United States he worked as a cook for a white family, and that led to his joining the Salvation Army. Out of curiosity one day, he followed the Salvationist band back to their headquarters. He was hired as a cook by the chapter and eventually elevated to the position of secretary. **PLATE 85.** Fuyintang, the Gospel Christian Methodist Church, Jackson below Stockton. The churches in Chinatown offered the only formal English-language programs available in Chinatown. They were also places where social activities were regularly held, attracting those members of the community who were especially alienated and lonely. The sheer economic power of these Christian missions had a great impact upon Chinatown. (Genthe's title: "Passers-by.")

5 WOMEN AND CHILDREN

Within the depths of the Tangrenbu male society, there survived a small but important subculture of women and children. Although over two-thirds of Genthe's photographs of Chinatown included women and/or children, the reality was that the exclusion and antimiscegenation laws insured that only the select merchant class could legally have families in the United States. The great majority of laborers may have had families, but they were still in Guangdong, China. Separated from them by many thousands of miles, workers would faithfully save their hard-earned nickels, dimes, and dollars to send back to their loved ones. Occasionally after years of hard labor they would have saved up enough additional funds to make a visit back to their home village, perhaps have a child, and return to the United States. Some workers would never see their wives, children, and families again. A nineteenth-century southern Chinese folk song expresses the tremendous sadness and tragedy of these broken homes:

> Flowers shall be my headdress once again
> For my dear husband will soon return from a distant shore.
>
> Ten long years did I wait
> Trying hard to remember his face.
> As I toiled at my spinning wheel each lonely night.[1]

And another poem is still recited in the Guangdong countryside:

> If you have a daughter, don't marry her to a Gold Mountain guy.
> Out of ten years, he will not be in bed for one.
> The spider will spin webs on top of the bedposts,
> While dust fully covers one side of the bed.[2]

Just as male Chinese workers in the United States lived in isolated bachelor societies, a subculture of lonely wives emerged in mid-nineteenth-century southern China. Once married to a *jinshanke* (*gam saan hok*), or "traveler to the Golden Mountain," the "proper" woman was expected to fulfill her familial responsibilities and wait for her spouse to come home. Many heroic and bitter stories, woven into the fabric of Chinese folklore, recount such tribulations of women in old China.

In a rare autobiography of a Chinese working woman, as told to the American journalist and writer Ida Pruitt, Mrs. Ning* gives us some insight into the wretched roles

women were sometimes expected to sustain. In 1887, her husband, addicted to opium, did not return for days on end.

> Day after day I sat home. Hunger gnawed. What could I do? My mother was dead. My brother had gone away. When my husband brought home food I ate it and my children ate with me. A woman could not go out of the court. If a woman went out to service the neighbors all laughed. . . . I did not know enough even to beg. So I sat at home and starved. I was so hungry one day that I took a brick, pounded it to bits, and ate it. It made one feel better.[3]

While Mrs. Ning was from northern China, her plight illustrates the degree to which women throughout the country were often trapped into a lopsided dependence upon their husbands in such a universally patriarchal society.

Daughters were brought up to serve their future spouses and married in their midteens. As children, boys and girls would freely play outside, but once a girl approached puberty her hair, no longer cut short, was braided into a single long queue, and she was kept indoors, learning how to cook and sew, until she was married. When a family wanted to know more about a prospective daughter-in-law, they asked her mother's neighbors what kind of girl she was. The ideal answer was, "We do not know, we have never seen her."[4] Once married, women were called by their husbands *nei ren*, "inside person," which was a proprietary expression used synonymously with "my wife." They would work in the house, raise children, obey their husbands, and, most importantly, try to coexist with their mothers-in-law, who often lived in the same house or nearby. The married woman's authority was limited to her children. Eventually her daughters would leave the home and family, but the sons would carry on the family name. When the wife became a mother-in-law, she gained new-found power through her son, and the cycle was repeated.

As the social fabric of nineteenth-century rural southern China frayed and then burst at the seams, sons and daughters, mothers and fathers, were uprooted and pulled apart. In Guangdong Province, it was acceptable for the men of the family to journey across the seas to seek a better life. Women, however, were generally expected to

stay home, work, and raise families. The wives of *jinshanke* endured their loneliness with the hope that their men would earn a great deal of money and either return to their village and retire as wealthy landowners, or possibly send for members of the family to settle in the United States.

Before the 1882 Exclusion Act few Chinese women came to the United States because of traditional cultural taboos and limited financial resources. After the restriction it became illegal for all but merchants' wives and derivative citizens to immigrate. The United States census registered 2790 Chinese women in San Francisco in 1890 and 1303 in 1900. Although these statistics are of questionable accuracy, the ratio of Chinese men to women was no less than 20 to one.[5] Some women came as wives to successful Chinese businessmen. Others were smuggled in with promises of fancy clothing, quick wealth, and/or marriage. Some women must have come searching for freedom from the bonds of the highly restrictive traditional Chinese culture. Other women, like Lilac Chen, were brought to the *jinshan* (*gam saan*) involuntarily. Lilac Chen vividly described, to Victor and Brett de Bary Nee, her father's selling her in China:

> I was six when I came to this country in 1893. My worthless father gambled every cent away, and so, left us poor. I think my mother's family was well-to-do, because our grandmother used to dress in silk and satin and always brought us lots of things. And the day my father took me, he fibbed and said he was taking me to see my grandmother, that I was very fond of, you know, and I got on the ferry boat with him, and Mother was crying, and I couldn't understand why she should cry if I go to see Grandma. She gave me a new toothbrush and a new washrag in a blue bag when I left her. When I saw her cry I said, "Don't cry, Mother, I'm just going to see Grandma and be right back." And that worthless father, my own father, imagine, had every inclination to sell me, and he sold me on the ferry boat. Locked me in the cabin while he was negotiating my sale. And I kicked and screamed and screamed and they wouldn't open the door till after some time, you see, I suppose he had made his bargain and had left the steamer.[6]

The women who came to America were limited to three primary occupational roles. They were usually either a merchant's wife, a house servant, or a prostitute. In the rural wilds of Idaho, Montana, and the Western frontier, local folklore has portrayed a few Chinese women as rugged and liberated frontier settlers; however, the women in San Francisco's Tangrenbu were closely guarded and highly valued commodities. Merchants could freely bring their wives over and establish families. Abiding by traditional customs, these women were seldom seen in the streets of Chinatown. The great majority of men did not have the right to have a family. Before and after 1882, certain tongs specialized in smuggling young Chinese women past United States immigration agents. To enable them to pay their way to this country, exploitative contracts were drawn up similar to those many poor male workers came under. However, there was a significant difference: where the men paid off their debts with their labor, women paid off their debts with their labor and their bodies. One contract read:

> AN AGREEMENT to assist a young girl named Loi Yau. Because she became indebted to her mistress for passage, food, etc, and has nothing to pay, she makes her body over to this woman Sep Sam to serve as a prostitute to the sum of

five hundred and three dollars. . . . Loi Yau shall serve four and one-half years. On this day Loi Yau may be her own master, and no man shall trouble her. If she runs away before the time, and any expense is incurred in catching her, then she must pay the expense. If she is sick 15 or more days she shall make up one month for every 15 days.[7]

Young girls would often start off as house servants and occasionally work at odd jobs like stripping tobacco. Upon reaching a certain age they would either marry a wealthy merchant or enter into several years of prostitution. Some merchants considered experienced prostitutes ideal wives because they were attractive, sociable, and adept at entertaining guests. House servants were treated with varying degrees of respect and disrespect, depending on the individual character of the families they served. Some young girls were brutally treated. They worked hard and were sometimes horribly beaten. Others were treated like members of the family. Lilac Chen experienced both extremes. When the madame who owned her needed money, Lilac would be subcontracted to work for a family as a house servant.

> Everywhere I had been they were very kind to me, except this last place she sent me. Oh, this woman was so awful! They say she was a domestic servant before and was cruelly treated. She used to make me carry a big fat baby on my back and make me to wash his diapers. And you know, to wash you have to stoop over, and then he pulls you back, and cry and cry. Oh, I got desperate, I didn't care what happened to me, I just pinched his cheek, his seat you know, just gave it to him. Then of course I got it back. She, his mother, went and burned a red hot iron tong and burnt me on the arm.[8]

Prostitutes were treated according to their attractiveness and the class of brothel they worked. Entire sections of Tangrenbu along Bartlett Alley and Sullivan's Alley were filled with a full range of regular and high-class houses. Some were frequented not only by Chinese, but by non-Chinese as well.

A great deal of literature was written during Genthe's time in San Francisco, primarily by crusading Protestant missionaries, decrying the horribly degrading conditions Chinese "slave girls" were subjected to and praising the valiant efforts of such individuals as Donaldina Cameron of the Protestant Home Mission, based at 920 Sacramento Street, to rescue these girls from further exploitation. It is incontestable that a number of Chinese women house servants and prostitutes were treated abysmally; but the selective attention focused on Chinatown by these missionaries betrayed a paternalistic attitude of saving "poor helpless" Chinese "heathen" from further sin while essentially ignoring the far greater number of white prostitutes who were almost literally down the road on Sacramento Street, parts of Waverly Place, Dupont Street, etc. This racial hypocrisy was often sourly resented by the residents of Tangrenbu. In many respects the sharply contrasting roles of Chinese women—who were either proper wives remaining indoors and sheltered from the outside world, or else sexual objects available to whoever was willing to pay for their time—were not all that different from the roles imposed upon white women by the then predominant middle-class Victorian morality. "Good" women were idealized and placed on a pedestal, while their husbands were often away from home enjoying the company of sexually promiscuous women. Although neither culture can be excused, even on its own cultural

terms, for the exploitative kinds of relationships it fostered, it is important to keep in mind that what appeared to Western moralists as barbaric and heathen practices, peculiar to the Chinese in America, needs to be viewed in historical perspective and compared to the kind of morality most commonly practiced in America.

The primary responsibility of the merchant's wife was to bear children and raise the family. These women made valiant efforts to inculcate in their children a sense of homeland customs and culture. The maintenance of cultural continuity was a difficult project amid life in such a radically different society. Although Chinatown was segregated from the rest of San Francisco, its streets were not at all immune from American ways and ideas. As was true for immigrant youth across the nation, urban streets were exciting community spaces in which you learned about the world, as well as what happened to Wong on Waverly Place. Mothers often tried desperately to keep their children inside, vainly blocking the influence of Americanization. In the streets Chinese youth learned about "bad" habits, dirty words, other cultures, work, politics, and sex. The children born in the United States qualified as American citizens, but were treated de facto as secondary citizens. In 1858, the State Superintendent of Public Instruction ruled that "Africans, Chinese, and Diggers [Native American Indians]" were barred from the public schools. Chinese public schools were therefore established. In 1903, a Chinese merchant tested the staying power of this racist ruling by petitioning the state legislature to end segregated public schools. The original ruling was upheld. Some of the wealthier families would send their children, usually just the boys, back to China for a few years, just as upper-class San Francisco youth were sent east to boarding schools.

The 1000 to 2000 children of Tangrenbu received plentiful attention, gifts, and love from their many "uncles." They had the run of the streets. The children were the real and symbolic future of the community. And it was in them that merchants and workers alike invested their hopes for a better and more just society. Insofar as they were American citizens, the social pressure upon this emerging generation was not to return to China, but to become

Americans by white Anglo-Saxon Protestant standards. If there ever was a melting pot, it tended to dissolve racial and ethnic identities that did not conform to the dominant culture of the United States. By 1910, United States-born Chinese-Americans composed ten percent of the Chinatown population. The Native Sons of the Golden State, which later became the Chinese-American Citizens Alliance (CACA), was formed in 1895 to fight for the civil and political rights of Chinese in the United States. Many recreational and service-oriented groups, such as the YMCA, were organized, reflecting the trend to assimilate Chinese-Americans into the mainstream of American society. Western dress, language, attitudes, and mannerisms became more commonplace among young Chinese-Americans. Theirs was a bilingual and bicultural subculture, fraught with new conflicts between two very different societies. Their parents, with traditionally Chinese sensibilities, were not always sympathetic to their qualitatively different problems and experiences, and the pervasive racism in American society kept Chinese-Americans at arm's length.

The options available to Chinese women and children in the United States were severely limited both by the discriminatory laws of the larger society and by the role expectations of the tradition-bound culture they came from. It would take some 40 years after these photographs were made for the laws and cultural restraints to loosen their hold sufficiently to allow them a wider range of possibilities.

Notes

[1]S. W. Kung, *Chinese in American Life,* Seattle, 1962, p. 12.
[2]Communicated privately to the present author in Gujin, Xinhui County, China, November 1982.
[3]Ida Pruitt, *A Daughter of Han,* Palo Alto, 1945, p. 55.
[4]*Ibid.,* p. 29.
[5]Mary Roberts Coolidge, *Chinese Immigration,* 1909, pp. 498–502.
[6]Victor G. and Brett de Bary Nee, *Longtime Californ': A Documentary Study of an American Chinatown,* 1973, p. 84.
[7]Berkeley Asian Women's Collective, *Asian Women,* Berkeley, 1971, p. 22.
[8]Nee, *op. cit.,* p. 85.

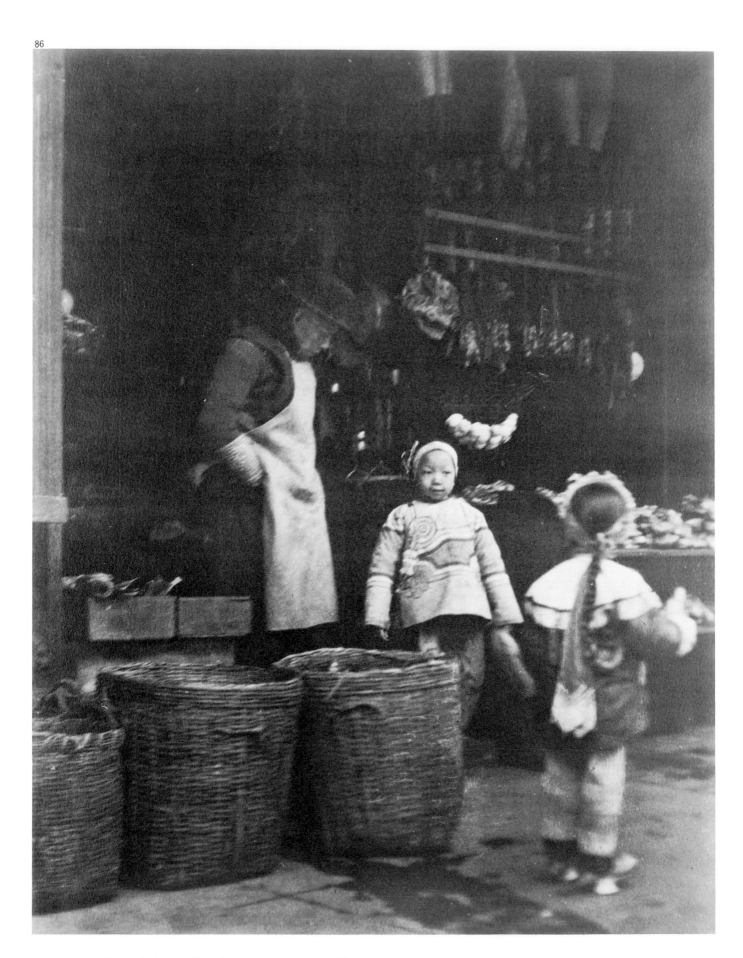

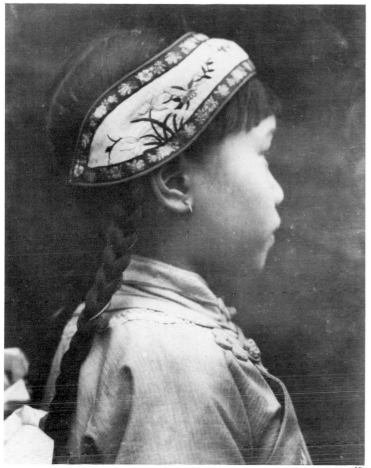

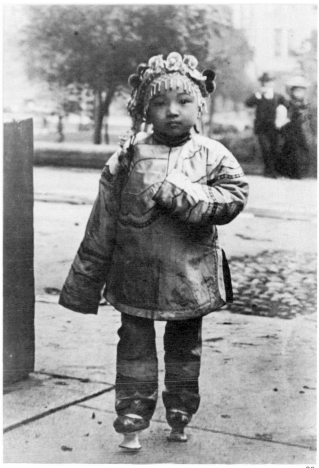

87

88

PLATE 86. "The Grocery Store." Behind the two girls dressed in ornate attire are ducks, sausages, eggs, and hams hung for display. PLATE 87. "Little Plum Blossom." This portrait details the lovely silk embroidery on the girl's headband. She has her hair braided in two ribboned pigtails with bangs in front. Her simple corduroy top has frog buttons in traditional style. Her ears are pierced and she wears gold earrings. PLATE 88. "In Holiday Finery," across from Portsmouth Square. During holidays young girls would have their hair pinned up and wear elaborate head-dresses. This girl, daughter of the herbalist Yow Wong*, is dressed up specially for Chinese New Year. Pearls and probably rubies dangle from the embroidered flowers on top of the head-dress. Her silk tunic is padded, indicating cooler weather. The shoes she is wearing were introduced to China by the Manchus in the 1600s and became fashionable for "big-footed" women who did not have their feet bound.

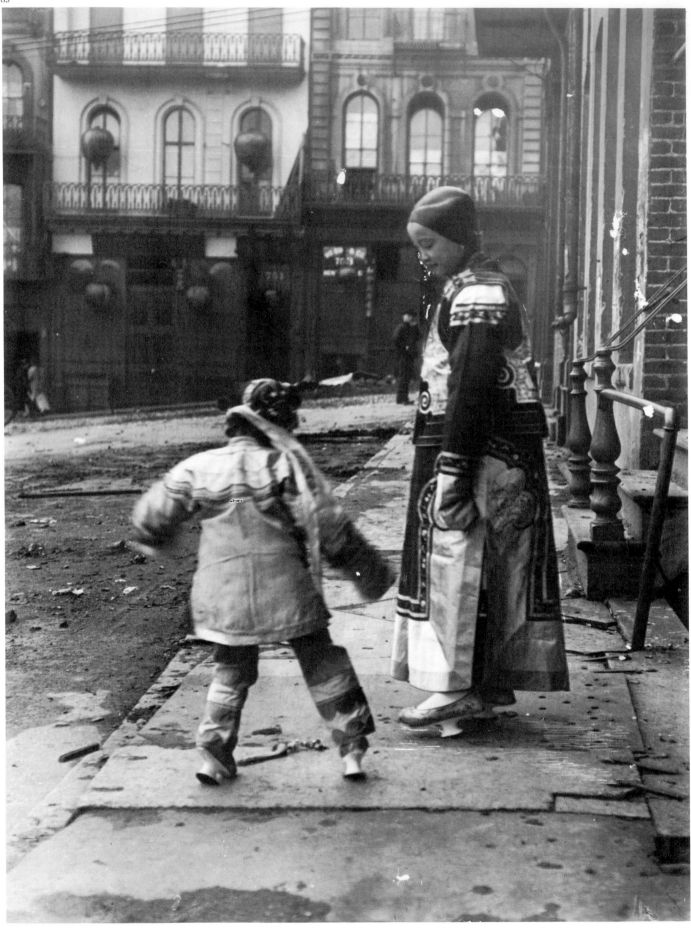

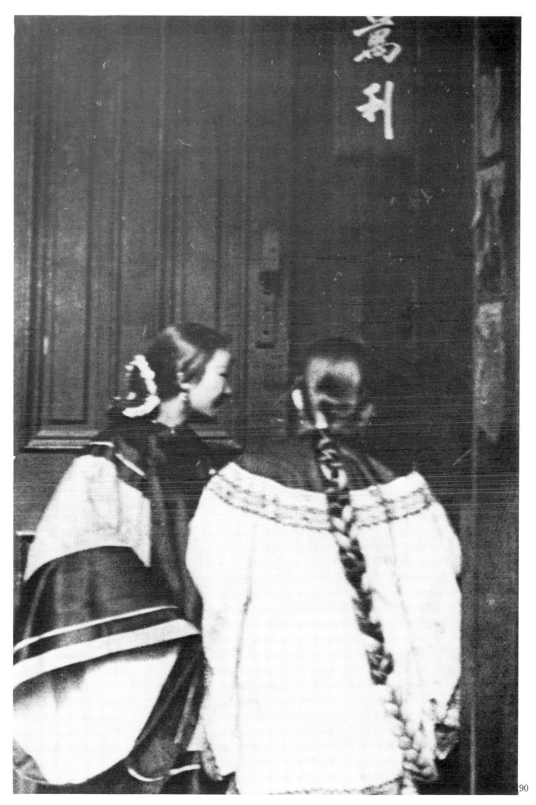

PLATE 89. Brenham Place and Clay Street, off Portsmouth Square. The young woman is dressed in a long Manchu robe, or *qizhuang*, worn only in families that had been awarded special status. Usually men with military backgrounds were given such honors. When girls reached puberty they let their bangs grow out. On special occasions the hair was slicked back with hair oil and arranged in various fashionable styles. At this age, "respectable" women were not allowed to walk outside unescorted except on certain holidays and special occasions. The platform shoes had an aesthetic appeal to Manchu tastes similar to that which high heels have had to twentieth-century Westerners.
PLATE 90. "Dressed for the Feast," 814 Washington Street. The single braid of the woman on the right indicates that she is not married. Interwoven with the hair is raw silk to extend the length of the queue. In contrast to the men, women did not shave their foreheads. Once every seven years the "Good Lady Festival" was celebrated in Tangrenbu, during which all the women in the quarter were accorded the same rights as men and allowed to walk the streets freely.

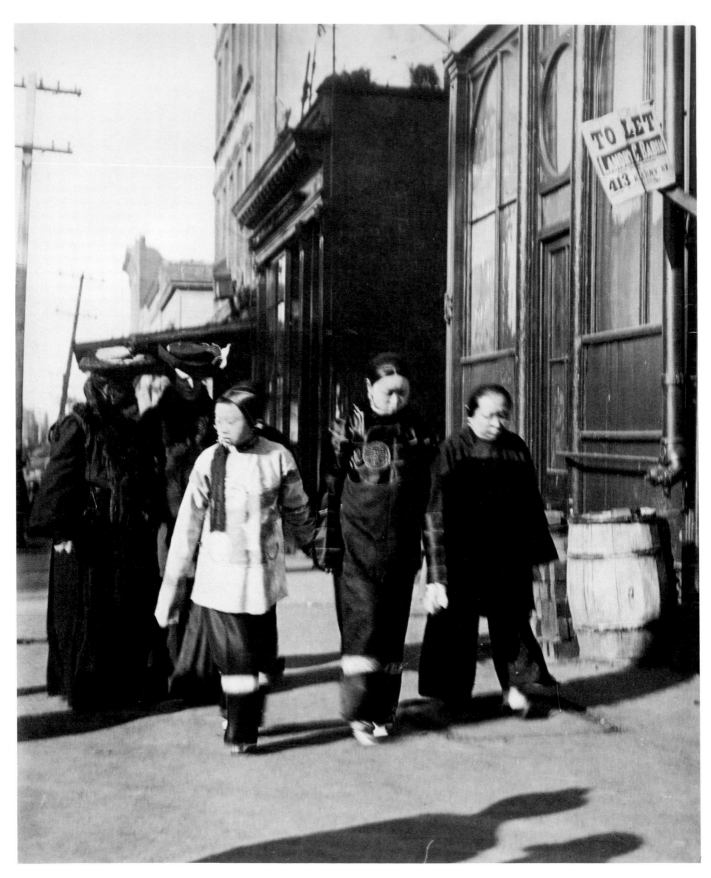

PLATE 91. Three Chinese women walking down Kearney Street. The center woman is dressed in very modern, stylish dress. Two white women clad in Victorian dress and furs follow behind. Either the center woman is a prostitute and the older woman is her madame and the younger girl a servant; or, the more likely explanation (because of the older woman's plain dress), the center woman and the girl are mother and daughter being escorted by their house servant.

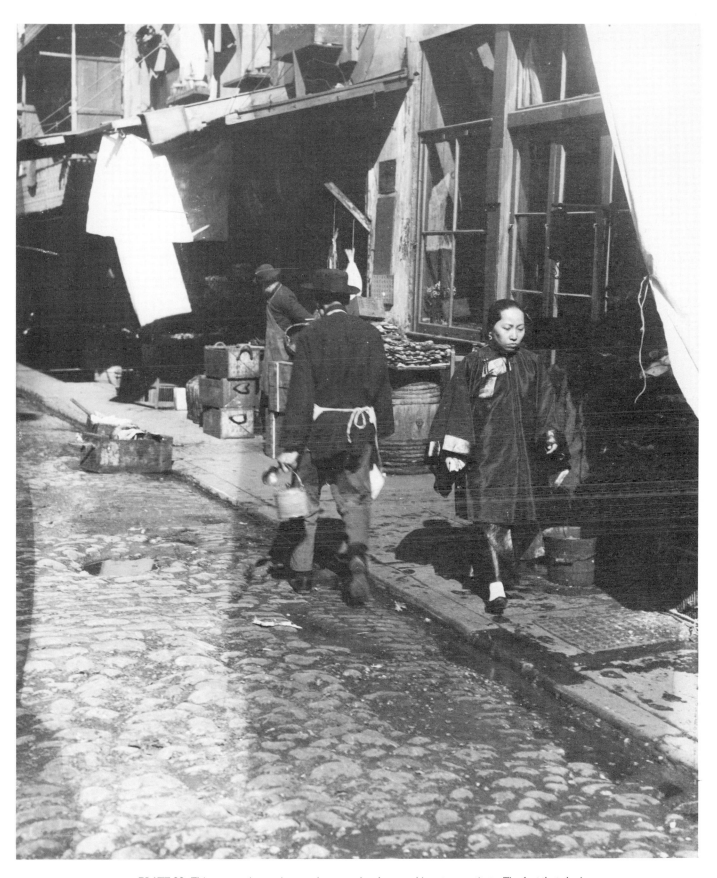

PLATE 92. This woman is wearing regular, everyday dress and is not a prostitute. The fact that she is alone suggests that she is a house servant out on shopping errands. The man she is passing is carrying a metal pot and ladle. His white apron indicates he is either a cook or a waiter returning from a food delivery.

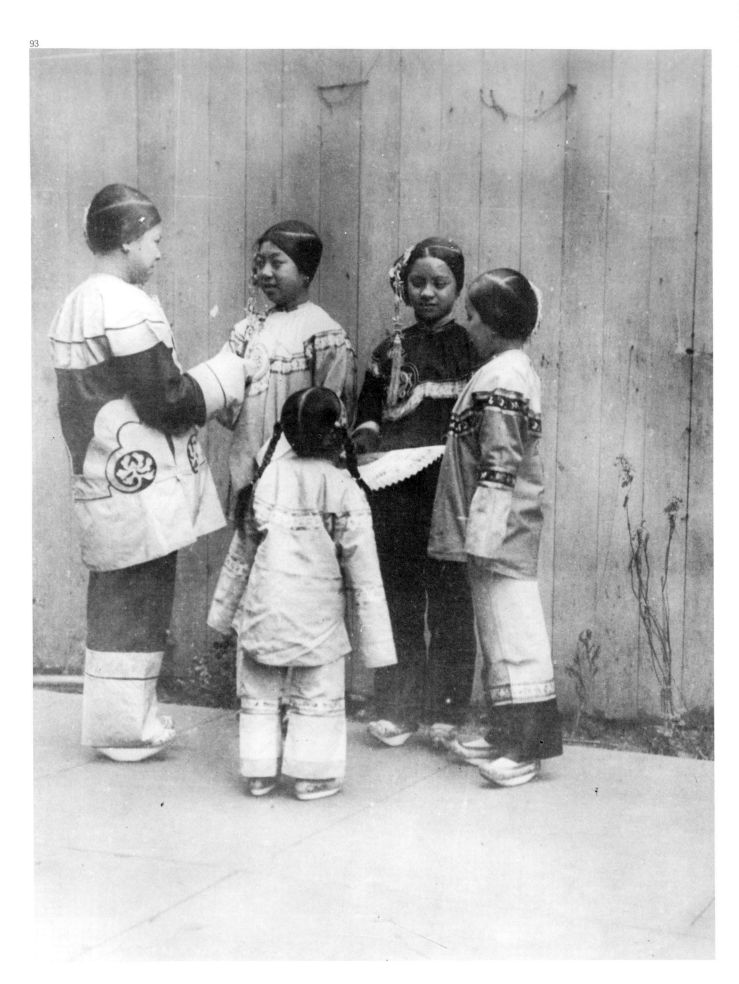

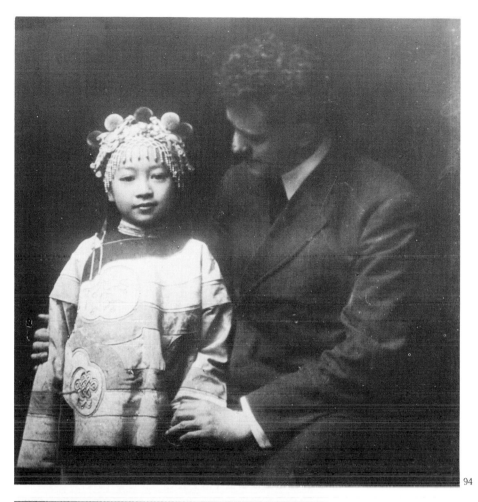

94

95

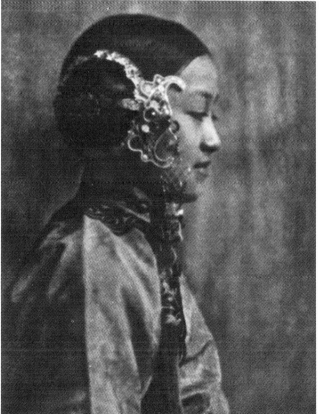

PLATE 93. "Rescued Slave Girls," Protestant Mission House courtyard, 920 Sacramento Street. These young women are in holiday dress with very stylish hairstyles. From 1895 on, Donaldina Cameron (known to Chinese as Lo Mo*, or "Old Mother") was the director of the Protestant Mission House. Accompanied by police, she would undertake daring raids through the alleys and over the rooftops of Chinatown and the Bay area, searching for young Chinese girls who were reported as being badly treated by their employers or families. The girls stayed for varying lengths of time. Those who stayed the longest often became devoted Christians and ended up working for the Mission permanently. **PLATE 94.** "Friends," Minnie Tong and Arnold Genthe. Minnie Tong's Chinese name was Tea Rose. She was one of Donaldina Cameron's favorite pupils. **PLATE 95.** "Little Tea Rose." This beautiful portrait was taken of Minnie Tong several years after "Friends." Her hair is coiled in a bun to one side, with an ornamental hairpiece decorating it. (See also back cover.)

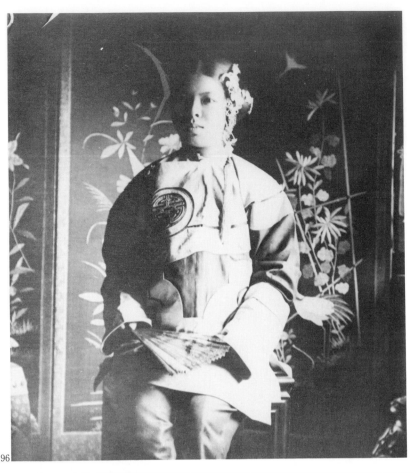

96

97

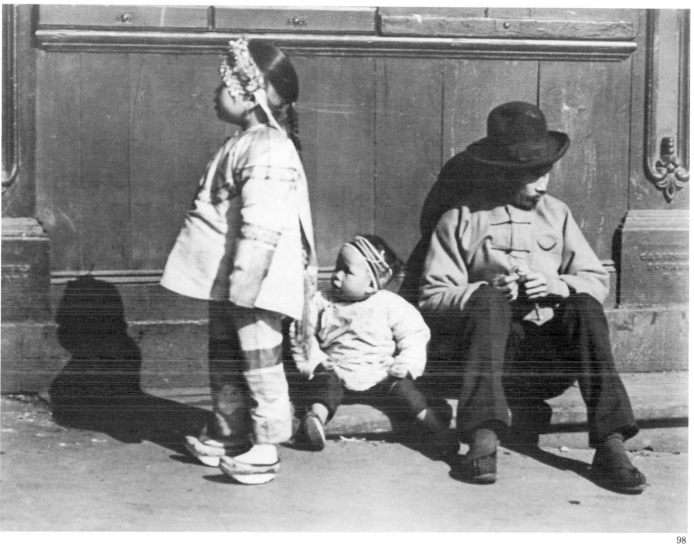

98

PLATE 96. The two Genthe photographs in this plate and Plate 97 are uncharacteristic. Both were taken indoors, probably at "920." The stiff pose of this portrait suggests that it was taken early in Genthe's photographic career. The panel in the background is inlaid with depictions of cranes, flowers, and other traditional motifs. **PLATE 97.** The paneled room with four prints of Western paintings amid mixed Chinese and American decor is most likely in the Mission. Genthe had procured such reproductions for Miss Cameron from generous art dealers, in order to introduce the Chinese girls to Occidental art, and he was very proud of his contribution. **PLATE 98.** "An Afternoon Siesta." Fully two-thirds of Genthe's over 200 Chinatown negatives had children in them. Considering that children formed less than ten percent of the total community population, this visual selectivity reflected both a personal and commercial bias. Constantly attracted to the colorfully garbed children who were so loved and prized by the community, he also was acutely aware of the broader commercial appeal of these photographs.

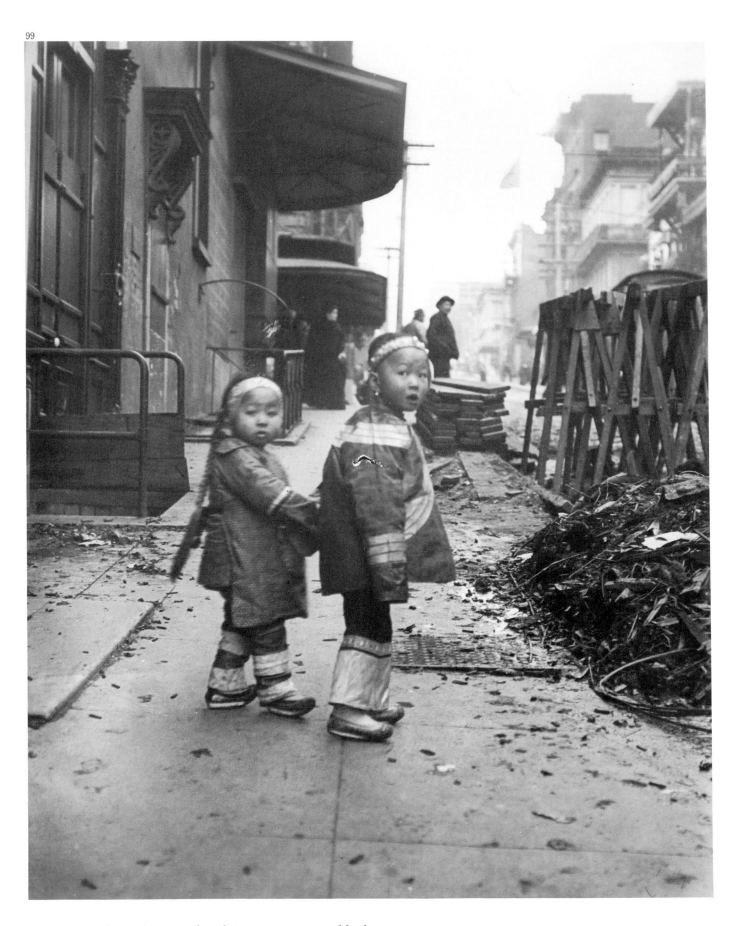

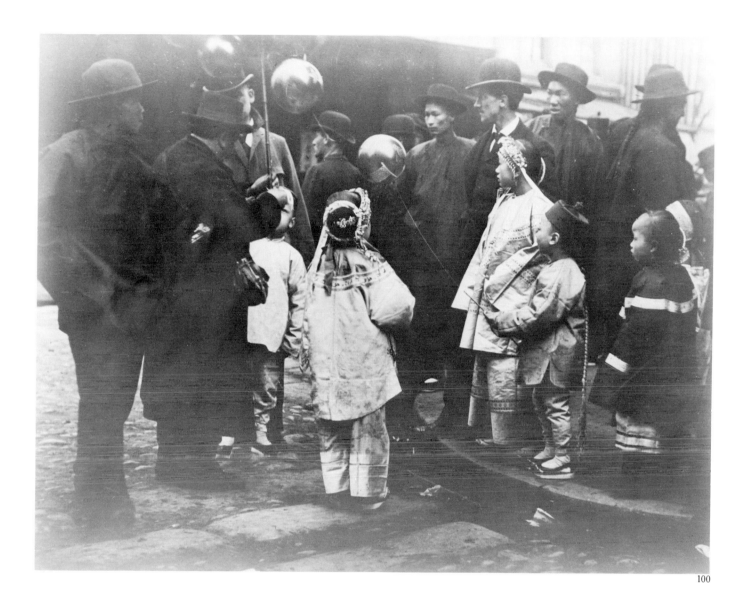

100

PLATE 99. "Their First Photograph." Two girls holding hands next to construction rubble. Their father owned a shoe store on Washington Street that catered to the needs of miners and cooks. **PLATE 100.** "The Balloon-Man." Two boys and three girls buying balloons from the vendor. The balloon on the right has an American flag stenciled on it. A pearl hairclip adorns the bun of the girl on the left.

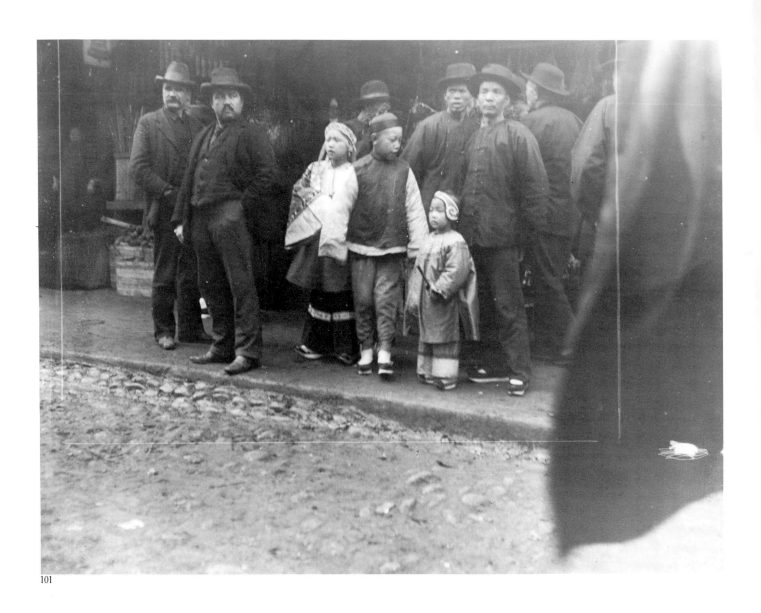

101

PLATE 101. "A Corner Crowd." The crop marks visible on this print, as on a number of others, were made by Genthe for purposes of publication. **PLATE 102.** Children of this age could walk freely around the community unaccompanied by adults. These children in holiday dress are of wealthy parentage. Genthe has scratched out a white man in an overcoat originally appearing behind the boy on the right. A Chinese man, who has been blended into the background, is standing to the left. **PLATE 103.** "Buying New Year's Gifts." The clothing the girl is wearing is extremely ornate. She has a very large pearl attached to her headdress. Etched out of the top of the photograph is a sign reading "Chas. S. Lee, Dentist." The barrels in front of the produce stand contain various pickled vegetables.

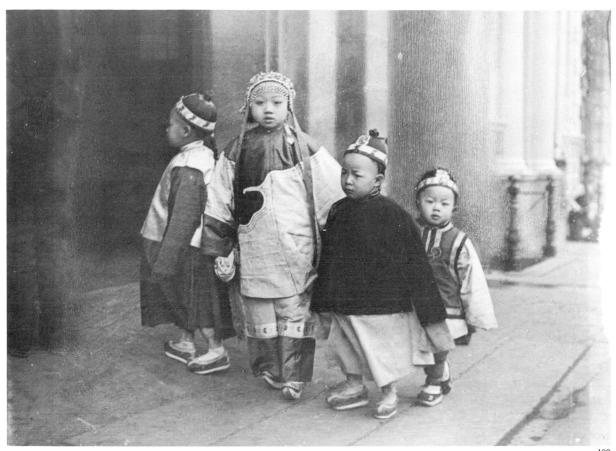

102

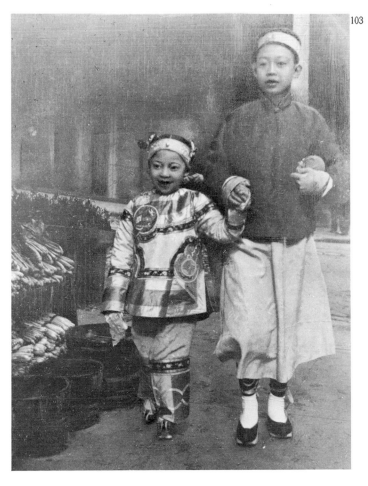

103

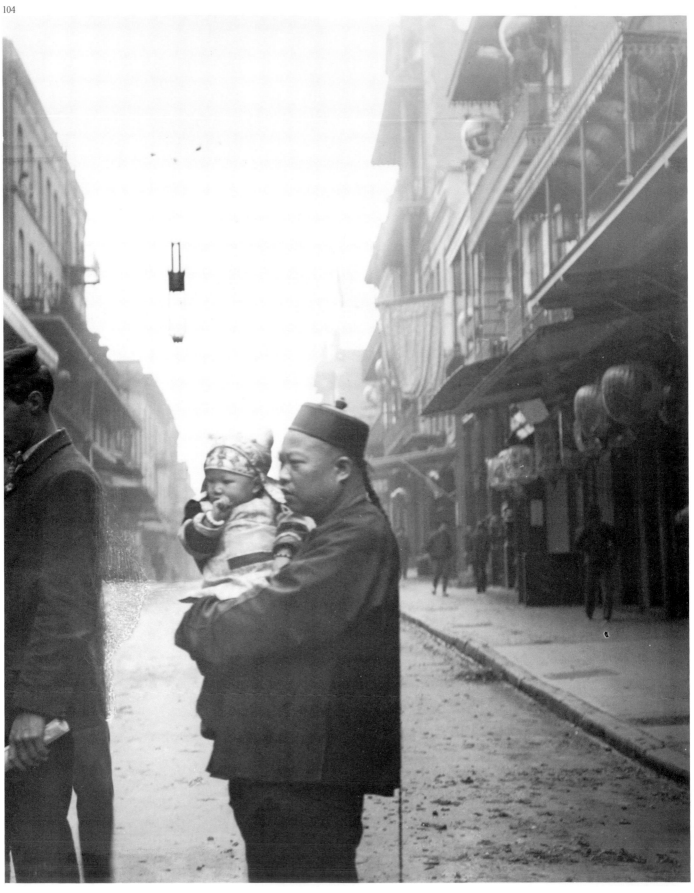

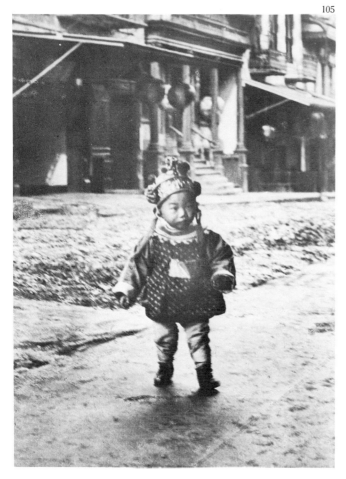

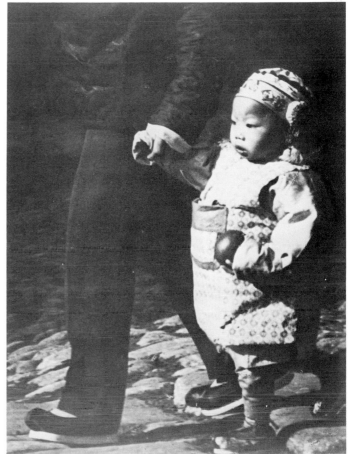

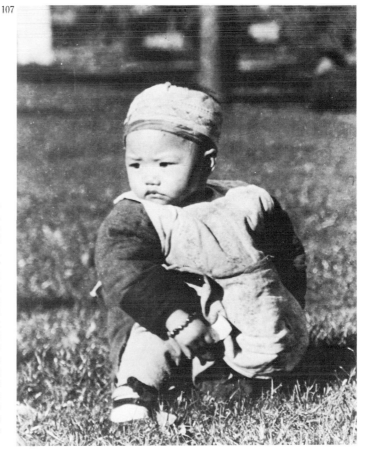

PLATE 104. "A Proud Father," Dupont Street. A man's elbow has been etched out of the photograph. The object hanging above the street is an electric street light attached to a pulley. When the bulb burned out, the light would be pulled over to the side of the street and changed. **PLATE 105.** "The First Born," Waverly Place, Tianhou Temple in background. Headdresses were often red with pearls or jewels and a red fluffy pompom on top. Sometimes bells were attached so that when the child moved they would make a noise. Silk tassels often hung down on both sides. The difference between the headgear of boys and girls was that girls' headdresses came down and covered their ears, whereas boys' did not. Girls' holiday clothing generally had embroidered edges absent from comparable clothing for boys. **PLATE 106.** The boy is holding some type of ball or fruit. The pouch on the front of his bib is meant to hold a glass bottle with a long flexible hose and nipple. This ingenious arrangement allowed older infants to nurse past the breast-feeding stage, while they retained full use of their arms. This cut down on the breakage of glass bottles. **PLATE 107.** "A Native Son," Portsmouth Square. This boy is in everyday dress. Many babies wore bead bracelets around their right wrists. The cylindrical column behind his head is the Robert Louis Stevenson memorial statue of a clipper ship, which once stood on the northern side of the square.

108

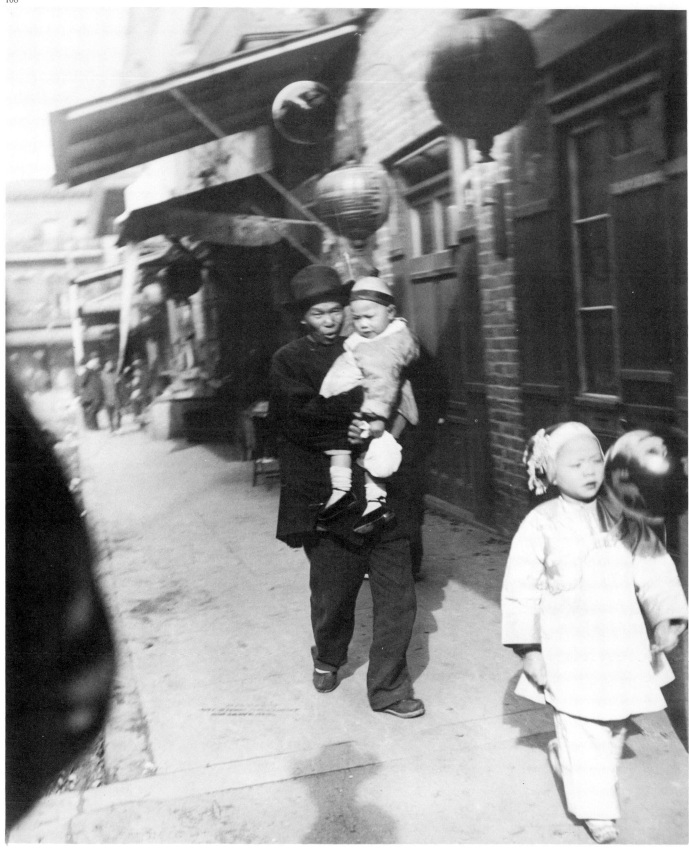

114 Genthe's Photographs of San Francisco's Old Chinatown

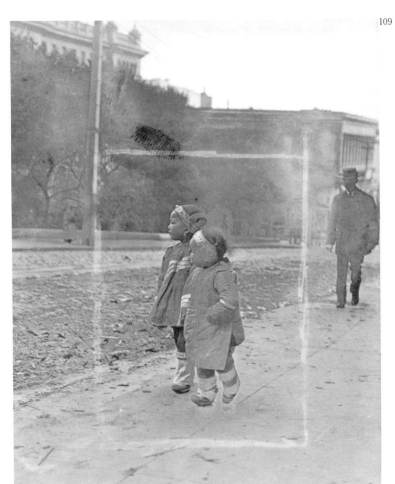

PLATE 108. "A Holiday Visit," ca. 1897. The baby is wearing Western shoes. The girl with the balloon is a member of the SooHoo* family. She was one of three sisters and four brothers. She later married a Jung* and had eight children. After the earthquake, her father was a carpenter for white families who needed skilled craftsmen to restore their houses. PLATE 109. "A Stroll on the Plaza," Portsmouth Square. The Hall of Justice is in the background. The crop marks outline the portion of the negative used in *Old Chinatown*. PLATE 110. Boy in doorway of lamp store. The design on his hat is the word for long life.

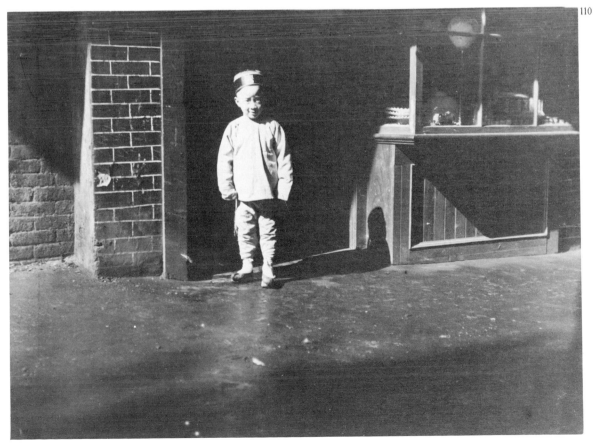

Women and Children 115

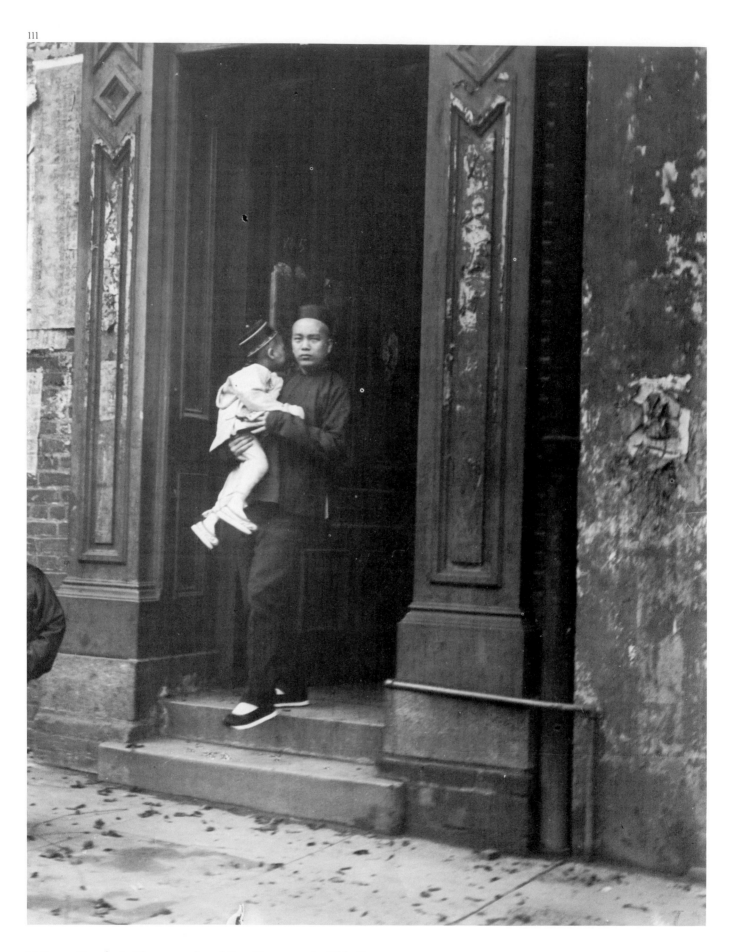

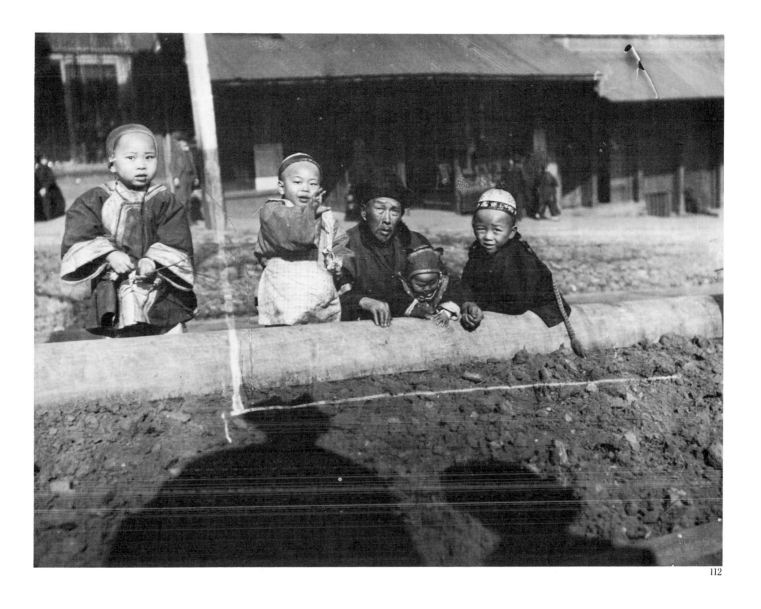

112

PLATE 111. Father and boy. PLATE 112. "The Airing," Portsmouth Square off Washington Street. The four children are being taken care of by an "uncle." It is highly unlikely that this weatherworn, poorly dressed man was wealthy enough to have his own family. The shadows of Genthe and his assistant are in the foreground. As evidenced by the crop marks, Genthe printed the four people on the right as a separate photograph.

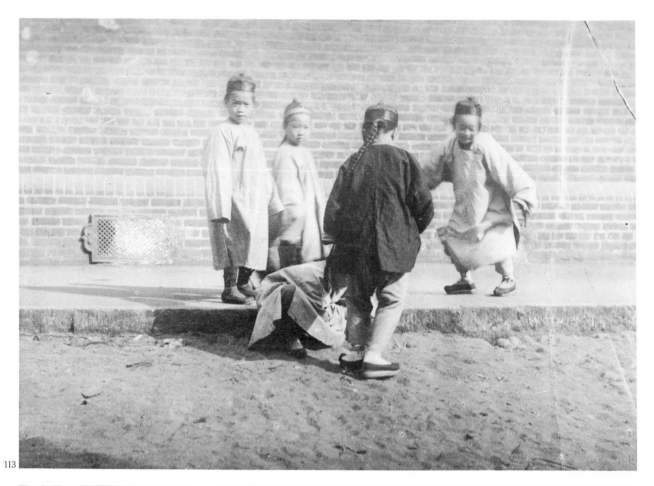

113

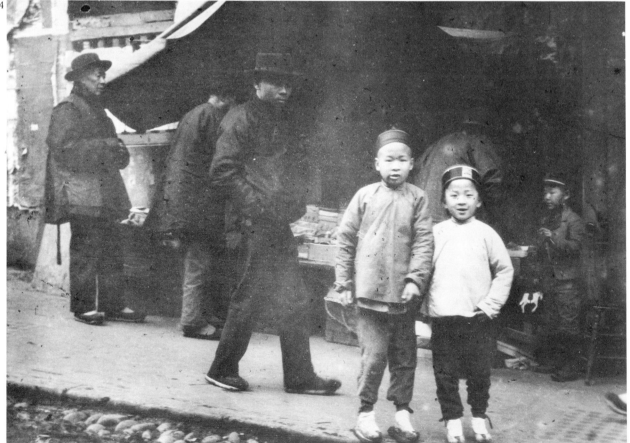

114

PLATE 113. "Boys Playing Shuttlecock." Although Genthe took many photographs of children, he rarely caught them at play. These four boys are playing a traditional game in which the object is to keep a feathered, leather-tipped shuttlecock up in the air by kicking it with the feet. It is a free-form game that requires quickness and great agility. This photograph was entitled "Fire-crackers" in *Camera Craft*, December 1900. Genthe was quite indiscriminate in the titles he used for the same photographs. **PLATE 114.** "Two Sheenies." Two boys are graciously posing for Genthe's camera. The boy in the back is wearing all Western clothing. The reason that Genthe titled this "Two Sheenies," which is usually a derogatory name for Jews, is not clear. **PLATE 115.** "Hairy Kid." This girl with the troubled expression and unruly hair is wearing leather boots. Genthe has scrawled some imitation Chinese words on the sign above her head. **PLATE 116.** "Pigtail Parade." Despite extensive retouching, Genthe managed to capture a magical scene of four children holding each other's pigtails like circus elephants linking trunks and tails. Children were free to wander within the confines of Chinatown. When they left its borders, however, they had to be constantly on guard for white street toughs.

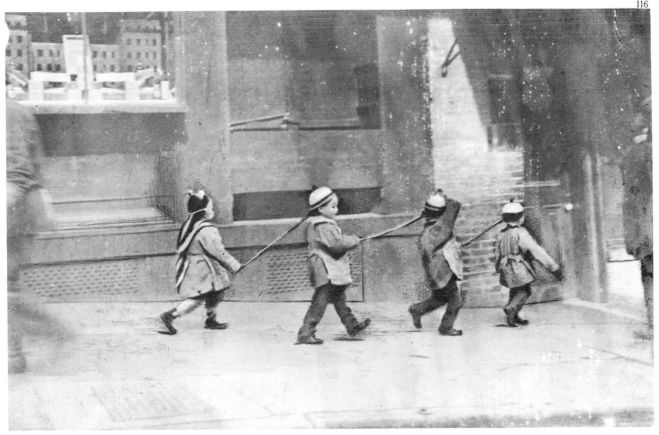

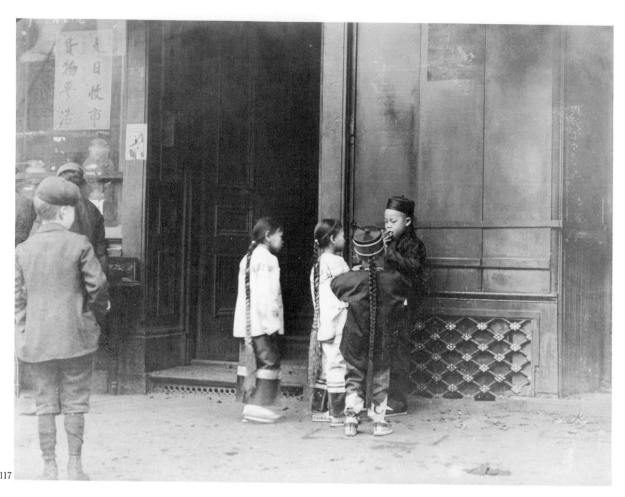

117

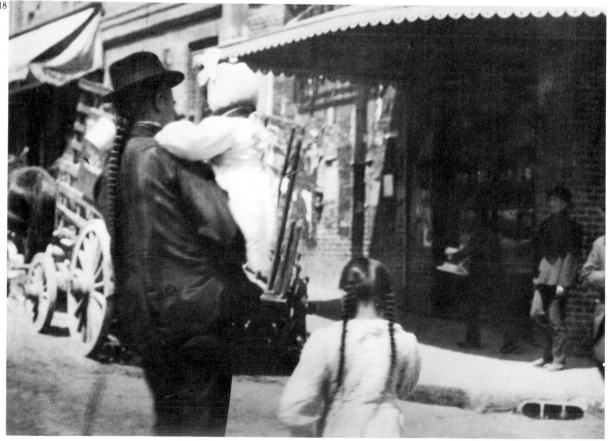

118

120 Genthe's Photographs of San Francisco's Old Chinatown

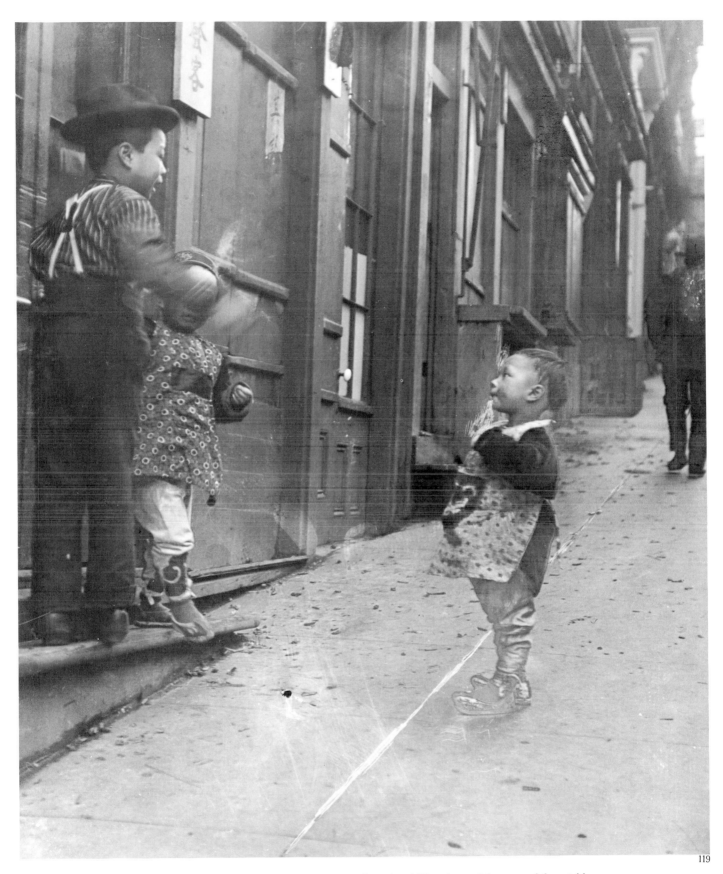

119

PLATE 117. "His First Cigar." The streets were where the children learned the ways of the world. PLATE 118. Father and children on Dupont Street. More and more children were brought up with Western customs and outlooks. The infant is dressed in American baby clothes and the young girl is wearing an American-style dress. PLATE 119. "Little Ah Wu." Ah Wu's left hand is inexplicably scratched out of the negative. He has no queue. The older boy is in totally Western garb.

Women and Children 121

6 EARTHQUAKE, FIRE, AND THE NEW CHINATOWN

At 5:13 A.M., Wednesday, April 18, 1906, the earth shook for 47 seconds. In Tangrenbu, windows blew out, fire escapes and balconies collided on the streets, and it rained bricks. Leland Chin* recalled his experiences that terrible morning:

> We were all in bed. In those days we only had a gas light, didn't have electricity in the house. But you could still have hot water, because people used to have a little hook, you see, get a little wire, and get a pot, and let the jet, the flame of the gas light heat the water. So when you get up in the morning, there's the hot water! (Laughs) So the day of the earthquake, it happened, my, where I slept, it happened they had the pot there, and it struck out the gas light, and it shake and the water spilt, see. And the water dripped on my head, I feel a little hot, I wake up, and here everything is shaking. And then, it shook quite a while, and of course I was only a child, but, then, here went everything tumbling down! And then I went out to the door, and looked out way down California Street . . . where the Dr. Sun Yat-sen statue is, we used to have a lot of wooden buildings on the block, and the first thing you know there's a big crack there. And the street had a big hole there. And then later on the sparks, the fire, the blaze began to start down around Montgomery Street, along the financial district. At that time only the Merchants' Exchange Building was there, that's about the highest building they have, and just about all, all the whole building was enveloped with flame.[1]

Three days later Chinatown was reduced to rubble and smoldering ashes. The day after the quake many Chinese gathered up on Russian Hill, watching the fires that were raging throughout the city. It was a cold, breezy day and soot filled the air, turning a sunny sky into an eerie grayness. Explosions could be heard throughout the city. Martial law had been declared and the army was dynamiting buildings to make wide alleys through city blocks and thus limit the spreading destruction. Chinatown burned and, as everywhere else, its residents were prevented from reentering the quarter. Federal troops with bayonets were commanded to shoot looters and anyone who disobeyed their orders.

Arnold Genthe was sleeping in his four-story house and studio on Sutter and Jones Streets, just south of Nob Hill, on the morning of April 18th, and "was awakened by a terrifying sound—the Chinese porcelains that I had been collecting in the last years had crashed to the floor. . . . The whole house was creaking and shaking, the chandelier was swinging like a pendulum, and I felt as if I were in a ship tossed about by a rough sea."[2] After dismissing his Japanese servant and quickly inspecting his house, he put on suitable "earthquake attire," as he termed it, and went to see the damage wrought by the quake. After wandering about, visiting friends, and having a free breakfast at the Saint Francis Hotel, he returned to his house to get his camera. "The one thought uppermost in my mind was not to bring some of my possessions to a place of safety but to make photographs of the scenes I had been witnessing. . . ."[3]

After discovering his cameras had been damaged by falling plaster, he went to his camera dealer on Montgomery Street and was given, free of charge, anything he wanted. He took a Kodak 3A Special, stuffed his pockets with film, and started out on his photographic expedition. After the fire abated, Genthe returned to the rubble that was once his house to find that practically everything he possessed had gone up in smoke. Amid the bricks and charred wood his worst suspicions were confirmed. "The thousands of negatives which I had made during that time were now but chunks of molten, iridescent glass, fused together in fantastic forms."[4] This nightmarish scene did not represent total disaster, however. He had heeded the prophetic advice of Will Irwin, who, before the quake, had looked through his Chinatown pictures and remarked, "You really ought not to keep these plates and films here. Someday the whole city will burn up. There'll never be another Chinatown like this one, and you have its only picture record."[5] After the quake and fire, the negatives were found unharmed, safely stored inside a friend's vault.

After the fire, the Chinese scattered all over the Bay region. The city government immediately set up the Subcommittee on Relocating the Chinese. The assumption was that the Chinese would not be allowed to return to the rubble-filled streets and alleys of Tangrenbu. The real

estate was simply too desirable for downtown commercial interests. On Sunday, April 22, the Chinese who remained in the Chinatown area were segregated into a camp at North Beach. The racist hostility toward the Chinese before the quake continued and actually intensified during the days following the disaster. By Monday reports of severe suffering among the Chinese had reached even President Theodore Roosevelt. Though he was hardly sympathetic to the plight of the Chinese in the United States, the situation was so bad that Roosevelt warned the San Francisco Red Cross not to discriminate along racial lines in giving out first aid. As it turned out, the bulk of the aid for Chinese and Japanese in San Francisco did not come from the municipal government and public agencies, but from the communities themselves.

In the ensuing days a great deal of discussion went on among city officials on where to relocate Chinatown. At no time were the Chinese workers or merchants consulted. First it was decided that Hunter's Point would be the new location, then that plan was objected to because the city would stand to lose the substantial discriminatory taxes that Chinese paid into the city's coffers each year. By Thursday, the day after the quake, the North Beach camp was moved to the golf course at the Presidio. Perhaps that location, it was thought, could be the permanent Chinatown. On Friday a delegation of Presidio residents, many of whom were local property owners, called on the military authorities and strenuously objected to their new neighbors. The summer zephyrs, they claimed, would blow the odors of Chinatown to their front doors. This was said to be enough to drive these upper-crust white folk into the Bay in terror.[6] So the few Chinese that remained, less than a hundred, were moved once again to a more remote section of the Presidio.

Meanwhile Chinatown was being looted by neighboring Italians from North Beach, and by the National Guard, which was supposed to be protecting the area. The Consul General, Ching Pao-Hsi*, raised this issue to Governor Pardee to no avail. Curfews and protective regulations were relaxed for Chinatown. No efforts were made to stop looters and certainly no shots were fired. Looters carried off "bushels of bronzes, brasses and partly melted jewelry."[7] By the last week of April the mistreatment of the San Francisco Chinese had reached such flagrant proportions that the city officials of Los Angeles offered to supply them with a new home. While all this controversy occupied city officials, those few Chinese who owned land in Tangrenbu had already begun reconstruction. Chinatown was not moved, but remained in the same location as old Chinatown—alleyways and all.

The one positive consequence of the quake and fire for Chinese was that all U.S. Customs immigration records were destroyed. This made it virtually impossible to determine the number of Chinese who were legally allowed to live in the United States. An intricate underground network of false papers was to grow out of the ashes of these destroyed records, often resulting in successful efforts to get more Chinese into the United States. Thousands of Chinese who were in the United States when the fire occurred would now claim that they were U.S. citizens and apply to bring their sons and/or families over.

In 1911, Genthe left San Francisco for New York City. One year later, an event of monumental historical importance occurred in China. Dr. Sun Yat-sen led a revolution that succeeded in establishing the Republic of China, overthrowing centuries of dynastic rule. In a letter written by Arnold Genthe to Will Irwin in 1912, appearing as a Postscript to *Old Chinatown*, Genthe sentimentally bemoaned the disappearance of the feeling of the old Chinatown quarter:

> It was the evening before my departure from San Francisco, just about a year ago. I had strolled down to Chinatown for a last visit. In the glare of blazing shop fronts, in the noise of chugging automobiles carrying sightseers, I again, as so many times before, found myself trying to see the old mellowness of dimly-lit alleys, the mystery of shadowy figures shuffling along silently. . . .
> At last I, who for years had tried to deceive myself with sentimental persistency—just as one searches for traces of lost beauty in a beloved face—was forced to admit that Old Chinatown, the city we loved so well, is no more. A new City, cleaner, better, brighter, has risen in its place.[8]

The shuffling, shadowy figures that Genthe rather condescendingly referred to were deeply affected by the revolution in China. The Manchu foreigners had been overthrown and a new parliamentary-style government had been formed, led by the Western-educated Dr. Sun. That event, far more than the earthquake and fire, affected the appearance and attitude of Chinese in San Francisco and the world. Queues were cut off in celebration of the ending of 268 years of Manchu domination. China and Chinese eagerly entered the twentieth century. Wanting to strengthen the nation, Sun encouraged patriotic youth to learn from Japan, the United States, and Europe. Within Tangrenbu, Western-style dress became more and more common, slowly displacing traditional everyday and holiday wear.

Genthe was to return to San Francisco several times before his death in 1942. In 1927 he took a few photographs of Chinatown, some of which were published in *Asia* magazine under the title "Time's Whirligig in Chinatown." His captions noted the differences he found: "The once quaint streets are now brilliantly illuminated, smoothly asphalted, filled with noisy automobiles and crowds in American clothes."[9] "Cash-register and department-store manners have replaced the abacus and the patient, unfailing courtesy of the old-time shops."[10] And "American clothes are replacing the picturesque garments of yesterday, and an ambition to be 'American' in manners as well as appearance is evident—in nobody more noticeably, of course, than in the children."[11] The new Tangrenbu was far less exotic to Western sensibilities. Genthe still focused his camera on favorite subjects—street-corner scenes, alleyway walls filled with posters and notices, and of course, children. He took these new photographs, however, not to give a complete picture of the new community, but to provide a selection of scenes that could be contrasted with those of his pre-earthquake compositions. These photographs are more like random reflections upon lost times than enthusiastic affirmations of the new community.

The American-born Chinese were now raising their own families of second-generation citizens. The "old-timers" were disappearing one by one. These new conditions brought their own problems and possibilities. Old Chinatown had faded into the background. Its physical traces had been all but destroyed, but its memories were

still carefully harbored by the residents who were old enough to remember. And it is these stories salvaged from individual memories, combined with Genthe's photographs, that give us the opportunity today to reconstruct the everyday street life of Tangrenbu.

Notes

[1]Victor G. and Brett de Bary Nee, *Longtime Californ': A Documentary Study of an American Chinatown*, 1973, p. 76.

[2]Arnold Genthe, *As I Remember*, 1936, p. 87.

[3]*Ibid.*, p. 89.

[4]*Ibid.*, p. 96.

[5]*Ibid.*, p. 98.

[6]John Castillo Kennedy, *The Great Earthquake and Fire, San Francisco, 1906*, 1963, p. 237.

[7]*Ibid.*, pp. 235–37.

[8]Arnold Genthe, *Old Chinatown*, 1913, p. 205.

[9]Arnold Genthe, "Time's Whirligig in Chinatown," *Asia*, April 1927, p. 301.

[10]*Ibid.*, p. 303.

[11]*Ibid.*, p. 304.

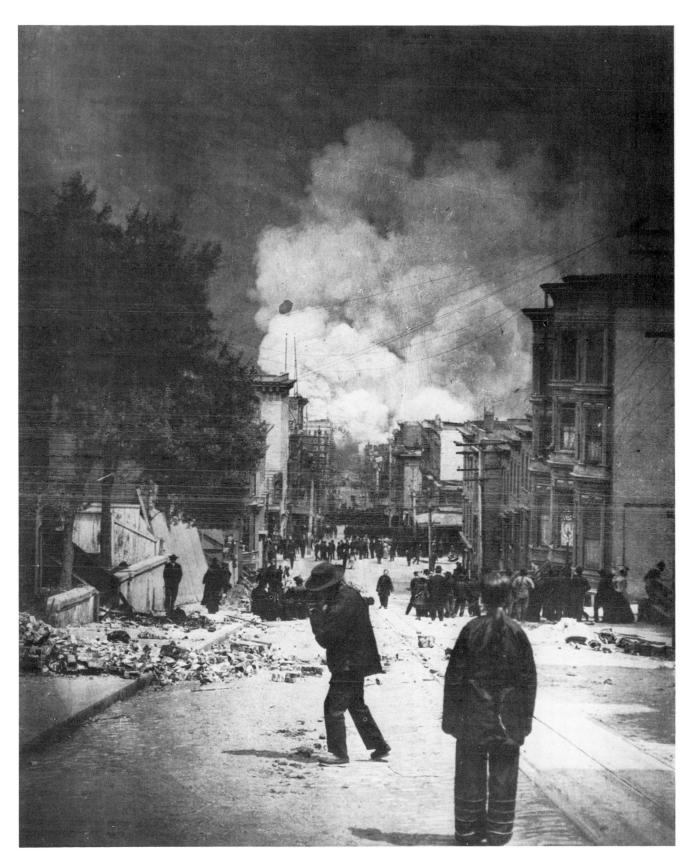

PLATE 120. "San Francisco, April 18, 1906." Groups of people stand watching the fires rage out of control by the docks. The earthquake had ruptured the major water mains and little could be done to extinguish the fires. Genthe was known to have taken only this and the following two photographs of the Chinatown area at this time. This one was taken looking down from Clay Street just west of Tangrenbu. Stockton is the cross street below. It is not known how many Chinese died in the catastrophe, but charred bodies were found throughout the quarter.

Earthquake, Fire, and the New Chinatown

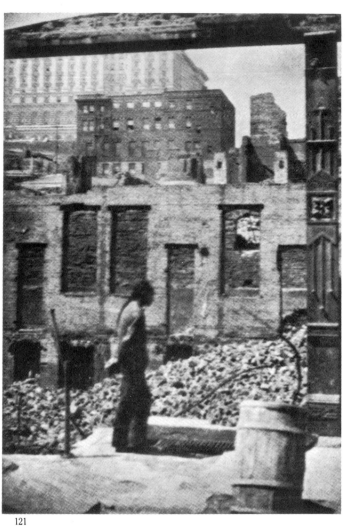

121

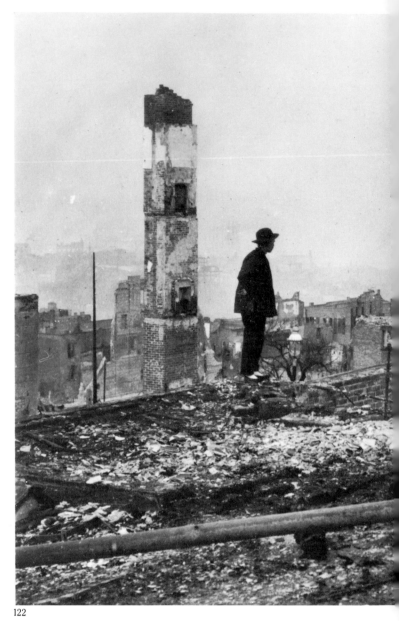

122

PLATE 121. "After the Fire, 1906." A Chinese man walks by the doorstep of what was once a Chinatown building front. The Fairmont Hotel can be seen in the far distance still intact. **PLATE 122.** "On the Ruins (April 1906)." The devastation by the fire was enormous. Here a Chinese man inspects the extensive damage to Chinatown. The column on the left was a chimney. The quake itself did relatively little damage. Fireplace and gas fires tossed about by the quake (and unextinguishable because the quake had also broken the water mains) were primarily responsible for the eventual destruction of the city. The half-fallen dome of the Hall of Justice, located on Kearney Street at Portsmouth Square, stands in the background.

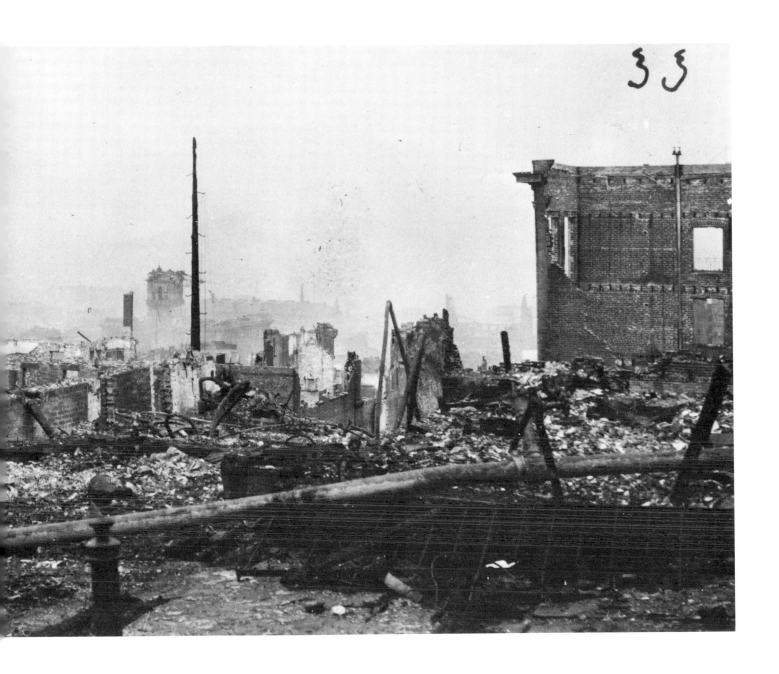

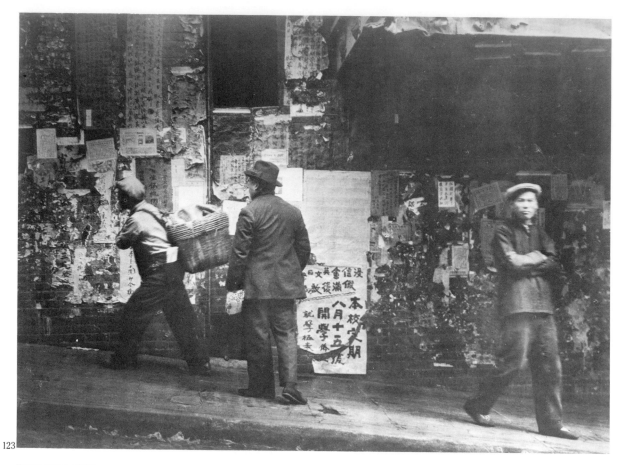

123

124

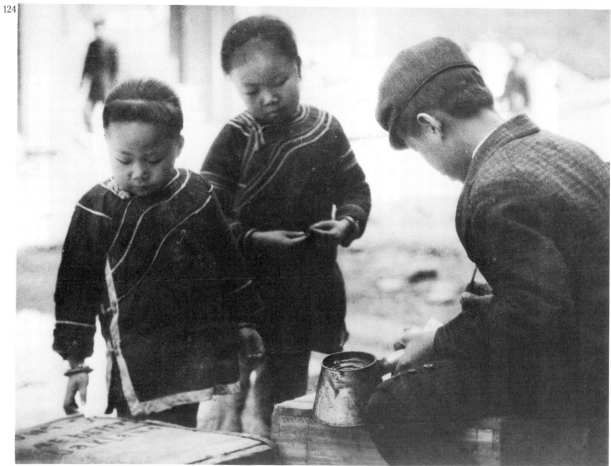

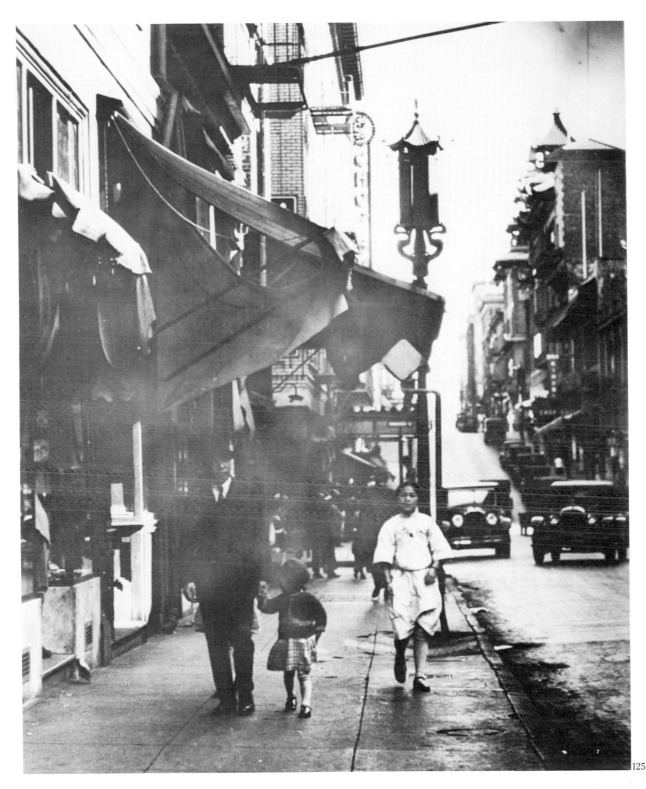

125

PLATE 123. Wall posters, Washington Street, just west of Grant Avenue (Dupont Street), late Teens or early Twenties. Within the 20- to 30-year span between this photograph and Plate 76, poster styles remained relatively unchanged, but clothing styles were modified. Chinese tops became more closely fitted, and the Chinese man with the basket is wearing Western-style overalls The practice of putting up wall posters gradually disappeared after the quake. The posters here include an exhortation to realize Sun Yat-sen's Three Principles of the People. **PLATE 124.** "Artist," 1927. The two girls are wearing fairly traditional everyday clothes; the boy, however, is without a queue and is wearing a cap and knickers. He is painting addresses on wooden crates for

shipment. The empty lot across the street suggests that not all leveled buildings were replaced immediately after the earthquake and fire. **PLATE 125.** Grant Avenue from Bush Street, 1927. After the quake, Dupont Street was renamed Grant Avenue. San Francisco Chinese, however, continued to use the old name in Chinese. By the 1930s, neon chop suey signs replaced lacquered lanterns, and pagoda roofs topped off decidedly Western-style brick buildings. Grant Avenue had become a tourist haven. The quasi-Chinese-style street lamps were erected by the Chinese Chamber of Commerce, in conjunction with the city, in the 1920s. This photo shows the same 400 block of Grant Ave. (Dupont St.) as "Entrance to Chinatown" (Plate 6).

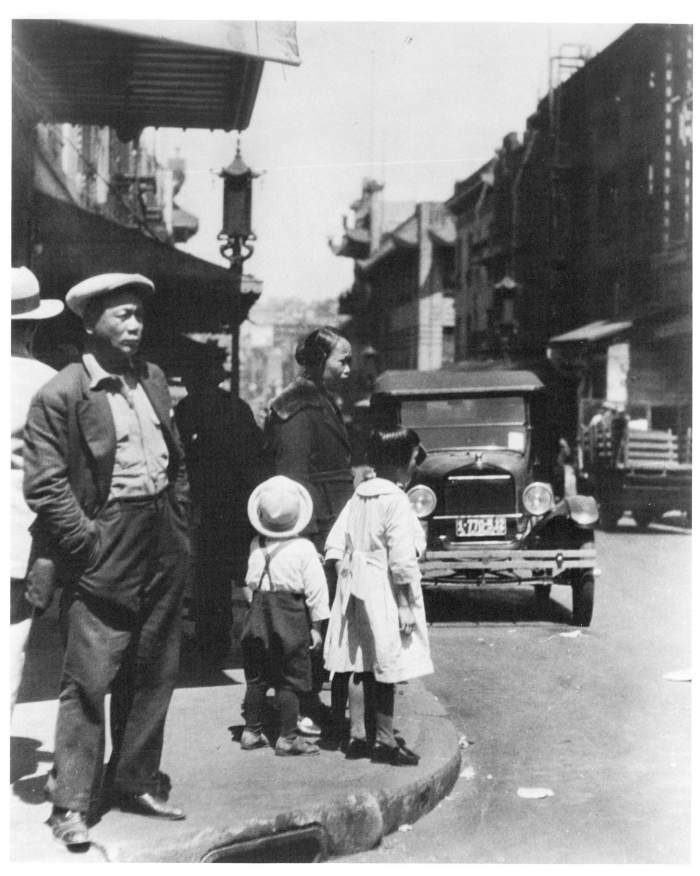

PLATE 126. Clay Street and Grant Avenue, 1927. It is interesting to note the sharp contrast between the street-corner scene in this photograph and that in Plate 29. The feel of Tangrenbu changed tremendously in a 30-year time span.

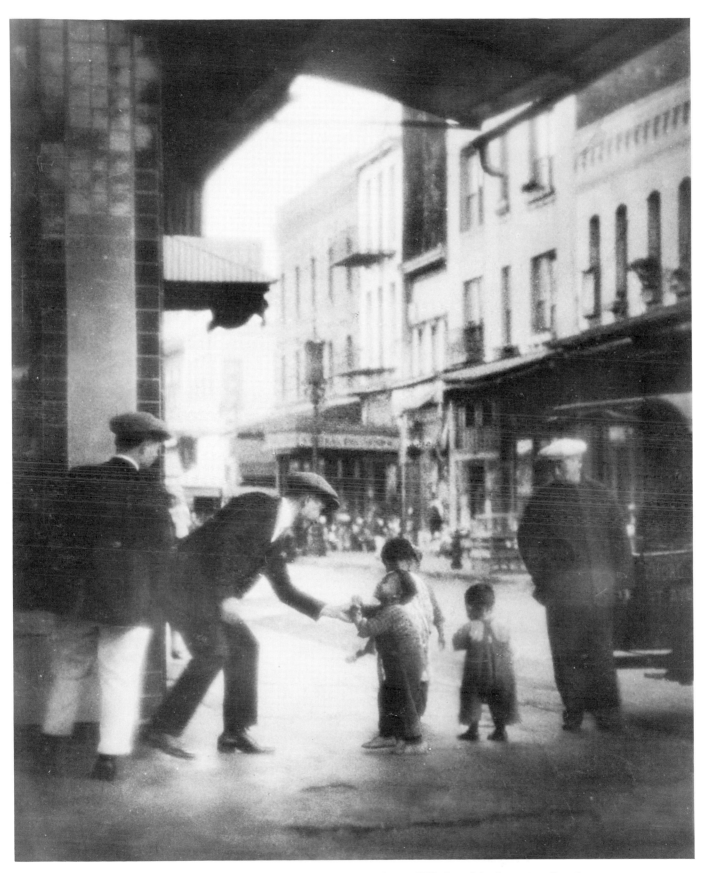

PLATE 127. Grant Avenue near Commercial and Clay Streets, 1927. One of the deepest sentiments running unbroken from the bachelor society of the 1800s through that of the early 1960s was the great affection the community's many "uncles" had for the children of the quarter. The three men are all wearing the same-style cap. The older man wears a more traditional Chinese jacket, whereas the younger men are in stylish American clothing.

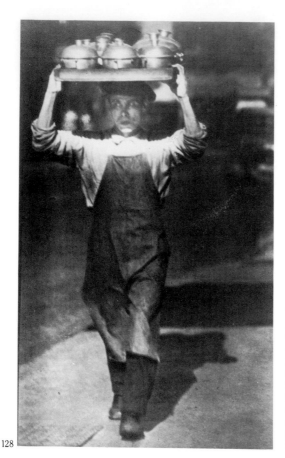

128

129

PLATE 128. This man is delivering food door-to-door. This was a common sight in Chinatown until World War II. Sometimes a waiter could be seen carrying an entire table-load of food, complete with table, on his head. These metal containers often had hot-water compartments underneath to keep the food warm. **PLATE 129.** Hang Ah* Alley, near playground, 1927. The ties and white shirts indicate that some of these boys attended Christian grade school. For boys, playing with shuttlecocks had pretty much given way to riding tricycles and go-carts. These are the children of the generation of boys who had played shuttlecock (see Plate 113).

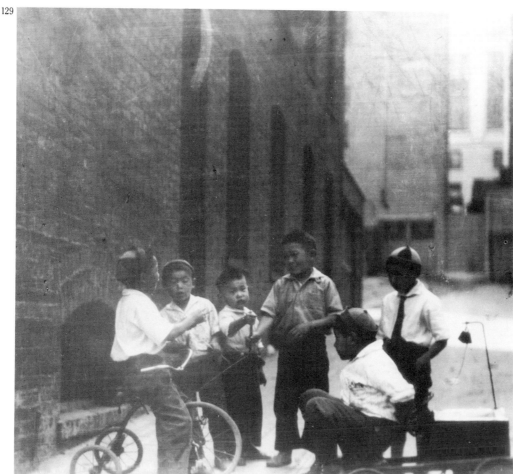

BIBLIOGRAPHY

This list includes writings by Arnold Genthe, writings about his Chinatown photographs, and photographs of Chinatown published by Genthe.

"The California Camera Club: A Critical Estimate of This Year's Print Exhibit." *The Wave*, 3 December 1899, p. 5.

Dragon Stories: The Bowl of Powfah, the Hundredth Maiden, Naratives [sic] *of the Rescues and Romances of Chinese Slave Girls* (photographs by Arnold Genthe). Oakland, Calif.: Pacific Presbyterian Publishing Co., 1908.

GENTHE, ARNOLD. *As I Remember.* New York: John Day, 1936.

———. "The Children of Chinatown" (article and photos). *Camera Craft*, December 1900, pp. 99–104.

———. "A Chinese Fishing Village" (photomontage). *The Wave*, 18 December 1897, p. 12.

———. "Chinese New Year" (photo). *The Wave*, 23 December 1899.

———. "A Critical View of the Salon Pictures." *Camera Craft*, February 1901.

———. "Four of a Kind" (photo). *Camera Craft*, December 1900, p. 145.

———. "New Years in Chinatown." *The Wave*, 25 February 1899, p. 11.

———. "New Year's Visitors in Chinatown" (cover photo). *The Wave*, 6 February 1898.

———. *Old Chinatown: A Book of Pictures*; with text by Will Irwin. New York: Mitchell Kennerley, 1913.

[———.] *Pictures of Old Chinatown*, by W. H. Irwin (photographs by Genthe). New York: Moffat, Yard & Co., 1908.

———. "Rebellion in Photography" (article and photos). *Overland Monthly* 43, no. 2 (August 1901).

———. "Street Life in Chinatown" (photomontage). *The Wave*, 18 December 1897, p. 17.

———. "Time's Whirligig in Chinatown" (article and photos). *Asia*, April 1927.

HOAG, BETTY LOCHRIE. *The Magic Lens of Dr. Genthe (1869–1942)* (exhibition brochure, Carmel Art Museum). Berkeley, Calif.: Bancroft Library, University of California, n.d.

KINGSTON, MAXINE HONG. "San Francisco's Chinatown." *American Heritage* 30, no. 1 (December 1978), pp. 36–47.

MAURER, OSCAR. "The Grand Prize Exhibit: A Criticism of the Work of Arnold Genthe." *Camera Craft*, February 1901, pp. 298–99.

QUITSLUND, TOBY. *Arnold Genthe: A Pictorialist and Society* (exhibition brochure). New York: International Center of Photography, 1984.

STATEN ISLAND INSTITUTE OF ARTS AND SCIENCES. *Arnold Genthe, 1869–1942: Photographs and Memorabilia from the Collection of James F. Carr; A Survey Exhibition* (28 September through 2 November 1975). New York, 1975.

YUNG, JUDY. "Alice Fun: Aging with Grace and Dignity." *East West* (San Francisco), 7 April 1982.